D0939388

Theory and Use
of Color

Theory and Use of Color

Luigina De Grandis

Translated by John Gilbert

Prentice-Hall, Inc., Englewood Cliffs, New Jersey
and Harry N. Abrams, Inc., New York

Rancho Santiago College
Orange Campus Library

Frontispiece: Adolph Gottlieb. *Sign.* 1962. Collection of the artist

Editor, English-language edition: Beverly Fazio

Library of Congress Cataloging-in-Publication Data
De Grandis, Luigina.
 Theory and use of color.

 Translation of: Teoria e uso del colore.
 Bibliography: p. 153
 Includes index.
 1. Color. I. Title.
QC495.D3613 1986 701'.8 85-20132
ISBN 0-8109-2317-3 (pbk.)

QC 495
B3613
1986

Copyright © 1984 Arnoldo Mondadori Editore S.p.A., Milan
English translation copyright © 1986 Arnoldo Mondadori S.p.A., Milan
Translated by John Gilbert

Published in 1986 by Harry N. Abrams, Incorporated, New York
All rights reserved. No part of the contents of this book may be reproduced
without the written permission of the publishers

Printed and bound in Italy by Officine Grafiche Arnoldo Mondadori, Verona

Contents

Preface

One particular feature of this book – which may not be obvious at first glance, and which I would therefore like to emphasize – is that it is concerned with the fundamental desire to know and to understand. It teaches in great detail how different theories can interrelate and be applied in combination with each other, leaving out nothing that could usefully be included and showing how every piece of information can be used to supplement the reader's knowledge with facts that are not superficial notions but a part of our culture.

Anyone who has any interest in color, for whatever reason, will already be fully aware of the vast amount of knowledge necessary before one can use the medium freely and comfortably. This book not only provides a complete panorama of the various aspects under which color can be considered, but explains everything in concrete terms, a factor Luigina De Grandis considers very important for anyone who studies or works with color. Another important feature of the book is that it is presented as a true manual, where what counts is not the pomp and show of culture, but the communication of experiences gained from a full and well-organized career. The arguments are put forward with the depth and lucidity that only an expert can fully appreciate. However, this is clearly no encyclopedia, as one can tell from the author's enthusiastic style, which tempts the reader to study and try out different techniques. The result of many years spent in the world of art, this volume bears witness to the generosity the author has always shown in her teaching career, and from these pages the reader will be able to form a true, if incomplete idea of her personality.

It is not possible to teach everything, but certainly a lot can be learned from this book. I would therefore like to draw attention not only to the wealth of subjects considered in this book – ranging from physics to physiology, from psychology to technology and aesthetics – but also to the amount of space given to each in order to retain an overall balance, while at the same time suggesting how each idea can be assimilated and applied in the widest possible context. For the average reader, unfamiliar with the deep and age-old rift between artists and philosophers, scientists and technicians, it will seem natural to include all the points dealt with and mentioned in the various disciplines.

This book is not based on any previous publication and is meant as a handbook, not a bible, which, through either the text or the illustrations, will continually encourage the reader to try out various suggestions and considerations for him- or herself. For this reason it will be extremely useful to a whole range of individuals from students to teachers, academicians, artists, and scientists.

Osvaldo da Pos

Introduction

Before undertaking to write this book I stopped a moment and thought, knowing that it would demand a great deal of time and trouble. I had grown used to hearing complaints, especially from educated people, about the inability of young people today to apply themselves to systematic study, and their predisposition toward superficial, prepackaged ideas of the type generated by the mass media such as newspapers and television. However, my long experience of teaching in art schools has enabled me to take a less pessimistic point of view. My dealings are with young people whose desire it is to become artists and who are determined to express their own individuality and originality, and I have seen how much they are willing to sacrifice in order to realize this ambition. In his own way, an artist, like a scientist, tends to be a specialist and to strive for perfection; but whereas science can be learned by patient application to study, art, with its sudden and fleeting glimpses of meaning, cannot. Colors, plastic materials, sounds, and word combinations are the formal means by which the artist conveys mental processes that would otherwise be impossible to express. Even if art does not easily lend itself to theory, the means by which it is expressed, as they belong to the physical world, conform to intrinsic laws based firmly on reason. From these laws, therefore, it is possible, even desirable, to formulate a body of theories.

Of course, art is the realm of permanent change, the dialogue of opposites, and its masterpieces frequently emerge as a result of the very violation or negation of the intrinsic laws governing its methods. However, in order for anything new and fertile to spring from such violations and denials of conven-

tion, one has to know exactly what is being contravened and to be aware of the likely consequences. Any amount of useless, frustrating work can be avoided if only an artist has some knowledge of the peculiarities and the possibilities of the means at his disposal. By choosing to enroll in an art school, students show their desire to acquire such knowledge. It is with them in mind, and recognizing those same ambitions that had once been mine, that I decided it would be worthwhile embarking on this book dealing with the subject of color.

An art teacher will frequently be asked to define color, and certainly it would not be enough to do so simply in terms of its properties and appearances. The subject raises all sorts of problems, depending on the way in which it is approached (scientifically or aesthetically, for example), the area of intended application, and the amount of information required. Color is available to everybody—whether used for simple entertainment in the free play of our imagination, heedless of rules and theories, for artistic ends, or for precise practical purposes; consequently, any discussion of color must take into account the wide range of interest that may prompt an enquiry as to its nature, and endeavor to provide answers that satisfy all parties.

For practical reasons, it is convenient nowadays to distinguish what is objective from what is subjective; thus the results obtained from scientific research on color (be it chemical, physical, or physiological) are, by definition, objective, while individual reactions to color that can be explained by particular physical or mental conditioning are clearly subjective. The phenomenon of color, therefore, must clearly be exam-

ined from two points of view: it can be described objectively according to chemical, physical, and physiological laws, and subjectively in terms of biology and psychology. Furthermore, one could extend the enquiry to the realms of biophysics, biochemistry, and psychoanalysis, although for present purposes these branches of science will only receive passing mention here.

As far as chemistry is concerned, we shall examine the molecular constitution, physical state, and specific qualities of color as applicable to painting as an art form and to its use in industry.

With regard to physics, we shall discuss the refraction of white light, the fundamental concepts concerning light rays, the objective causes that determine chromatic phenomena, and the ways in which colors are analyzed and classified.

The section on physiology deals mainly with the apparatus of vision. In conjunction with biophysics and biochemistry, it explains how we perceive images in monochrome and color. The reader may feel, at first glance, that I have devoted too much space, in a work dealing with color, to the physiology of the visual mechanism, but I am convinced that it deserves to be treated in some detail as a useful and necessary preface to the subject as a whole. Any artist or color technician whose work depends on keen eyesight ought to know something about the way in which the apparatus of vision functions. But what is even more illuminating for the painter is to reflect on the mental processes involved, the manner in which the sense of vision is enhanced by the workings of that most astonishing of computers, the human brain. From the innumerable messages conveyed by the sense organs and assembled in the memory centers, the mind not only draws the information necessary for practical functioning, but also derives the food for thought and fantasy; indeed the processes are sometimes so closely linked that, for example, the visual sensation of an objective stimulus almost automatically evokes another, or others, originating in a different sensory source. It is this faculty of sensory and conceptual interactions that creates the world of human emotions and ideas—the world that the artist strives to interpret and reproduce imaginatively in his works.

Colors cannot be used haphazardly, since they are subject to precise laws and rules, the neglect of which could produce results lacking all artistic meaning. Color has to be considered in its many aspects—all of which are related to one another, and none of which can claim to be predominant—so that in virtually any work in which color plays a role, all must be taken into account. Since the aim of this book is to make the student aware, as far as possible, of the rich complexity and diversity of the subject, all these aspects have been covered; and my hope is that when, eventually, theory is converted into practice, the value and importance of this methodical approach will be recognized. It may then be appreciated that not only does theory aid practice but that practice itself is a constant source whereby theoretical research is deepened and enriched. Thus knowledge and art go hand in hand.

Of course, the basis of many works of art is an unusual sensitivity to colors and the skill to use them; slavish observation of theoretical precepts can be of little avail unless there is inspiration, individuality, and talent.

The purpose of this book is not to create artists but simply to provide those who wish to be artists with the indispensable tools of their trade.

Analyzing Color

Luminous radiations. Decomposition of white light. Natural color pigments with organic and inorganic bases; artificial or synthetic colors

Anyone who wishes to use color effectively must bear in mind from the very start that color is polyvalent and constantly changing, thus defying precise definition. Chromatic or color sensation, in fact, arises from a combination of factors, among them the following:

a) chemical and physical factors: the physical reality of matter and light. Matter, depending on its molecular constitution, either absorbs or repels light rays, and the perception of this phenomenon is the origin of the various colors (red, orange, yellow, green, and so forth).

b) technical and practical factors used in art: glues, grounds, color mixtures, glazes; in short, the different methods of painting and the optical processes that derive from them.

c) visual apparatus: this transforms light rays into color sensations with their varying qualities of hue, luminosity, saturation, and intensity. These qualities are associated with the memory of other sensations, and consequently the organ of sight is connected with the other sense organs.

d) perceptive elements: these depend on the different arrangements of colors. The quality and constancy of the perception are derived from these, so precluding any exact definition. The luminous intensity of a given color may increase or decrease; even its tonality, purity, and saturation may be modified according to surrounding hues. Perceptive factors therefore influence the relationship between a painted surface and the observer's perception of this surface.

e) psychological factors: depending on the range of their experience, their sensitivity, and their intelligence, different observers may be affected in various ways by the same color.

These five factors will be dealt with in more detail in later chapters, but first it will be necessary to learn some basic information on the electromagnetic waves perceptible to the human eye, on the decomposition of light, on the pigments used for coloring, and on the theory and terminology of colors.

Light Rays

Light is a form of energy consisting of electromagnetic vibrations that radiate from their source at a speed of 186,281 miles (300,000 km) per second, traveling in straight lines and in all directions with an undulating motion. The wavelengths of the electromagnetic radiation go from a maximum to a minimum, and are measured in kilometers (km), meters (m), centimeters (cm), millimeters (mm), microns or thousandths of a millimeter (μ), millimicrons or millionths of a millimeter (mμ), and angstroms or tenths of a millimicron (A). The human eye perceives only those wavelengths between 380 mμ (violet color) and 780 mμ (red color). The group of radiations comprised between these two values gives us sunlight, which is perceived as white or uncolored light.

The threshold of human sight, or the limit of visible waves, varies from person to person; some, by reason of their training or profession, manage, under the most favorable conditions, to see the color violet to a wavelength of almost 360 mμ (gray-violet) and red up to a wavelength of almost 800 mμ (dark red).

Figure 1-1, which gives the known electromagnetic radiations—from long radio waves to cosmic rays —shows how limited is the zone of those wavelengths capable of stimulating the retina. Infrared and ultraviolet radiations, forming the boundaries of the longest and shortest visible rays (red and violet), are notable for their heat and chemical effects, respectively. Some animals, especially insects such as the bee, can still perceive ultraviolet rays as light.

Decomposition of White Light

White sunlight is composed of radiations of different

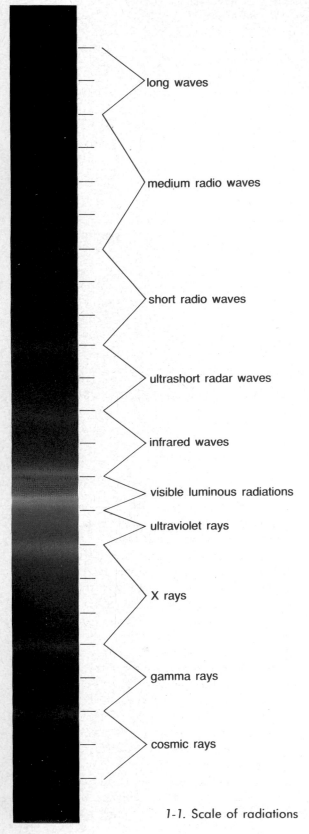

long waves

medium radio waves

short radio waves

ultrashort radar waves

infrared waves

visible luminous radiations

ultraviolet rays

X rays

gamma rays

cosmic rays

1-1. Scale of radiations

wavelengths, each of which corresponds to a particular color.

Optical prisms and other transparent, uncolored devices with unparallel, flat surfaces, break up white light, and so reveal its nature. Sir Isaac Newton was the first to demonstrate this experimentally, in 1676. By placing a glass prism in the path of a beam of sunlight, and then projecting the rays refracted by the prism onto a screen, he was able to observe a series of different colors and identify seven of them arranged in succession as exactly those that we see in the natural phenomenon the rainbow. He also defined the rules of refraction: the shorter the wave, the greater the deviation (refraction), the longer the wave, the smaller the deviation. From this rule of nature is derived the fixed arrangement of the seven corresponding colors, in order of greatest deviation, namely violet, indigo, blue, green, yellow, orange, and red (fig. 1-2).

These colors appear different because the single rays to which they correspond stimulate, in different ways, the three receptors or types of "cones" of the eye employed in color perception. The first receptor, when stimulated by almost any wavelength, produces a sensation of blue-violet, although this sensation is most pronounced in short wavelengths. The second receptor, too, is sensitive to all wavelengths, though particularly to medium waves, and always provokes the impression of green. The third receptor, although also stimulated by the whole spectrum, is most sensitive to long waves and gives the perception of red. However, each wavelength appears as a different color because of the different combinations of the levels of stimulation exercised on the three receptors (fig. 1-3).

Newton gave the name "spectrum" or "iris" to the progression of colors, and "dispersion" to the separation or decomposition of the individual color of white light. He demonstrated that each color of the spectrum is monochromatic, incapable of being broken down, because it is composed of only one wavelength. He proved that by passing an isolated color of the spectrum—for example, orange-red of 650 mμ—through a second prism, the corresponding ray again undergoes deviation but no further dispersion, and so maintains its color unchanged (fig. 1-4, top).

The subdivision of white light into seven colors is not clear-cut inasmuch as the spectrum exhibits a continuous series of gradations between one color and the next, each of which is a separate and individual hue

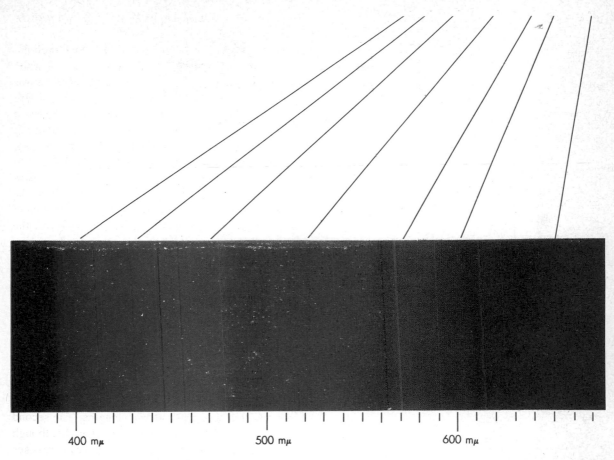

400 mμ 500 mμ 600 mμ

1-2. A ray of sunlight refracted by an optical prism exhibits a multicolored band known as the "spectrum of white light." The colors of the spectrum that appear most clearly to the eye are: violet, indigo (blue-violet), cyan (blue-green), green, yellow, orange, and red. As seen here, in refraction the shortwave rays undergo a greater deviation than long-wave rays.

determined by minimal changes in wavelength and not by color combinations; however, it is usual to list those that can be perceived most clearly. In any event, language does not possess specific names for every color.

If instead of a screen, which shows the seven colors, one places in position a second prism equal to the first but upside-down, the seven colors recombine, restoring white light (fig. 1-4, bottom). The same phenomenon of reunion occurs if in place of the second prism one uses a converging lens or a concave mirror.

Pigments

Pigments can be divided into two categories accord-

ing to their provenance: natural, and artificial or synthetic.

Natural pigments may be inorganic or organic, depending on whether they are mineral, vegetable, or animal in origin. Inorganic colors, made of minerals with a definite composition, are extracted from earths, fossils, marble, or other volcanic and sedimentary rocks in the form of silicates, carbonates, oxides, sulphides, and the salts of various metals, the most important of which is iron. The many raw materials important to the paint industry generally require working before they can be used.

In order to obtain pigments ideal for various painting techniques (watercolor, tempera, oil, etc.), the raw materials, particularly chosen for their suitability for art, have to be specially treated, which may diminish or increase the color yield. This will be discussed in more detail later. All that need be said here is that each pigment in question must exhibit the following principal requisites: no reaction to light or to the other liquids with which it is mixed; resistance to atmospheric agents, to heat, and to chemical agents; and good covering power and coloring intensity.

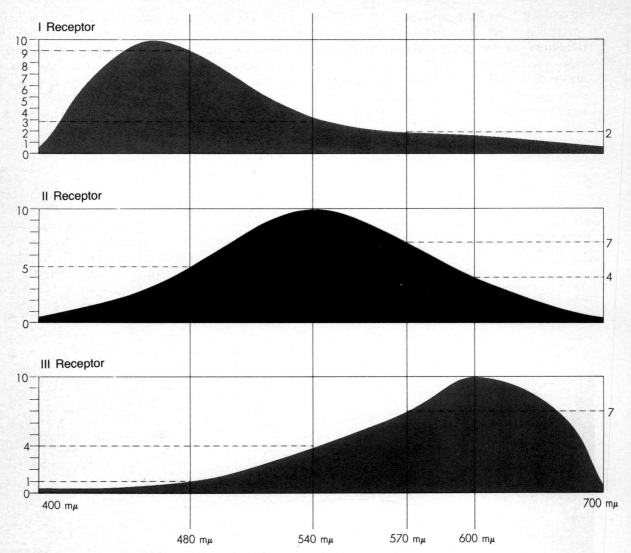

I Receptor

II Receptor

III Receptor

400 mμ

700 mμ

480 mμ 540 mμ 570 mμ 600 mμ

1-3. Graphs showing Helmholtz's theory of the way in which the three receptors of the eye function. The wavelength of 480 mμ stimulates receptor I to level 9, II to level 5, and III to level 1: the overall result is an impression of a cyanic blue color. The wavelength of 570 mμ, provoking the combination 2, 7, 7, causes a perception of pure yellow, because it stimulates the green and red receptors in equal measure. This same yellow may tend toward green or red when the receptors corresponding to green or red are principally stimulated: thus the wavelength of 540 mμ, which gives rise to the combination 2, 10, 4, causes the perception of a yellowish green. A different combination of 2, 4, 10, corresponding to the wavelength of 600 mμ, determines instead the perception of orange. In the same way sensations of all the other colors are determined: when any type of radiation stimulates the visual system, the color perceived is determined by the stimulation levels of the respective receptors.

Natural inorganic substances, such as those extracted from caves or mines, first have to be sifted through, the colored parts carefully selected, and then undergo operations to prepare them for the manufacture of pigments. Although such operations are not exactly the same for all substances, they generally consist of sifting, washing, exposure to air and sun, crushing, pulverizing, calcination (baking), grinding, further baking, and more grinding in order to modify the hue to the required color and make the pulverized substance homogeneous. This last process is the most important for the final color of the product, which can vary according to the size of the particles; the degree to which the particles can be ground is likewise important for the covering power of the colors, which is directly proportional to their fineness.

Some natural mineral pigments are zinc white obtained directly from pure zinc oxide, flake white derived from pure white lead, a mixture of calcium hydroxide and carbonate known as *bianco sangiovanni*, marble dust, chalk, all the yellow and red earths or ochers, the iron oxides, raw sienna, Cassel or Cologne earth, raw umber, various green earths, malachite or mountain green, lapis lazuli or natural ultramarine, graphite, and black earth. Natural mineral colors, as a rule, satisfy the requirements referred to above as indispensable for painting.

1-4. Top: The seven colors of the spectrum cannot subsequently be separated into other, simpler colors. In fact, by repeating the experiment of dispersion on only one of these rays, for example red-orange of 650 mμ, with another prism, the emergent ray is always of the same color.
Bottom: Recomposition of white light. If the seven colored rays emerging from one prism pass through an equivalent prism that has been placed upside down, they are reunited in a single point of white light.

Natural organic substances with a vegetable base (pigments and lacquers) are extracted from wood (sandalwood, Brazil wood, logwood), cork oak bark, vine shoots, lichens, roots (madder, alizarin, curcuma), peach stones, nectar of flowers (geranium, poppy, iris, sunflower, safflower, saffron), fruits and grasses (grapes, blackthorn, chicory). The complete extraction of the coloring principle is carried out by chopping up the various parts of the plants in which it is contained, and grinding and boiling them in a suitable water-based solution; the extracts then evaporate to a certain concentration and become dry. Excepted are the coloring principles of cork, vine shoots, and fruit stones, which are obtained by roasting the respective substances. All the colorants derived from plants can be used to make pigments and a great number of lacquers. The colors of lacquers, even though they may be deep-hued, are transparent, as they are produced by a fixed coloring solution or even combined with inert and uncolored substances.
Natural vegetable colors include madder lake, geranium red, sandalwood lake, violet lake, indigo, saf-

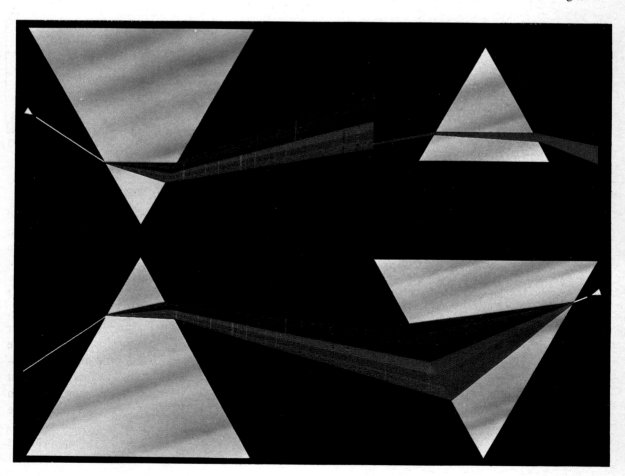

fron red, brown madder, yellow carmine, Indian yellow, German black, Spanish black, cork black, vine black, peach black, and sap green. Due to their lack of stability these pigments and lacquers are now rarely used by painters; they have largely been replaced by more permanent synthetic pigments.

Organic animal colors are obtained either by cooking or charring the bodies of small insects (cochineal), marine mollusks (oysters, cuttlefish), or parts of animals (bones, horns, shells, teeth, eggshells). Calcined products are washed for removal of impurities (tarry residues) and dried. Natural animal colors include carmine, sepia, bone black, and ivory black. Natural organic colors of plant or animal origin exhibit different degrees of perishability, durability, and resistance to light according to the original raw materials (wood, roots, flowers, animals) and the processes used to obtain them; but they can all acquire sufficient solidity with the addition of protein or oil binders. Many of them are not used in oil painting because, although they are extremely attractive, they have little covering power; they may, however, be used for glazing, and are quite suitable for watercolor painting.

Artificial or synthetic pigments are constituted of the same substances that are derived from natural sources, mineral, vegetable, and animal. Chemical processes are substituted for their extraction and the colors directly obtained from the various basic substances subjected to laboratory treatment. These minerals are either well-defined chemical compounds (e.g., zinc white) or the mixtures of two or more compounds (chrome green, chrome yellows mixed with Prussian blues, or zinc white itself, but resulting from several compounds). The various combinations made possible by chemical procedures yield an extraordinary number of hues with their respective gradations, at less cost than natural ones, which is why most of the colors used by painters belong to this group.

Artificial mineral or chemical mineral pigments include lead white; zinc white; titanium white; flake white; zinc yellow; cadmium yellow; chrome yellow; all the Mars yellows, reds, and violets; the Saturnine yellows and reds; vermilion; purple-red; Verona green; chrome green; cobalt green; cobalt blue; Thenard's blue; ultramarine; Prussian blue; and Paris blue. Artificial or chemical mineral lacquers used in painting are those obtained from alizarin with alumina (red), from phosphates of cobalt, and from manganese (other violets). Artificial mineral pigments satisfy the same requirements as natural mineral colors, but it is not always possible to find them all together in a single substance.

Other artificial or synthetic pigments are produced by the dry distillation of charcoal, anthracite, peat, petroleum, bones, and other animal materials transformed into coal by semicombustion. The final residue of these distillations is tar. Distillation of the tar yields various products (oils, naphthas, pitch, benzol, naphthalene) from which modern industry derives wholly soluble colorants.

Organic artificial colors are known as either tar or aniline, a colorless liquid distilled from fossil coal tar. The addition of other substances to the aniline produces a wealth of lacquers with marvelously bright colors, including magenta, solferino, aniline yellows and greens, Prussian and imperial violet, and other lacquers variously named according to their tendencies toward red, yellow, green, violet, and blue. Synthetic lacquers (except for those mentioned above) are seldom used in painting because they are slow to dry, have little covering power, and do not remain bright for very long. The aniline lacquers, rendered insoluble by the addition of appropriate salts (of sodium, zinc, barium, and calcium), are, however, greatly preferred to natural organic lacquers in the manufacture of glazed paper and in the textile industry, because they display more uniform characteristics of granulation, color purity, adjustment of tone to suit current fashions, and resistance to light, heat, solvents, and washing. Aniline lacquers also make it possible to shorten the time necessary for the application of dyes to textile fibers, whether plant or animal, and combine with the latter without the need for a mordant.

A large number of other coloring substances derived from tar, when suitably treated, form synthetic organic pigments much valued for their tonal intensity and purity, their insolubility in oil and solvents, their solidity in light, and their high resistance to heat, weather, and chemical action. Because of these qualities, they are widely used in the manufacture of printing inks, paints, and enamels that require baking in an oven, of varnishes, for coloring leather and artificial skins, and for making synthetic thermoplastic resins and all types of plastic materials.

The Theory of Color

*The terminology of color: primary and secondary colors; the color circle; color mixtures;
shades or nuances; complementary colors. The luminosity of colors and their
quantitative relationships. Earths. Achromatic colors. Warm and cold colors. Achromatic
and chromatic chiaroscural scale. Saturation and intensity. Systems of representing colors: one-
or two-dimensional series or scales, and three-dimensional structures. Hickethier's cube. Classification on
a perceptive basis: Ostwald's double cone Munsell's system; other
systems (DIN, Color System, etc.) for industrial use*

In everyday language the word "color" is often used with two fundamentally different meanings. According to correct terminology, we should say "chromatic pigment" when referring to materials or colored substances used for painting and "color" when we speak of the eye's perceptions when it is stimulated by specific light waves of various lengths that are emitted by these materials.

The painter and the physicist have demonstrated that there are three basic (primary) colors from which, by appropriate mixing, an infinite variety of hues can be derived. The British physician and physicist Thomas Young suggested in 1807 that the primary radiations of the spectrum are red-orange, green, and blue-violet; but as far as painters are concerned, the primary colors,[1] as demonstrated by another British physicist, David Brewster, in 1831, are still red, yellow, and blue. These colors are regarded as absolute, because they cannot be obtained by any mixing.

The difference between the primary colors of the physicist and the painter has been brought out by numerous experiments with combinations of colored light and pigments. By combining two primary spectral colors (spectral color is that which is perceived by the three visual receptors stimulated by a single wavelength), new colors are obtained, whereas by mixing the two corresponding pigments, only dirty grays are obtained. The most convincing proof, however, occurs when red and green lights are superimposed, creating a yellow light; mixing red and green pigments (complementary to each other), however, results instead in a dark gray or black, depending on the intensity of the component hues.[2] Another important demonstration compares the superimposition of the three colors of the spectrum, which produces white light, with the mixing of the three primary pigments, resulting in a black color. The former yields an additive result, because light is added to light; the latter, however, is the consequence of subtraction, for light is taken away from light.

An explanation for the difference in results was given around 1855 by Hermann von Helmholtz, a German scientist whose additive and subtractive laws concerned the composition of lights and pigments respectively. For a comparison of the two types of behavior of additive and subtractive mixing, see page 79.

It is important to understand how primary colors react when they are mixed so one can predict the diverse results obtainable from pigments of different hues. Until about ten years ago, some artists used to make a distinction between one triad of warm primary colors (vermilion red, golden yellow, and ultramarine blue) and another of cold primary colors (ruby red, lemon yellow, and turquoise blue). Yellow and blue produce different colors, depending on whether their tone is warmer or colder; for example, vermilion red, very warm, gives a good orange but not a violet, while ultramarine blue, tending to red, gives neither a sufficiently pure green nor violet.

Chemists have recently synthesized three basic pigments of acceptable purity, making it possible to obtain a wide range of other equally pure colors, difficult to produce with either of the aforementioned triads. These pigments are magenta, a red tending to purple, equidistant from yellow and blue; yellow, neither warm nor cold but very luminous and bright;[3] and cyan, a blue tending to green. Magenta, yellow, and cyan, already utilized in all systems of color

[1] The definition of a primary color properly refers only to the fundamental light rays of additive synthesis. It is customary, however, to use the term in reference to the three fundamental pigments of subtractive mixing, which ought properly to be called basic colors.

[2] Every pigment determines its color by selectively absorbing some radiations and reflecting others. Two pigments are called complementary when one absorbs all the radiations reflected by the other, and vice versa; and when these are mixed, the result is black, because all the rays are absorbed and none reflected.

[3] This yellow, equidistant from magenta and cyan, corresponds to light cadmium, which comes close to the most saturated (573 mμ) yellows in the spectrum.

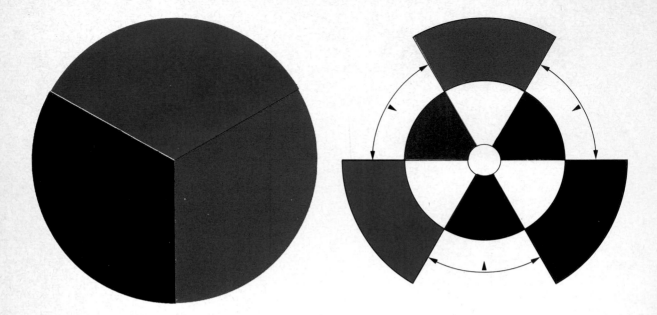

printing, in photography, and in cinematography due to their suitability for the reproduction of determined hues, have also been chosen by an international commission of experts as the triad of pictorial primaries most suitable for the uniform manufacture of pigments. Nevertheless, the artist, not bound to the industrial primaries, may continue to use the reds, yellows, and blues of his or her choice.

Figure 2-1 shows the three basic pigments currently used and underlines their individual qualities: the magenta is intense, the yellow luminous, the cyan dark. Magenta, yellow, and cyan are autonomous, each uninfluenced by the other two. When any two are mixed in equal parts, we get secondaries: orange,[1] green, and violet, which assume the individuality of new colors, likewise regarded as pure (fig. 2-2). The primary and secondary colors are considered fundamental, given their importance in the composition of other colors by subtraction.

Various regular geometrical shapes are customarily used for the structured depiction of colors, these being the simplest for colors in successive order or in combination. For instructional purposes, the commonest shape used is the circle, which brings out the color relationships most clearly.

To give each color its proper position, the circle is subdivided into six equal sectors, alternating prima-

ries and secondaries: this is called the ''color circle'' (fig. 2-3). This circle can also be obtained by superimposing three color filters that have the property of transmitting, from the incident white light, the same rays that the pigments reflect, and with analogous values (fig. 2-4). The color circle shows both the primary color common to two neighboring secondaries (e.g., magenta, common to both violet and orange) and its complementary, that is, the secondary placed opposite (e.g., magenta and green); furthermore, it enables the observer to compare and measure the effects and sensations aroused by such combinations. Among the various possible mixing combinations that the color circle illustrates are:

a) the mixing of two primary colors, such as magenta and yellow or yellow and cyan, which can be done in equal or different proportions;

b) that of two adjacent colors, one primary and one secondary, such as yellow and green or cyan and violet, in equal or different proportions;

c) that of two opposed colors, one primary and one secondary, such as magenta and green or yellow and violet, in equal or different proportions.

Two primaries mixed in equal proportions give a secondary that represents the balance between the two components; mixed in different proportions, they give combinations in which the color added in greater quantity predominates. For example, when magenta and yellow are mixed, the resulting orange tends toward magenta or yellow depending on which color is present in a greater quantity. If there is a gradual tran-

1 Magenta and yellow arranged in equal proportions on a rotating disk give a reasonably pure orange, and an equally pure orange-red when mixed for painting or printing. For an orange of average tonality, the painter should use a mixture of 1M + 3Y.

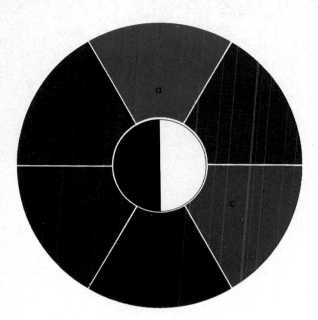

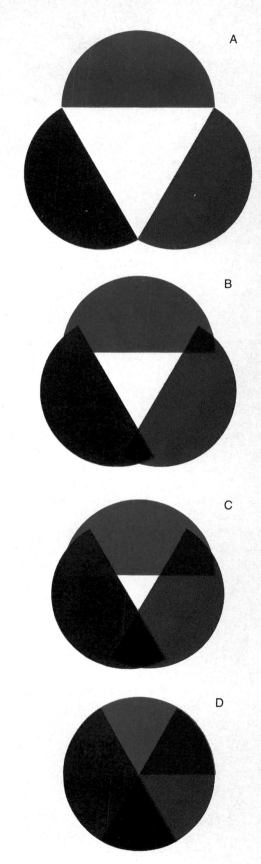

2-1. Opposite, left: Primary colors—magenta, yellow, and cyan.

2-2. Opposite, right: Secondary colors—orange (magenta + yellow), green (yellow + cyan), violet (cyan + magenta).

2-3. Above: Color circle. The order of the letters indicates the succession of the fundamental colors in the sectors, with white and black at the center. The hues represented are magenta, orange, yellow, green, cyan, and violet.

2-4. Right: If three semicircular filters, magenta, yellow, and cyan respectively (arranged as in A), are placed over a pane of window glass illuminated by sunlight, and then superimposed and slowly turned toward the center (B and C), we get, along with the primary colors, the three secondaries of orange, green, and violet, or the color circle (D).

sition from magenta to yellow by continuously and regularly changing the proportions of each, it is possible to obtain infinite graduations or nuances of the two colors. These transitions can be achieved either by means of guesswork and good judgment (fig. 2-5) or by means of prearranged quantity ratios: thus one can mix 9 parts magenta and 1 part yellow, 8 parts magenta and 2 parts yellow, 7 parts magenta and 3 parts yellow, and so on, or keep the quantity of one color unchanged while altering the other.

Alfred Hickethier, a German painter recently deceased, in an attempt to overcome the lack of names for the various nuances in color and to find a method for polychrome printing that would make it

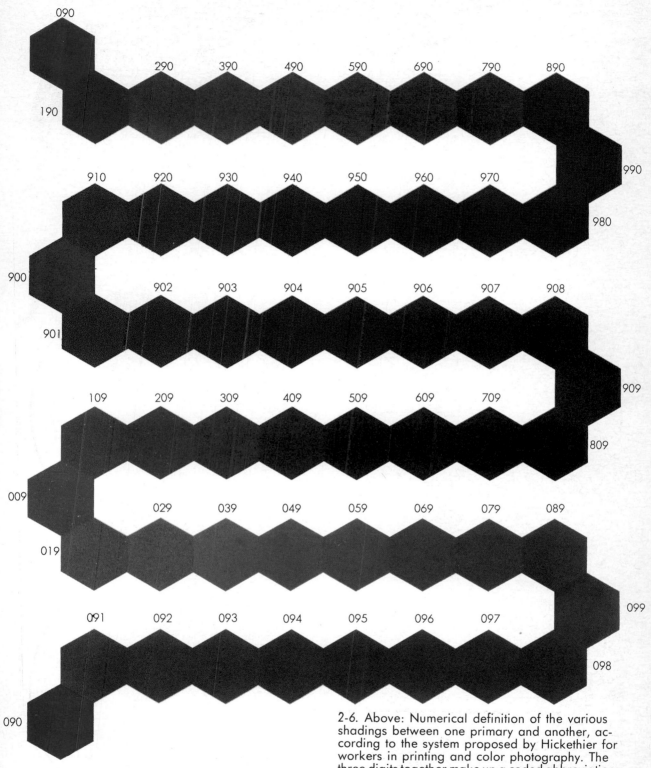

090
290 390 490 590 690 790 890
190
990
910 920 930 940 950 960 970
980
900
902 903 904 905 906 907 908
901
909
109 209 309 409 509 609 709
809
009
029 039 049 059 069 079 089
019
099
091 092 093 094 095 096 097
098
090

2-5. Opposite: Transitions of one color to another, guided by sensitivity

2-6. Above: Numerical definition of the various shadings between one primary and another, according to the system proposed by Hickethier for workers in printing and color photography. The three digits together make up a coded abbreviation; thus each digit is read by itself as an indicator of the quantity of each primary color composing that particular shade.

possible to indicate precisely the quantitative relationships linking each nuance to the respective primaries from which it is derived, proposed a very simple system to describe them. This system has proved useful in the techniques of both color photography and painting. Employing as a basis the principle that by mixing the primary pigments in various quantities it is possible to reproduce all colors, and that inversely, with the aid of special equipment (color analyzers) it is possible to break down a compound color into its constituents, he gave each gradation a three-digit number. Each digit refers to one of the three colors used and is listed in a fixed order: the first digit always refers to yellow, the second to magenta, and the third to cyan. He gave the value 9 to the full color, 0 to the absence of color, and the intermediate numerical values from 8 to 1 to the corresponding quantities, in descending order. So the three primaries

2-7. Chromatic circle divided into twelve parts

would be represented as 900 (full yellow, no magenta or cyan), 090 (no yellow, full magenta, no cyan), and 009 (no yellow or magenta, full cyan). If we add yellow to magenta, keeping the quantity of magenta unchanged, we get a series of reddish oranges indicated as 190 (1 part yellow, 9 magenta, 0 cyan), 290 (2 parts yellow, 9 magenta, 0 cyan), etc. If instead we maintain an unaltered quantity of the yellow, we get a series of yellowish oranges indicated as 910 (9 parts yellow, 1 magenta, 0 cyan), 920 (9 parts yellow, 2

magenta, 0 cyan), etc. Mixtures of yellow and cyan and of magenta and cyan are likewise represented by appropriate numerals.

The varied gradations of color, by their tendency to move toward the dominant primary, give the colors an appearance of movement and expressive richness. The modern artist, highly conscious of these qualities and of the emotional reactions they arouse in the observer, prefers to use such nuances or mixtures rather than the full or primary colors, which maintain a stable value.[1] The technical understanding of these transitions makes it possible to reproduce the infinite gradations of natural color with only a few tints.

Two adjacent colors—that is, one primary and one secondary—mixed in equal proportions give intermediate colors known as "tertiaries": magenta and orange, orange and yellow, yellow and green, green and cyan, cyan and violet, violet and magenta give, respectively, red-orange (or magenta-orange), yellow-orange, yellow-green, blue-green (or cyan-green), blue-violet (or cyan-violet), and red-violet (or magenta-violet). With the three primaries, three secondaries, and six tertiaries, one can obtain a circle subdivided into twelve parts (fig. 2-7).

By mixing a primary with a tertiary in equal proportions, one gets a "quaternary"; by mixing a secondary with a tertiary in equal proportions, one gets a "quinary." If we introduce these new hues between the various sectors of the color circle, we get a circle of twenty-four colors, each of which is considered pure because it is derived from the combination, in definite proportions, of only two equidistant primaries. The relative importance of the primaries, secondaries, tertiaries, quaternaries, and quinaries shown on the circle is indicated by the lesser or greater extension of the sectors (fig. 2-8).

To clarify this matter still further, let us look at figure 2-9, which shows, by means of ratios, the quantities of magenta and yellow used to obtain secondaries, tertiaries, and so forth. Given the value of 8/8 to the primaries (a and b) and taking 1/8 as the unit of measure, we see that the secondary (c) corresponds to 4/8 M + 4/8 Y, that the tertiaries (d and d') are formed respectively of 6/8 M + 2/8 Y (d) and 6/8 Y and 2/8 M (d'), the quaternaries of 7/8 M + 1/8 Y (e) and 7/8 Y + 1/8 M (e'), and the quinaries of 5/8 M + 3/8 Y (f) and 5/8 Y + 3/8 M (f'). We can proceed

[1] Wassily Kandinsky writes that, compared with the primaries, the tones or nuances of color resemble softer music and thus arouse much finer, inexpressible vibrations in the mind. (*Tutti gli scritti 2*, Milan: Feltrinelli, 1974, p. 115.)

2-8. Circle of twenty-four colors

a and b	primaries
a + b = c	secondary
a + c = d	tertiary
b + c = d'	tertiary
a + d = e	quaternary
b + d'= e'	quaternary
c + d = f	quinary
c + d'= f'	quinary

The same levels occur if yellow is mixed with cyan and cyan with magenta.

along similar lines with the pairs of magenta and cyan and cyan and yellow.

We can also construct color circles with an even greater number of colors. In order to demonstrate the infinite number of colors that can be obtained by the mixing of two primaries, Paul Klee proposed (in addition to the color circle) three half-moons, one colored red, one yellow, and one blue. Each half-moon is arranged in rotation over a circle and occupies two-thirds of its circumference, the remaining third being assigned to the respective complementaries (fig.

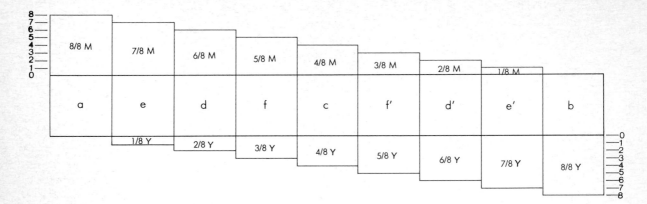

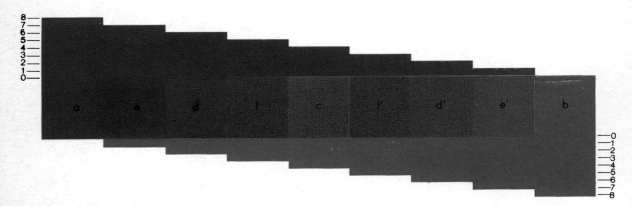

2-10). Each basic color, as appears in the figure, is free from the influences of the other two only in the center of the half-moon; here it is seen fully, while gradually decreasing to a vanishing point toward either side, where the other two likewise reach their culmination and then vanish. The movement of the color along the circumference is continuous and without interruption—unlike that occurring along the diameter of the color circle, which is pendular. In this infinite and never-ending progression, the colors continually merge with one another, producing variations that are likewise infinite, and the difference in the quality of a color, even for a short stretch, is made evident. Klee called this total organization of colors the "canon of totality."[1]

Two colors in an opposite, complementary position to each other (magenta and green, yellow and violet, cyan and orange) mixed in equal proportions produce a murky color tending toward black, just as occurs when the three primaries are mixed, inasmuch as each pair of complementaries likewise contain all or a greater part of the primaries (in the paired magenta

2-9. Above: Diagram representing the fraction of each primary color (magenta a and yellow b) necessary to make up the secondary c, the tertiaries d and d', the quaternaries e and e', and the quinaries f and f'

2-10. Below: Paul Klee's "canon of totality"

[1] Paul Klee. *Teoria della forma e della figurazione*. Milan: Feltrinelli, 1955, pp. 483–92.

2-11. Mixture of a primary color with its complementary. The three digits beneath each combination show, according to Hickethier's system, the quantitative relationship of each primary (one digit) and its complementary (the other two).

and green, the green comprises yellow and cyan; in the paired yellow and violet, the violet comprises cyan and magenta; and in the paired cyan and orange, the orange comprises yellow and magenta). In conclusion, each secondary is complementary to the primary not included in its mixture.

Since all colors and gradations, and not just primary and secondary colors, have their own complementary, all pairs of colors that when mixed in equal parts tend to neutralize each other, giving a grayish black, are known as complementaries to each other. The color circle clearly illustrates these complementary qualities because in it the colors of the pair are found in a diametrically opposed position. Subdividing the circle into twelve, twenty-four, or more sections of equal size, we can assemble six, twelve, or more pairs of complementaries. The colors of every com-

25

plementary pair neutralize each other in mixing only when they have the exact tonality and the exact saturation—that is, they possess the same intensity (in relation to their respective hues) and the same degree of color density. Just as it is very difficult to establish precisely this combination of relationships, it is equally difficult to attain the achromatic result. The gray tone is not in itself important as a color, but simply as a demonstration that the colors of the pair are in equilibrium with each other, neither of them

2-12. Colored grays

prevailing. As we shall see in due course, when the eye observes a color the appearance of its complementary is spontaneously aroused, while when observing gray, it is in a state of equilibrium.
The mixing of two complementaries when the quantity of one or both is gradually varied produces a series of opaque combinations so lacking in the original colors as to be no longer recognizable as such and

no longer possessing the individuality of new grada-
tions and hues. For example, the addition of a small
quantity of green to magenta or of magenta to green
gives a magenta or green slightly diminished in color-
ation; by adding ever more green to the magenta and
vice versa, through a variety of grayish reds and gray-
ish greens that become increasingly neutral, opaque,
and imprecise, one comes near to reaching black
(which is finally approached when the quantities of
magenta and green are equal, as in figure 2-11).
Analogous series are obtained by the addition in
increasing quantities of violet to yellow and of yellow
to violet, or of orange to cyan and cyan to orange. The
addition of equal quantities of white pigment to each
of these series produces beautiful, delicately colored
grays (fig. 2-12).

Gray can also be obtained by the technique of glaz-
ing. The very beautiful gray tones that appear in the
masterpieces of the great colorists of the past were not
produced by mixing two complementaries with the
addition of white, but by superimposing on the more
luminous color successive layers of glazing taken
from its complementary color.

One can also arrive at gray by combining small areas
of complementary colors, which are then perceived
as a rich, vibrant gray, and by various other methods,
such as applying closely packed black dots on a white
ground. The intensity of the gray that results varies
according to the size and concentration of the dots
(figs. 2-13, 2-14).

Not all theorists agree on the position of the colors in
the circle, on the order in which they succeed one
another—clockwise or counterclockwise—or on the
number of fundamental colors. Both Goethe and
Adolf Hölzel, for example, begin the series with red,
because it is the most intense color; Klee chooses
violet-red, because it is formed of the union of the
two extreme colors of the spectrum; and the great
Swiss color theorist Johannes Itten places yellow at
the top, since it is the brightest color and the closest to
white light. Likewise, the number of components de-
pends on individual preference: some aim at an exact
subdivision of the circle into six or twelve parts, so as

2-13 (above) and *2-14* (below). The arrangement
of black dots on a white background evokes the
impression of a uniformly gray surface, which may
have various degrees of intensity depending on
the size and concentration of the dots. The same
phenomenon occurs with a mesh of interwoven
lines. Obviously these effects can only be per-
ceived from a distance.

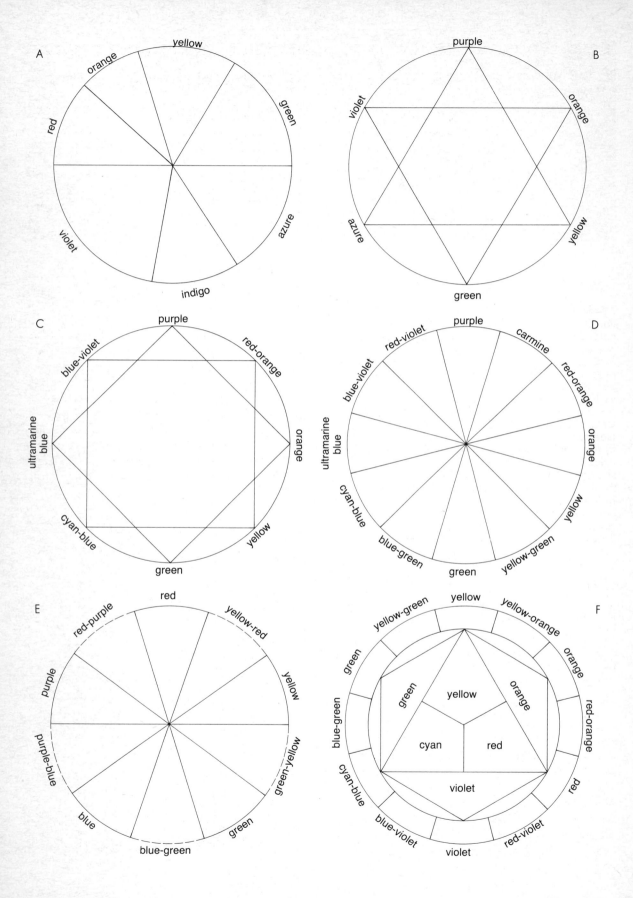

2-15. Opposite: Various systems of dividing the color circle.
A) Newton's color circle. The size of each sector corresponds to the extension of the respective color over the spectrum, their number to the number of colors that the eye manages to see.
B) Goethe's circle of pigmentary colors. Goethe placed two overlapping equilateral triangles opposite each other in a circle and colored their vertices with the three primaries and three secondaries respectively.
C) and D) Hölzel's diatonic and chromatic circles (see text).
E) Munsell's circle of fundamental colors as perceived in nature. The five principal colors are shown on the circumference by the continuous line, the five intermediate colors by the dotted line.
F) Itten's chromatic circle of twelve colors. An equilateral triangle with the three primaries, set in a hexagon with the respective secondaries, is placed by Itten in a circle of twelve parts in which all the colors are equidistant.

Above: An interesting comparison between a color photograph of a field of flowers with opposite colors in the foreground, and its translation into the grays of a "black-and-white" photograph.
Right: Accentuation of opposite colors in a painting by Pablo Picasso (The Studio. 1928. Peggy Guggenheim Collection, Venice): the greens of the two disks are reinforced by their position on the red ground.

to guarantee that each color is equidistant from the next (since the tints in between are produced by the mixture in equal proportions of two neighboring colors); others go for sensory impressions rather than equidistance between one color and another, dividing the circle according to expressive relationships that better match the series of component colors. Hölzel, a German painter and color theorist, for example, in order to diminish the sharp chromatic separations be-

tween purple and orange and between ultramarine and green, has designed a circle of eight equal sections, which, using musical terminology, he calls "diatonic," introducing orange-red between the first pair and cyan-blue between the second. He has also devised a circle of twelve sections, all equal (introducing violet-red between violet-blue and purple, crimson between purple and orange-red, yellow-green between yellow and green, and blue-green between cyan-blue and green), which he calls "chromatic," and in which the transitions appear more gradual and the "result of sensation" less sharply contrasted. Klee, on the other hand, writes that "the

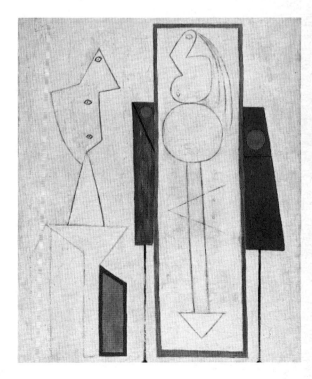

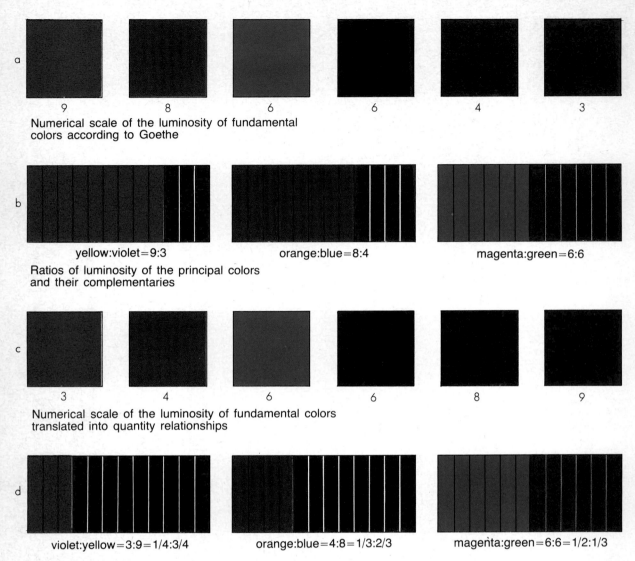

a

9 8 6 6 4 3

Numerical scale of the luminosity of fundamental
colors according to Goethe

b

yellow:violet=9:3 orange:blue=8:4 magenta:green=6:6

Ratios of luminosity of the principal colors
and their complementaries

c

3 4 6 6 8 9

Numerical scale of the luminosity of fundamental colors
translated into quantity relationships

d

violet:yellow=3:9=1/4:3/4 orange:blue=4:8=1/3:2/3 magenta:green=6:6=1/2:1/3

Two complementary colors appear to balance as far as
luminosity is concerned, if they cover surfaces that are
inversely proportional to their respective luminosity

painter's psychology requires the circle to be divided
into three and six parts because 1/6 is a number more
attuned to a circle than 1/8.''[1] Newton, who includes
indigo as ''fundamental'' because it appears among
the clearest colors of the spectrum, subdivides the
circle into seven parts, possibly because of its anal-
ogy with musical notes. The color circle of American
painter Albert Henry Munsell displays ten fundamen-
tal colors perceptive in nature, of which five are prin-
cipals and five intermediates (fig. 2-15). However, in
the applied fields (printing, painting, photography,
and television), the most common subdivision is into

2-16. Relationships between luminosity of dif-
ferent colors (a and b) and quantity relationships
(c and d)

six, a multiple of the three primaries of the trichro-
matic theory of Helmholtz. Multiples of four are also
used—although more rarely—largely because of the
tetrachromatic theory of the German physiologist and
psychologist Ewald Hering.
Whatever color one wishes to place at the top or an-
other position to start a series, and whatever the sub-
division of colors on the circle, provided the hues are
arranged in proper sequence and distance, the com-
plementary pairs are conventionally found in a dia-

[1] Paul Klee. *Teoria della forma e della figurazione*. p. 507.

2-17. a) Harmonic relationships between pairs of primary and secondary colors (1), pairs of primaries (2), and pairs of secondaries (3); b) harmonic relationships of the three primaries; c) harmonic relationships of the three secondaries

metrically opposite position. When two colors are not equidistant from each other, as on Hölzel's color circle, the pairs of complementaries are not perfectly opposed (fig. 2-15).

The study of complementaries is highly important in painting and of great interest from a technical point of view, with regard to both the hues produced by mixing them and the effects of their combination. Every primary color is toned down or becomes gray, without reaching black, when variable quantities of its complementary are added, but the color intensity of both is heightened when they are placed close to each other. Apart from this, the proximity of two complementary colors arouses in the eye the series of contrast phenomena that will be discussed in chapter seven.

Luminosity of Colors

The luminosity of the color pigment depends on the spectral structure of the light reflected by the pigment itself; yellow appears the brightest of all because it is the nearest to white, violet the least bright because it is the nearest to black.[1] The descending scale of luminosity of the fundamental colors is as follows: yellow, orange, magenta and green, cyan, violet. Goethe attributes a luminous value of 10 to white and the value of 0 to black, establishing the numerical sequence: yellow 9, orange 8, magenta 6, green 6, cyan 4, violet 3 (fig. 2-16, a).

From this scale of values we may deduce that the pair of complementaries with the greatest contrast of luminosity is yellow and violet (9:3); the contrast decreases between orange and cyan (8:4) and is cancelled out between magenta and green, which are of equal luminosity (6:6) (fig. 2-16, b).

When fundamental colors are used together, in order to obtain a harmonic balance of hues so that the brightness of one does not predominate, one should vary the relative extension of these in inverse proportion to the luminosity, according to the following surface areas: yellow 3, orange 4, magenta 6, green 6, cyan 8, violet 9 (fig. 2-16, c). The complementary colors will appear to be in equilibrium if they cover surface areas that are inversely proportional to their respective luminosities. Therefore, when painting a surface yellow and violet, the violet area should be

three times the size of the yellow; if cyan and orange are used in combination, the cyan area should be double the size of the orange; but if the surface is painted with magenta and green, the two areas should be of equal size (fig. 2-16, d).

In the same way, one can establish harmonic surface relationships between "pairs" of primary and secondary colors or between "pairs" of primaries, such as yellow-orange (3:4) or yellow-magenta (3:6), respectively. The harmonic proportions of the primaries are 3:6:8, those of the secondaries 4:6:9 (fig. 2-17). If we proceed according to the normal chromatic gamut, arranging the six fundamental colors on the surface of a circle divided into sectors, we should give the following portions of the total 360° area to the individual colors: yellow 30°, orange 40°, magenta and green 60° each, cyan 80°, violet 90° (fig. 2-18).

It is important to bear in mind the fact that such harmonic relationships are valid only when the colors are represented in their full intensity. Therefore, if we increase or decrease the brightness of a color, we have also to vary, in proportion, the relative surface areas. But this is not a discussion on aesthetics. The artist knows by instinct exactly when and where colors should quietly balance and when and where to subject them to violent contrasts.

Earth Colors

Earth colors are generally regarded as colors in their own right, colors that do not have to be made up from

[1] Energy of the stimuli, functioning of the senses, and quality of rays are the fundamental factors that distinguish, on the perceptive level, the bright colors and the dark colors, so making it possible to construct a descending scale of luminosity of the color range as illustrated in figure 2-16, a.

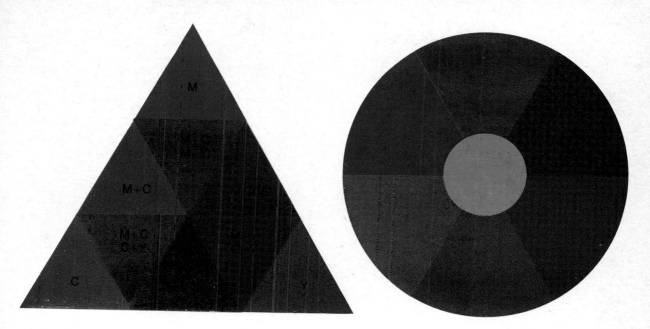

2-18. Opposite: The different sizes of the sectors assigned to the individual colors are designed to balance their different degrees of luminosity.

2-19. Above, left: The three fundamental earths—reddish earth obtained by mixing violet and orange, yellowish earth composed of orange and green, greenish earth produced by green and violet. Above, right: Circle of six colors with the fundamental earths in place of the primaries. In it each earth is the complementary of the secondary that has not participated in its formation.

a number of different elements since they are extracted from a variety of natural mineral substances or can be obtained artificially by chemical means. These colors are marketed commercially. Nevertheless, it is also possible to obtain them by mixing the three primaries in varying proportions or, better still, two secondaries (which, as we remember, contain the primaries) in equal proportions. The three basic earths derived from them are opaque but warm and golden brown, unlike the opaque and grayish combinations obtained by mixing two complementaries. Reddish earth or dark red, yellow earth or yellow ocher, and greenish earth or olive green are composed respectively from violet and orange, orange and green, and green and violet (fig. 2-19). The tendency of the earths toward red, yellow, or green depends on the primary common to both the secondaries. Therefore, if we mix violet and orange, the earth tends to magenta because this is the prevailing color, found both in violet and orange. If we mix orange and green, the

earth tends to yellow, since this is contained in both the secondaries while magenta is found only in orange and cyan only in green. If we mix green and violet, the earth tends to a bluish olive green because cyan is predominant, contained both in violet and in green, whereas magenta is found only in violet and yellow only in green. Hölzel, in his theories on this subject, calls the three earth colors "rouge," "citron," and "olive."

In the six-color circle, if we substitute rouge, citron, and olive (primary earths) for the ordinary primaries, we see that each of these complements the secondary that did not have a part in its formation (fig. 2-19). Just as when in the circle of pure colors a primary is mixed with its opposite secondary, the mixture in equal parts of a primary earth with its opposing secondary produces a neutral dark gray; this can be verified because in each of the pairs rouge and green, citron and violet, and olive and orange there are equal proportions of magenta, yellow, and cyan. For example, in the pairing of rouge and green, the rouge is composed of a dominant proportion of red and a minimal proportion of yellow and cyan, while in the composition of green the quantities of yellow and cyan are preponderant so that the result of their mixing is the balanced presence of each primary.

The mixing in different proportions of two secondaries, or of a secondary or a primary with an earth, or the mixing of all three primaries together, still in different proportions, results in a series of increasingly opaque and cloudy earth colors known as browns or chestnuts such as yellow-brown, yellow-chestnut,

33

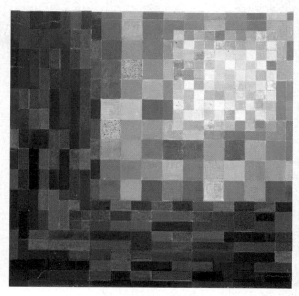

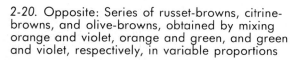

2-20. Opposite: Series of russet-browns, citrine-browns, and olive-browns, obtained by mixing orange and violet, orange and green, and green and violet, respectively, in variable proportions

2-21, a. Above: Warm colors (left) and cold colors (right)

orange-brown, orange-chestnut, red-brown, red-chestnut, green-brown, green-chestnut, and violet-brown. This occurs because in the above mixtures either the two primaries prevail simultaneously or the color that previously prevailed becomes less dominant. For instance, if instead of violet (cyan plus magenta) we add a reddish blue to the orange (magenta plus yellow), the magenta, although containing both colors, is less accentuated than the rouge: the color that derives from it is brown. If we continuously alter the proportions of these mixtures we obtain an unpredictable variety of colors with characteristic similarities—brown-rouges, brown-citrons, and olive-browns—which may be lighter or darker but which always tend to brown or chestnut (fig. 2-20).

The best-known colored earths are the yellow, red, and green ochers. The yellow earths or yellow ochers change their color during baking in relation to the temperature to which they are subjected, ranging from yellow to red, brown, azure, and violet, and being known by different names according to the variety of hues they assume: light and dark yellow ocher, golden ocher, brown ocher, violet ocher, and so forth. The red and green ochers also have different names according to the color they take on: light and

dark pink-ocher, blackish, red-brown, azure, green earth, olive, brown green, to name a few.[1]

Achromatic Colors

White, black, and gray are regarded as achromatic or neutral, that is, lacking color. However, whether white and black should or should not be considered colors is open to question. The reply depends largely on whether the question is approached from a psychological, physical, or chemical point of view. Psychologically, white, black, and gray are regarded as true colors, inasmuch as they arouse appropriate sensations in the observer. Physically, as far as light is concerned, however, white light is not defined as a color but as the sum of all radiations of the visible spectrum, while black is the absence of light. From the chemical viewpoint, pigments white and black are both considered to be colors: white a primary color because it cannot be obtained through other colors; black a secondary color since it can be mixed using other colors.

Warm and Cool Colors

Warm colors are those that are generally associated in the mind with sunlight and fire, such as vermilion red or cinnabar and the red earths, yellows derived from

[1] Commercially, ochers and native earths are also distinguished by the name of their place of origin: Rome, French, English, and Chinese yellow-ocher; Sienna earth; Armenian bolé, English, Vienna, Indian, Persian, Venetian, and Pozzuoli red; Verona, Bohemian, and Siberian green earth; etc.

35

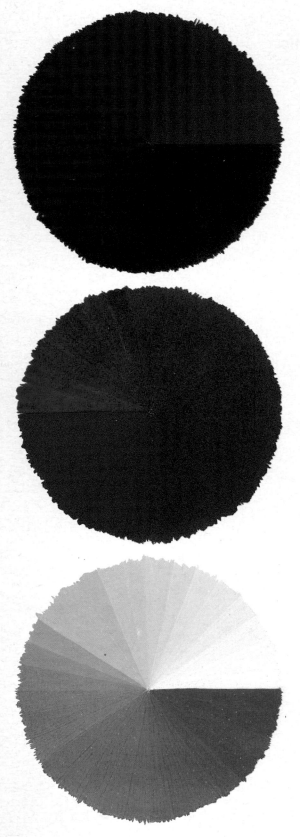

iron (ranging from the palest yellow to shades of red and brown), and orange and other related hues. The warmest is orange-red, known as Saturnine red.

The cool colors, associated with water and moonlight, are azure-green, soft violet, and those colors in which various shades of blue predominate (Prussian blue, ultramarine, cobalt, turquoise, and the cyan known as water azure). The coldest is manganese blue, or barium manganate.

All hues, except for orange-red, can be made warmer by adding to them a little yellow or red. For example, blue can be made warmer by the addition of yellow (yellowish blue-green), and violet by the addition of red (red-violet). Similarly, adding small quantities of blue, blue-green, or even white can make hues cooler (fig. 2-21). Thus yellow is cooled by the addition of blue (greenish yellow); red by the addition of violet or blue (violet-red or bluish red); blue, red, or magenta by the addition of white (sky blue, pink, azure-magenta, or cyclamen). Gray, when it is composed of a mixture of white and black, appears to be cool, because it tends to azure; it appears warm when composed of a mixture of yellow, red, blue, and white, or of virtually any pair of complementaries with white. Green, which is on the bounds of both a warm color (yellow) and a cool color (cyan), may show a greater propensity toward warm or cold according to whether yellow or cyan predominates. The same is true for the series of commercially available mineral greens produced from blends of yellows, azures, and blacks; the exception is viridian, a bright-green, chrome-based pigment (hydrated chromium hydroxide) that is not produced by mixing and always has decidedly cool rather than warm undertones. Because yellow is a bright as well as a warm hue, if, in the composition of green we maintain a fixed quantity of blue, with yellows of varying brightness (Naples yellow, Indian yellow, cadmium yellow, chrome yellow, etc.), we can obtain a wide range of greens from very light and cool to very dark and warm. If we then also vary the quantity and quality of the blue, we can even further enrich the countless varieties of green. Green may also appear cooler or warmer according to whether it is situated next to warmer or colder colors (fig. 2-22). Similarly, all colors—even the very warmest and the very coldest—may appear warmer or colder according to whether they are next to cold or warm hues. Warmth, in fact, is the result of a sensation. Thus orange-red appears even warmer if surrounded by cold colors, and blue-green appears colder alongside an orange than if next to a green-blue.

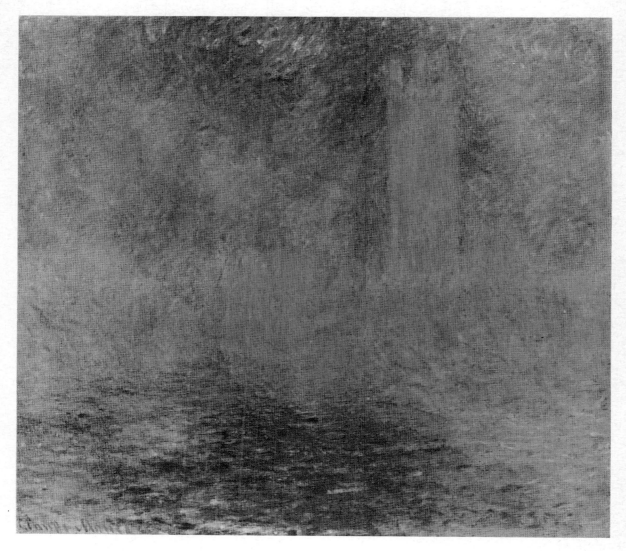

2-21, b. Opposite: Warm and cold colors

Above: In this painting by Claude Monet (London, Houses of Parliament. 1904. Galerie du Jeu de Paume, Musée du Louvre, Paris), we see how the yellow, orange, and red—in themselves very intense—are "warmed" by being close to cold colors. In fact, when the latter are covered, the effect of the former is immediately diminished.

Chiaroscural Scale, Value, and Lightness

Colors appear to us in different ways. Sometimes they appear as characteristics of reflecting surfaces so that we speak, for instance, of red paper or green velvet, or as characteristics of light sources, in which case we refer to a yellow bulb or a red traffic light.

The intensity of a light source is considerably greater than that of light reflected from a surface, which may at most appear as white, but never as a source of light. Only in particular cases is the painter successful in creating the illusion of light or of shadow by using only reflected lights and combinations of related colors about which it is almost impossible to theorize. The intention of this book, however, is not to dwell upon ways in which such "illusions" can be created but rather to suggest a simple method of reproducing a determined color by following precise rules. In order to be able to do this we use achromatic and chromatic chiaroscural scales. An achromatic chiaroscural scale, that is, one without color, defines the different gradations of gray obtained either by mixing white and black in varying proportions or by gradually thinning the black over a suitably prepared sur-

face, generally white. The number of grays of different lightness may be fairly high (a trained eye can distinguish at least two hundred); however, in practice scales are made up of eight, ten, or twelve tonal transitions, usually determined more by sensitivity than by mathematical calculations. The fewer divisions on the scale, the greater the difference between the transition, but, whatever their number, it is important that the transitions should proceed harmoniously, emphasizing their relationship yet making their differences evident (fig. 2-23).

These grays, ranging from white to black, form a series or graduated scale with different degrees of lu-

2-22. Above: Diversity and relativity of warm and cold in green colors.

2-23. Opposite, left: Scale or series of grays, from white to black.

2-24. Opposite, right: Monochrome scales in which the values of chromatic shadings can be compared with chromatic grays of equal luminosity. The degrees of saturation and luminosity of each color can likewise be compared.

minosity and lightness, each of which is identified by a number or a letter, called a *value*. These values show the progression of lightness at the perceptive

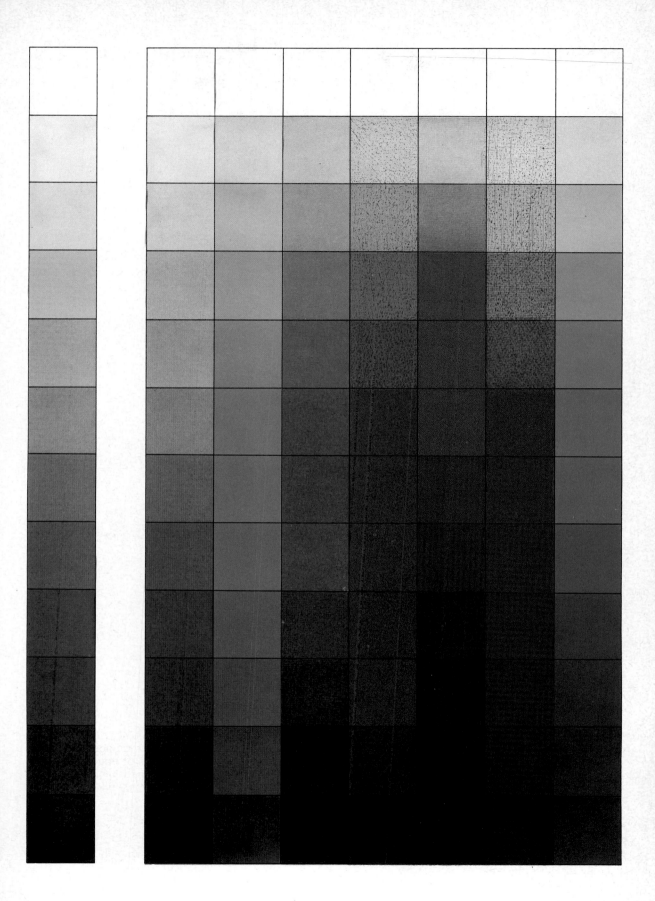

level without any reference to the quantity of light that the various shades of gray reflect (physical measure).[1] The number or value decreases from the lightest to the darkest gray.

In the chromatic chiaroscural scales the tonal values (or gradations) are obtained by mixing pure colors with white and black (monochrome scale). In this case, however, the gradations of color—becoming lighter or darker depending on how much white or black is added—lose chromatic strength and brightness. In particular, the glue colors, especially temperas, and a large number of opaque oils appear pale or faded, that is, less intense and pure, when white is added; they seem reduced, dull, and dark when mixed with black. In addition, they undergo changes of tone. For example, with the addition of white, vermilion red tends to pink, and with added black to brown or chestnut; orange, too, becomes brown or chestnut when mixed with black but alters its tone to become a salmon or beige color when mixed with white; magenta and crimson turn slightly azure with the addition of white, yellow becomes colder, blue remains almost unaltered, appearing sky blue, and violet becomes lilac. With added black, magenta and crimson tend to violet, yellow to green, and blue and violet immediately turn dull. The colors that alter most with the gradual addition of black are yellow and blue; green, however, changes least, whether mixed with white or black, although it is slightly altered by the latter.

The term *gamut* is applied to a scale of equidistant gradations representing the steady transition of a pure color toward white and black. The same word is also used to indicate both a continuous series of warm or cool colors, or nuances, and an ordered succession of colors (for example, the gamut of the color circle or that of the color of the iris).

The scale of grays from white to black represents all the values of light and shade. This scale is used to classify, comparatively, both the lightness value of pure colors and the degree of brightness of the relative gradation. In fact, in order to get an almost immediate perception of the values of brightness ranging between the poles of black and white one is more or less compelled to refer to a scale of neutral colors. It is impossible to get such a rapid valuation by look-

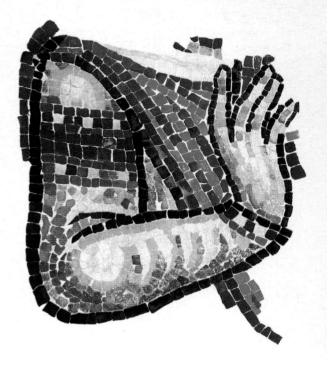

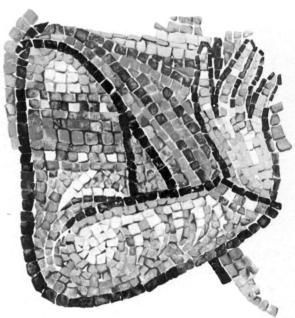

2-25. Every chromatic difference contained in the various tesserae of the mosaic above is revealed in the image below by means of grays of differing lightness, that is, in terms of luminosity, ranging from white to black.
In this example the lightness of each color and shade in the mosaic can be classified on the basis of the luminosity it attains in comparison with the achromatic scale.

[1] In an achromatic scale, the physical measures of the various shades of gray are expressed in percentages of reflected light; equal distances between physical measures are not perceived as such and, conversely, perceptive equivalents of distance are not measurable in physical terms.

ing at the gamut of almost any other color, for each of which there is always a different power of absorption. The simultaneous juxtaposing of color scales and the scale of grays shows the different positions that, in respect to the scale test, the various pure colors occupy in terms of brightness. In a gamut of twelve tonal values of each color, pure yellow (the brightest color, white included) corresponds to the fourth grade of gray; violet, the least bright, corresponds to the tenth. The gradations of all colors based on differences in lightness are situated closer to white or black (fig. 2-24).[1]

The study of chiaroscural scales helps to improve sensitivity to colors, enabling the artist to define their tone, value, and purity, to use chiaroscuro correctly—both in abstract and figurative compositions, whether in black-and-white or color—and to understand the essential relationships of forms in space, developing his or her own sense of depth.

In black-and-white photography, all chromatic differences are translated into grays of varying degrees of lightness. The relative poverty of a black-and-white compared with a color photograph is due to the fact that in black-and-white colors of different tone or saturation, but of equal lightness, are represented by the same level of gray. The two extremes, namely the lightest and darkest colors, are represented respectively by white and black. It is thus possible to arrange between these limits all the grays in diminishing order, in such a way that there is a transition from light grays to dark grays, culminating in black. If we try to compare a black-and-white photograph and a color photograph, we see that the same order the various grays assume in the scale of white to black applies to the corresponding colors, but measured in terms of relative lightness.

Although we have ample opportunity—through books, magazines, and black-and-white and color photographs—to train ourselves to recognize the different lightness values of both gray and color, only a few people succeed in doing this. In fact, it is extremely difficult, within the limits of an image, to distinguish between lighter and darker tones when the differ-

a b c

2-26. The red in a, applied in a uniform manner on a white ground, appears bright and saturated. If the layer of pigment is increased, the same red appears less saturated (b), because it diminishes the value of reflection of the incident light. If the layer is further increased, the red appears ever less vibrant and darker (c).

ences between them is minimal. Proof of this comes, for example, when we try to transfer a color painting into chiaroscuro (white–black–gray). If this has to be done, the lightness of each color in the painting must be classified according to the level of brightness it attains when compared with the scale of grays (fig. 2-25).

Saturation and Intensity

The term "saturation" is used to describe the state of absolute purity of a color. In the case of material colors, this remains merely an abstract hypothesis. In actual fact a pigmentary color, which always appears slightly gray, does not reflect simply a determined ray but a mixture of radiations (in different proportions) in which the specific wavelength of its tonality predominates. Thus it is not a contradiction in terms to speak of degrees or levels of saturation (or purity). Pure colors mixed with white, gray, or black suffer a deterioration of hue, which becomes pale, opaque, or dull respectively—in any event the color always appears weaker, never brighter. Mixed with other hues, even in minimal quantities, pure colors become yellowish, reddish, bluish, and so on. Colors produced from such mixtures are called "unsaturated." The lowest level of saturation is obtained by mixing two complementaries in equal parts, and maximum saturation is obtained when commercially prepared opaque paint film is applied full-strength in its natural

[1] The brightness of a chromatic color must not be confused with its lightness: a pure yellow is brighter than a green or a pure blue; a bright yellow cannot be dark and a green or a pure blue cannot be light, whereas a gradation of yellow, or of green or of blue, can be lighter or darker than one another.

Every gradation of every color, in relation to the quantity of black and white from which it is composed, has a value, a determined position along a kind of scale ranging from white to black, but not every gradation of color has an individual brightness, characteristic only of pure colors.

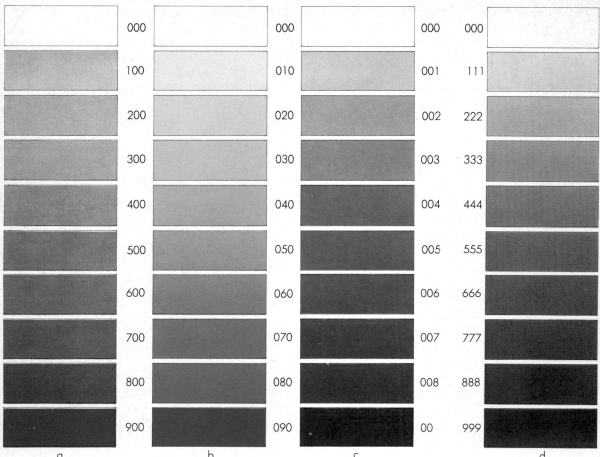

a	b	c	d
000	000	000	000
100	010	001	111
200	020	002	222
300	030	003	333
400	040	004	444
500	050	005	555
600	060	006	666
700	070	007	777
800	080	008	888
900	090	00	999

consistency, just as it comes out of the tube.[1] The sensation of purity cannot, however, be explained simply in terms of physics, since it also depends on the factors operating on visual perception, as we shall see in due course.

In order to achieve the exact color described on the label of any preparation, it is necessary to spread it evenly on a white ground (that is, a ground that almost totally reflects the light rays striking it), thickly enough to allow the incident white light to penetrate to the underlying layer of color and then be reflected back. For instance, if a bright red is applied to white paper so that the paint covers the background fully and uniformly, each granule of this color will strongly absorb the green and blue-green radiations of the spectrum and reflect all those with a higher wavelength value. The eye takes in the reflected radiations and so perceives bright red (fig. 2-26, a).

[1] The "opacity" of an opaque paint is not absolute but varies according to the type of pigment involved: the measure of such opacity indicates the thinnest layer of the paint necessary to completely cover the underlying ground, before it becomes transparent.

2-27. Above: The series or scales a, b, c display ten continuous grades of saturation, applicable to the primary colors (see text).
The achromatic series d shows ten values of gray from light to dark, almost black. Each transition is obtained by mixing the three primaries, each of the same shade, in equal parts. The three-digit numbers indicate the relationships.

2-28. Opposite: Composition represents:
1) The pure primary colors in varying measures of saturation (indicated by one digit accompanied by two zeros: 050, 006, 030, 003);
2) The colors, likewise pure, resulting from the mixture of two primaries (indicated by two digits and a zero: 056, 950, 903, 033);
3) The opaque or darkened colors, no longer pure, resulting from the mixture of the three primaries (indicated by three digits: 956, 933).

If another layer of paint is superimposed over the first, the density of the color will be increased but its intensity will not. Thick applications of paint prevent the incident rays from penetrating all the layers and therefore from being reflected back, thus bringing

about a greater degree of absorption (fig. 2-26, b). The more the layer of pigment is increased, the greater the absorption of rays and the darker and less vibrant the color becomes, assuming an appearance very different from that when applied thinly (fig. 2-26, c). Even watercolors become slightly darker if the layer of paint is further thickened after maximum saturation has been reached.

In order to lighten opaque and transparent colors without losing too much of their tonality, it is generally enough to apply them thinly to a white background. When they are lightened by the addition of white pigment, however, the saturation varies and the brightness decreases—some even change their tone in a different manner according to the hue. In order to lighten the hues of watercolors, conserving the tonality, it is sufficient to thin them with water.

Almost any pure color may vary from no saturation (the achromatic white of the background) to maximum saturation (full color). It seems that the human eye is usually unable to perceive more than ten transitions between these limits (white of paper to full color).

Systems and Instruments Used for Measuring Color Density

The series or scales of figure 2-27, a, b, and c show the ten degrees of saturation for the three basic colors. Each degree or transition is indicated by a three-digit number. The value of each digit, which is read on its own, refers to the quantity of color of a single primary (compare this with the system of numbering previously mentioned in figures 2-6 and 2-11).

When pure pigment and solvent are applied, the digit 0 signifies the presence of solvent only without color; the successive digits from 1 to 8 indicate an increasing concentration or density of pigment in the solvent; and the digit 9 indicates full tone, namely the maximum intensity for that color (optimal saturation). The sequence of reading for the primaries is fixed conventionally: yellow, magenta, and cyan. Therefore we have the yellow series or scale: 000, or paper white; 100, in which 1 indicates the first grade of saturation of yellow ("optimal brightness" or "minimal intensity"), 0 the absence of magenta, and 0 the absence of cyan; 200, indicating two parts of yellow, none of magenta, and none of cyan; 300, indicating three parts of yellow, no magenta, and no cyan; and so forth.

The magenta series or scale also starts with 000, paper white; this is followed by 010, zero parts of yellow, one of magenta (minimal density), and zero of cyan; 020; 030; and on up to 090. The same for the cyan series, from 001 to 009; the numbers 900, 090,

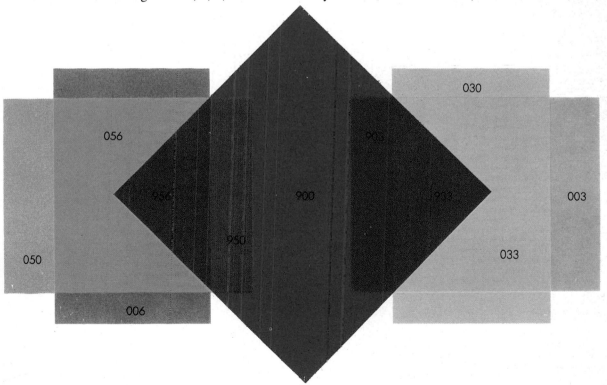

43

a

100% 90% 80% 70% 60% 50% 40% 30% 20% 10% 0%

b

0
10
20
30
40
50
60
70
80
90
100

c

0
10
20
30
40
50
60
70
80
90
100

100 90 80 70 60 50 40 30 20 10 0

and 009 indicate the optimal saturation or maximum intensity of yellow, magenta, and cyan respectively. When we superimpose, either by transparency or by mixing watercolors of yellow, magenta, and cyan, we get gray. With their maximal dilution, 100, 010, and 001, we obtain a very light gray, namely 111; by superimposing or mixing the colors of the second grade of intensity, corresponding to the numbers 200, 020, and 002, we get a slightly darker gray than the preceding (222), and so on until we superimpose or mix 900, 090, and 009, producing the darkest possible gray (999), almost black (fig. 2-27, d).

It is not, therefore, essential to add black or gray to darken colors or make them more opaque, since the same result can be obtained by adding to the primary color in question equal or different proportions of the other two (fig. 2-28).

An understanding of the principles of color saturation, useful for the painter who wishes to mix and superimpose colors, becomes indispensable to the uniform manufacture of transparent colors needed in many branches of industry (inks, enamels and varnishes, electric light bulbs, glass for illuminated signs and for indicators on vehicles, pharmaceuticals, food products, cosmetics, plastics and ceramics, printing , to name but a few).

In printing, whether two-color, three-color, four-color, or rotogravure, in which the color process is identical, it is possible to obtain a great many color impressions that vary in relation to density, even when the primaries are used on their own. This expertise enables the printer to make a fairly accurate choice of the ''weight'' of colors needed to obtain a predetermined hue or imitate a given color. In fact, even the slightest difference in the degree of saturation or density of one or two of the chosen pigments can produce colors that vary considerably from those required, making them darker or altogether altered. Similarly, in color photography, the use of the wrong filter can produce a very different effect from that intended.

''Densitometers'' are instruments that measure the thickness of the layer applied, and ''colorimeters'' measure a color's intensity, its level of brightness, and its saturation, expressing the differences among them in conventionally accepted ways. These two instruments provide objective information about a vast range of color features, even under variable lighting conditions. They are not, however, really necessary to the painter, engraver, or interior decorator, who bases his or her choices on personal feeling.

The series or scales of saturation that demonstrate how virtually any color varies when a single aspect of

2-29. Opposite: Linear or one-dimensional representation of the colors cyanic blue (a) and magenta red (b); the numerical values apply to the densities or degrees of color saturation. The color chart (c) illustrates all the possible variations of the color violet that can be obtained by mixing cyan and magenta. The numbers indicated at the sides represent the percentages of each color needed to obtain the corresponding mixture.

2-30. This page: Group of three color charts each showing 100 possible modulations obtainable by mixing magenta with cyan, cyan with yellow, and magenta with yellow.

it is modified, in this case the density, are called "linear" or "unidimensional"; they illustrate one-dimensional variations not from the point of view of perception (the individual features of lightness, saturation, or tonality), but from that of the color's material concentration.

When, however, we want to illustrate all the possible variations a color produced from two primaries may assume as a result of changing—simultaneously and to the same degree—the densities of the component colors, we use a "bidimensional" representation or "color chart." The numbers shown at the sides of the chart in figure 2-29 correspond to the concentrations of the respective colors. In figure 2-29, a, the saturation or intensity of cyan, at its maximum on the left side (practically 100 percent), diminishes progressively toward the right until it is lost in the white (0 percent of color); in figure 2-29, b, the intensity of the magenta, at a maximum on the lower side, diminishes to white as it gets higher. In the color chart c, obtained by superimposing a and b, the violet, which is the resultant secondary color, changes its intensity toward white in a diagonal direction: the variations indicated along the sides relate to the different percentages of each color needed to get the corresponding mixture. This chart is made up of an infinite number of colored

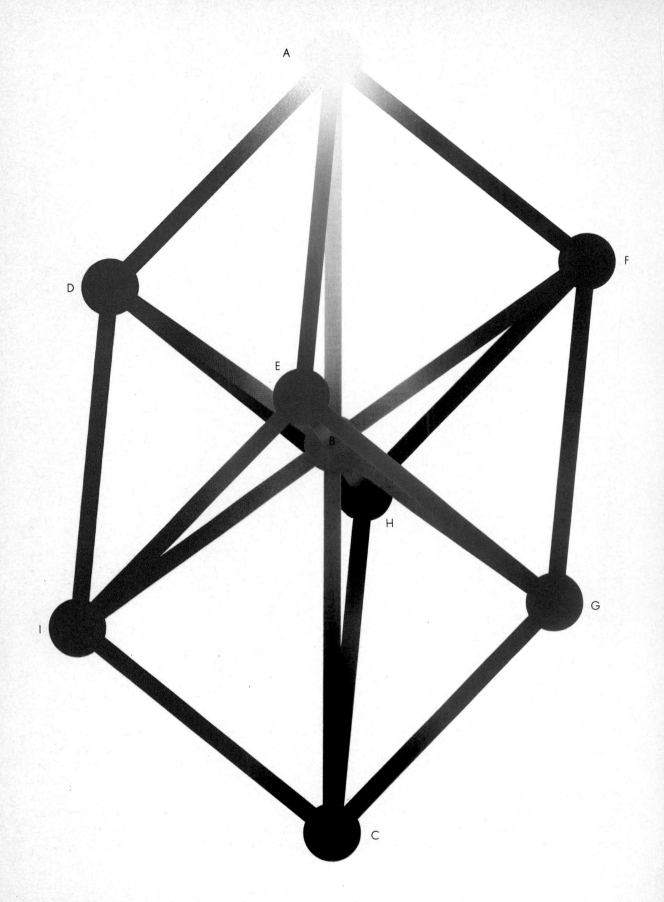

a

b

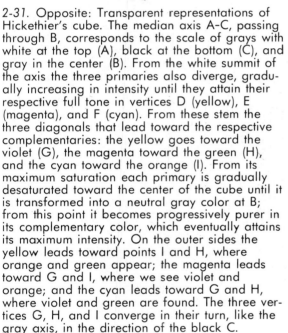

c

2-31. Opposite: Transparent representations of Hickethier's cube. The median axis A-C, passing through B, corresponds to the scale of grays with white at the top (A), black at the bottom (C), and gray in the center (B). From the white summit of the axis the three primaries also diverge, gradually increasing in intensity until they attain their respective full tone in vertices D (yellow), E (magenta), and F (cyan). From these stem the three diagonals that lead toward the respective complementaries: the yellow goes toward the violet (G), the magenta toward the green (H), and the cyan toward the orange (I). From its maximum saturation each primary is gradually desaturated toward the center of the cube until it is transformed into a neutral gray color at B; from this point it becomes progressively purer in its complementary color, which eventually attains its maximum intensity. On the outer sides the yellow leads toward points I and H, where orange and green appear; the magenta leads toward G and I, where we see violet and orange; and the cyan leads toward G and H, where violet and green are found. The three vertices G, H, and I converge in their turn, like the gray axis, in the direction of the black C.

2-32. This page: Hickethier's cube seen from the side (a), from above (b), and from below (c). (From H. Osterwalden *Farbenordnung Hickethier*. Hanover, West Germany: 1952, pp. 36, 37.)

dots, variously modulated, each of which is produced by different quantities of original colors: in fact, if we subdivide the table with ten horizontal and ten vertical lines, we get one hundred adjacent boxes in which it is possible to recognize one hundred different colors. The subdivision based on decimals can be carried further toward an even deeper analysis of colors. Figure 2-30, which combines three color charts, shows the one hundred different possible modulations that can be obtained from magenta and cyan, yellow and cyan, and magenta and yellow. Each tonal modulation is specified by a three-digit number (cf. fig. 2-23) so that

the proportions of basic colors used in the mixture and the degree of saturation can be read immediately: this is highly important both for recognition of the shade itself and for reproduction.

Construction of a Color Arrangement on a Subtractive Basis: Hickethier's Cube

If we want to represent all the possible variations that a color may undergo when all three primaries composing it are modified at the same time, we have to resort to the three-dimensional structure of a hexahedron resting on one of its vertices. Each axis shows the variation of a single primary color. Alfred Hickethier devised this model (known as Hickethier's cube) using only the three basic subtractive colors with a view to facilitating the practical use of color. The three dimensions (height, width, and depth) make it possible—by means of a regular division of yellow, magenta, and cyan—to obtain mixtures of all three colors and all their variations toward white, black, and gray. In figure 2-31, which gives a transparent view, we can see the inner structure of the cube. The color variations that can occur are explained in the caption accompanying this figure.

In figure 2-32, a and b, giving a view from the side and the top of the cube, the pure colors are shown; figure 2-32, c, viewed from below, shows only deep colors. All the colors, proceeding inward from the white and black vertices, make up an assortment of one thousand color modulations equivalent to the one thousand subdivisions of the solid. Each is described by a three-digit number. The regular arrangement of the digits enables us to define not only the tone but also the quantities of each primary that goes into the different mixtures; this is extremely useful for graphics and in other spheres where color is used for an industrial or scientific purpose.

The cube, for practical use, can be divided into ten parallelepipeds (prisms of six faces), each of which is in turn subdivided into one hundred cubes marked by respective digits (see fig. 2-33). An understanding of these systems relating to the formation of all colors on the basis of only yellow, magenta, and cyan is important in the professions of color printing, photography, film production, and stage lighting; it also helps to cut costs, because each mixture requires only the three primaries. It is not as essential for painting in art, where choice of materials is far greater, but it is useful to know in order to train the eye to distinguish between pure colors, shades, and measures of saturation.

Classification of Colors on a Perceptive Basis

From a completely different point of view, we can adopt color classification systems on a perceptive basis. Many scholars have sought suitable methods of representing simultaneously and with equal emphasis the three fundamental variants that characterize a color: tonality, also called the tone, tint, or hue (the qualitative variation of the color—yellow, green, cyan, etc.); lightness (relation of the color to white and black); and saturation (purity of the color).

Various three-dimensional models have been constructed for this purpose, the best-known of which are the pyramid developed by the Swiss mathematician, physicist, and illuminist Johann Heinrich Lambert (1728–1777); the sphere of Philipp Otto Runge (1777–1810), a German painter and friend of Goethe; the double-cone system of Wilhelm Ostwald (1853–1932), the German (of Russian origins) chemist and philosopher; Albert Henry Munsell's color wheel; the CIE triangle; the DIN 6164 system developed by Manfred Richter, a German engineer and physicist; the Natural Color System; and the rhombohedron of Harald Küppers, another German engineer and physicist.

The double cone or color wheel (fig. 2-34) consists of a vertical axis representing the scale of grays from white to black and the central section, or equator, constituting the base of the two cones, on which the color circle is located. The pure colors (arranged around the circumference of the circle) may number six, twelve, twenty-four, or more, with their complementaries diametrically opposed. The equator of Ostwald's color wheel divides it into twenty-four different tonalities. The colors of each tonality gradually intensify as they radiate from the gray center of the axis, finally reaching complete saturation at the periphery (clearly showing why saturation is defined in terms of absence of gray), and take on a higher content of white and black as they move vertically in the direction of the respective poles.

If the color wheel is divided vertically so that all planes pass through the poles of the axis, we get rhombi. The gray scale, because of its central position, divides each rhombus into two equilateral triangles (fig. 2-35), the three vertices of which correspond respectively to a full color, to white, and to black. If, for instance, we place blue-green as a pure color at the tip of the left-hand equilateral triangle, its complementary color, orange-red, will appear as a

2-33. Cube divided into ten parallelepipeds. The first, containing the colors from 000 to 099, is defined as "chart 0"; the second, containing the colors from 100 to 199, as "chart 1"; the third, from 200 to 299, as "chart 2"; and so on to the colors from 900 to 999 ("chart 9").

W

B

2-34. Ostwald's color wheel or double cone in its simplest diagrammatic form. The colors are at their most saturated on the equator; from this point they become lighter toward white or darker toward black in the direction of the poles of the neutral axis. The inside of the solid contains all the colors it is possible to mix with their relative gradations of lightness and darkness.

pure color at the tip of the opposite triangle. If, proceeding away from pure colors toward the upper vertex, we gradually add more white, then according to additive principles we get an ordered and graduated progression between full colors and white. This series of light colors represents the first of three ways in which a full color can be modified and is the first link between chromatic and achromatic. Similarly, to obtain an ordered progression of gradations between full color and black, we proceed from the lower tip of the axis, gradually adding more black. This series of dark colors represents the second way of modifying a pure tone. On the inside of the triangle are the colors

with low saturation, which are characteristically opaque and which we produce by mixing the full color with both white and black. This series of grayish and opaque colors represents the third and last way in which a full color can be modified. These triangles are all monochrome, since they contain all the possible modifications of a single tint with white, black, and gray. Each vertical section has 56 colors, 28 to each triangle. As a result, the complete solid of 24 triangles (fig. 2-36) contains 672 chromatic colors, plus 8 grades of the gray scale, giving a total of 680.

The color wheel can also be divided in planes parallel to the equator (fig. 2-37). Each of the resultant disks shows the overall level of lightness attained by the colors, both above and below the equator.

In the Ostwald system, the three color variants (tone, saturation, and lightness) are represented by a number and two letters. The digit corresponds to the number of the hue of the color circle (from 1 "yellow" to 24 "yellow-green") and simultaneously matches the number of the triangles that vary by a tone. The first letter indicates the content of white, the second the content of black.

Munsell uses a kind of sphere in which, in order to conform with Ostwald's double cone, the hues of the color circle are arranged along the edges of the equator of the sphere, the progression of each hue's lightness (ranging from white to black) along the axis, and the saturation along rays perpendicular to the neutral axis itself. In explaining his system, Munsell defines each quality of the color as "hue," "value," and "chroma," and uses the term "color" for all the tones of the colored solid. Every hue is assigned a number to indicate the "weight" of the tone, one or two letters to indicate the color (e.g., R=red, BR=violet), and two numbers separated by a dash to indicate the lightness (value) and saturation (chroma) respectively. The Standard DIN 6164 system as developed by Richter is a structure of the same type as Munsell's and is the system of standard use today in Germany.

A color, therefore, can be fully described only when the tone, the lightness, and the saturation are known: two chromatic samples have the same color only if they have the same hue, lightness, and saturation. In certain commercial, technical, and productive sectors such as clinical and chemical laboratories, the most precise color specifications are essential. In these cases the instrument used is a reflecting or transmitting spectrophotometer. This rather complex instrument analyzes a given color by defining its spectral characteristics. By using a spectrophotome-

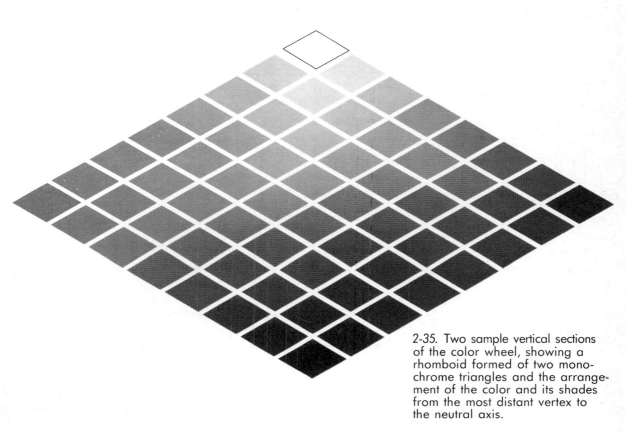

2-35. Two sample vertical sections of the color wheel, showing a rhomboid formed of two mono-chrome triangles and the arrangement of the color and its shades from the most distant vertex to the neutral axis.

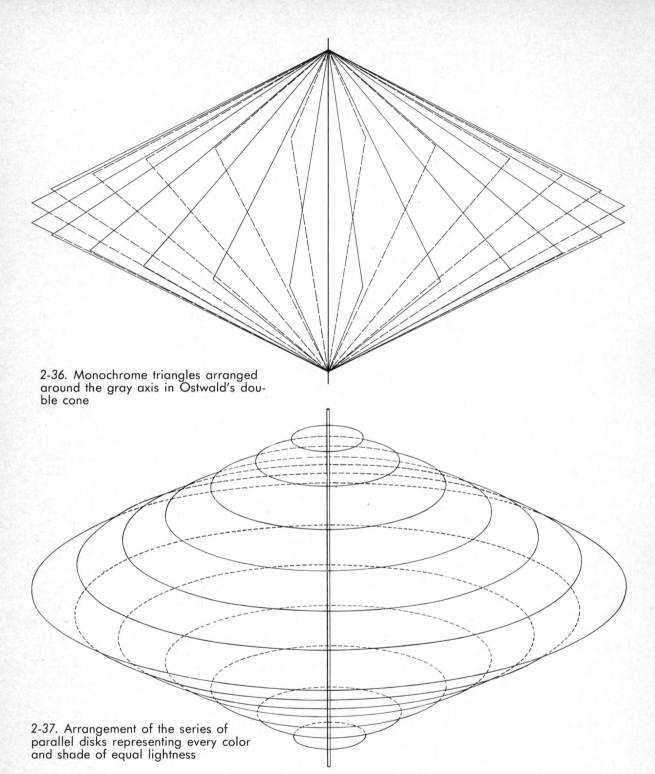

2-36. Monochrome triangles arranged around the gray axis in Ostwald's double cone

2-37. Arrangement of the series of parallel disks representing every color and shade of equal lightness

ter one can calculate the values of a color relative to its tonality, lightness, and saturation, so that these three variables are exactly specified (measurement of tristimulus values).

In the CIE system, the three so-called variables are replaced by the values X, Y, and Z, where Y corresponds to lightness and X and Z to other characteristics, from which, if necessary, we can infer tonality and saturation. This system, based on the additive synthesis, will be dealt with in more detail in chapter five when we discuss the trichromatic theory of the perception of color.

Physical and Chemical Factors of Color

Properties of bodies to absorb, transmit, or reflect light. Spectral bands of absorption and specific reflections of pigments and plant bodies. Modifications of color in relation to molecular structures and physical states of matter, to atmospheric agents, to environmental factors, to the physical and chemical action of light, and to processes of production

In total darkness all objects appear black. From this we can conclude that it is only the presence of light that brings out color.

Various substances exert an influence on the light that strikes them, modifying its spectral composition, partly reflecting it, partly absorbing it, and partly transmitting it, according to their molecular composition. Reflected light and transmitted light, however, differ from incident light, because they may wholly or partially lack the rays absorbed by the material itself. The quality of reflected or transmitted light thus depends both on the nature of the incident light rays and the nature of the substance struck by them.

Perfectly transparent bodies (clear water, ordinary glass, cellophane, etc.), especially if they are isotropic,[1] allow light rays to penetrate their every part indistinctly, without absorbing or reflecting any of them. In this manner they appear uncolored to our eye, for the colors of all the rays have passed through, creating the phenomenon of total transmission. If, because of partial transmission of rays, a body seen as transparent (for example, a pane of glass) transmits, or lets through, some red, yellow, or violet rays and absorbs all others (which thus have no effect on the eye), it appears to be red, yellow, or violet in color. The phenomenon of total or partial light transmission in a medium may vary according to the depth, thickness, and quality of the materials in question, so that in fact there are no absolutely transparent or absolutely opaque bodies. For instance, sunlight striking water, which is transparent, will penetrate only up to a certain depth; ordinary, perfectly transparent glass may appear semitransparent or even opaque if in several superimposed layers, at which point the rays are extinguished; a piece of paper will appear trans-

parent or opaque according to its thickness; gold, steel, aluminum, copper, and other metals, although indisputably opaque, will, when reduced to very thin sheets, retain their own reflected color but, if seen against the light, will let other rays pass through and assume a different transmitted color. The reflected and transmitted color may be identical—as in highly transparent and clear mediums—or different or complementary according to the different degrees of absorption through the thickness of particular substances, and in direct ratio to this thickness.

For example, if we gradually pour a fluorescein solution into a test tube, we see, if we look down from the top, the lower levels change from yellow to red and finally to green as the volume of the liquid gradually increases. By the same procedure, a solution of cochineal will first appear red, then violet-red, and finally green. Although the concentration of the two solutions remains constant, the increase in the volume of the liquids is accompanied by a growing presence of coloring principles penetrated by the incident light. This causes a continuous change in the absorption ratios and a consequent variation in color. For the same reason, gold and copper, which appear yellow and red by reflection, will appear azure-green and green by transparence when reduced to very thin sheets.

Opaque material (paper, wood, plaster, coal, stone, etc.), by reason of its thickness, molecular structure, and the variability of the constant of absorption in relation to the wavelength, may subtract all or part of the rays from the incident light, "reflecting" the remaining ones from the inner layers toward the surface and from the surface to the observer. These different actions constitute the phenomena of absorption and reflection. The phenomenon of total or partial light absorption does not occur only on the surface of opaque objects—especially susceptible to reflection—but also in the layer immediately below, and from there to a depth that is difficult to determine.

[1] A body can be said to be isotropic when its constituent particles, on subdivision into even smaller molecules, exhibit uniform properties and density throughout and in all directions. Such particles do not influence the speed of light, which proceeds in a straight line in every direction.

The phenomenon of reflection differs even when dealing with the same material, depending on whether the surface is rough, smooth, opaque, clear, polished, or dusty.

When a substance not itself colored is struck by sunlight, it absorbs part of the light and reflects (diffuses or refracts) part of it, and so becomes in its turn a source of light rays. These, too, are uncolored, but seen with the eye they are transformed into color sensations as a result of the chemical and physiological processes they provoke in the visual apparatus. These processes show clearly that color has no independent existence but is the offspring, as it were, of light; the eye, in fact, has no visual impressions of any kind unless light stimuli provoke them from the outside.[1]

An opaque material that absorbs some rays and reflects all others owes its color to the rays it reflects. If, for example, a surface absorbs all the rays of white light between 430 and 490 mμ inclusive, all the remaining rays will be reflected and material will appear orange-yellow; if, instead, it absorbs radiations between 610 and 730 mμ, it will appear blue-green; and so on.

The diversity of colors depends on the diverse molecular structure of the objects, which in each individual case will absorb different light rays. A red wall appears this color to us when its molecular constitution almost completely absorbs the green and blue-green radiations of the visible spectrum; the remaining waves, reflected to the eye, combine to provoke a uniform effect of red. The same happens with a lemon, which appears yellow to us when its rind almost entirely absorbs the short wavelengths (spectral zone of blue-violet) and reflects all the others, so producing the visual sensation of yellow. This is true for the color perception of any kind of surface. It is very difficult for a visible object to reflect only one monochromatic radiation or a narrow band of radiations. As a rule it reflects a broad band of the spectrum, in which a particular wavelength, corresponding to the perceived color, is dominant. As we have already pointed out, this is why colors almost always appear to us slightly saturated and rarely pure.

If a surface has the property of reflecting diffusely and uniformly the entire gamut of radiations of incident light, without sending back any particular dominant wavelength, this surface appears white.[2] Be-

cause there are no bodies in nature that totally reflect the light they receive, it follows that one cannot see an absolute white, but only various kinds of white—snow, chalk, lime, milk, eggshell.

So, too, a surface that appears black displays no particular dominant wavelength, but is characterized by an almost total absorption of the light received. Since in this case light is never totally absorbed by a body, it is impossible to see a perfect black. Lampblack and coal dust, which almost wholly absorb all radiations of any wavelength, are the closest approximations to the condition of pure black in the ideal physical sense.

Pigments, too, depending on their inner molecular structure, reflect the rays they do not absorb and therefore appear to be the characteristic color of the combined wavelengths sent back. Unlike other objects, pigments show a more marked absorption of radiations from certain zones of the spectrum.

When absorption occurs most completely in the zone of the complementary of the color being observed, we get a color that is theoretically pure; different behavior, caused by the inherent qualities of the original material or due to a variety of other factors, such as variations in the ratio of pigment to binder or chemical work processes, modifies the tone of the color, which appears less pure. Every primary, at a high level of purity, absorbs a third of the light striking it and reflects two-thirds: primary yellow absorbs all the short wavelengths (blue-violet spectral zone) and reflects the medium (green) and long waves (yellow, orange, and red); magenta absorbs all the medium waves, part of the medium-short (cyan-green zone) and medium-long (yellow-green), and reflects short and long waves corresponding to blue-violet and from yellow to red; cyan completely absorbs long waves and a few in the violet zone, reflecting the remaining part (which is minimal), together with all the medium-short waves (where cyan radiations predominate) and medium waves (green).

A secondary, produced by mixing two primaries, absorbs two-thirds of the incident white light and reflects a third, because the hue of this mixture performs a double process of absorption. Thus green, obtained by mixing yellow and cyan, appears through the following subtractive process: the yellow pigment completely absorbs the short waves (blue-violet) and reflects the long waves with a preponderance of yellow, but also reflects a considerable percentage of green waves subtracted from the cyan; the cyan subtracts long waves from its companion and reflects blue and green. Therefore the incident white light,

[1] In the complete absence of stimulation, what we get in reality is a perception of gray called "cerebral."

[2] In these cases we assume that the surface in question is not the only visual stimulus present but that there are also other surfaces visible at the same time, although darker. In the case of a black surface, these others must be lighter.

which has undergone a considerable subtraction of all light waves apart from the green, appears green to our eye. This occurs also with orange and violet, according to the respective processes of subtraction performed by the colors originating them.

By mixing all three of the basic subtractive pigments together, we get dark gray and black, because there is very strong absorption in each spectral zone. Each primary, in fact, works on its own account, subtracting certain rays from the light that strikes the mixture rather than others.

The mixture of two complementary colors (one a primary and the other a secondary) brings about the same result—dark gray or black—inasmuch as each color of the pair absorbs the wavelengths reflected by the other, so that the radiations of the whole spectrum are absorbed. When, on the other hand, two secondary colors, or a primary and a secondary not diametrically opposed in the circle, are mixed, the result, as a subtractive compound, is not black but yet another color, which in painting is known as earth. This is because the three primaries, always contained in the two component colors, are not present in equal proportions but in diverse quantities, with one clearly prevailing over the other (see section on earth colors, page 32–35).

If we mix two contiguous colors in the circle, for example red and orange, neither of the two will be absorbed and the result will be a color midway between the two (red-orange).

As for white pigments (or other white materials used in painting), one cannot obtain absolute white because even in the most accurate manufacturing process it is impossible to eliminate totally the traces of the metal used. For example, in lead white, the salts of a few lead particles, active in the absorption process, give the product a barely perceptible gray tint. In zinc white a few traces of cadmium salts make the product very slightly yellow, and traces of iron salts in titanium white color the product pink. Pure precipitate of barium sulphate (*blanc fixe*), sold commercially as a very fine dust and in the form of paste, is the product that comes closest to perfect white.

Similarly with black pigments it is impossible to obtain an absolute black. There are instead different grades of black, since even in products of the highest quality, there remain traces, though minimal, of reflecting inorganic and organic substances.[1] The best black obtainable is considered the one we see by looking at a hole, in a white background, opening onto a cavity lined with black velvet or painted with lampblack.

Unlike pigments—which reflect more kinds of radiations but always within a fairly wide band of the spectrum—most of the colors of natural living bodies (more than other objects) reflect, though always in different proportions, several lengths distributed over the entire spectrum. Spectrometers are used to measure the light reflected from colored bodies; by means of tests made with these instruments, it has been possible to verify, as a general rule, that there is a great difference in the spectral composition of the green colors of vegetation and the pigmentary greens used by painters to reproduce the colors of nature. In the two illustrations of figure 3-1, the course of the curves shows the richer reflectance of the greens of leaves (above), resulting from a mixing (in different proportions) of all the wavelengths of the visible spectrum, than that of the greens of pigments (below), the reflectance of which totally lacks red, has much less orange, and is minimal in the quantity of radiations reflected in the blue-violet zone.

Until now we have considered color as the physical and chemical characteristic of a surface, in that it absorbs, transmits, or reflects some particular wavelengths of white light rather than others. With a variation of the lighting, however, the same color appears modified.

A surface white in sunlight, if illuminated by a red, green, blue, or yellow lamp, will appear the red, green, blue, or yellow of the incident light. If a surface is illuminated by differently colored lamps, the sensation of the original color is no longer provoked as long as the two colors (surface and light) are equal. For instance, a wall that looks red in daylight, and remains unaltered at night if viewed under red light, will appear dark or almost black if illuminated by green, yellow, or blue light, that is, light in which there is no red present.

A substance does not on its own possess a fixed objective and constant color, since the color varies not only by virtue of its chemical constitution and the lighting but also in relation to the particular arrangement of the molecules within the substance. For example, ordinary transparent glass, when worn, looks cloudy; when finely ground, it becomes white dust; platinum appears grayish or opaque white, depending

[1]An ideal white would reflect 100 percent of the light and would thus have 100 reflectance; an ideal black would absorb 100 percent of the light striking and would have 0 reflectance. These limits are never attained; a piece of white board generally has a reflectance of 80 or a little more; a piece of black board has a reflectance of about 4. The reflectance of grays ranges from 4 to 80. (Fabio Metelli, ''La percezione della trasparenza,'' *Le Scienze*, No. 71, July 1974.)

3-1. The curve at top shows how a green leaf reflects, in different proportions, all types of spectral wavelengths; the curve at bottom, which mainly registers semilong and shortwaves (corresponding to the colors yellow, green, and cyanic blue), or radiations of two particular regions of the spectrum, indicates the percentage of light reflected by a green pigment. The black surface represents the amount of light absorbed by the respective greens in each spectral band.

on whether it is in the form of a porous mass (platinum sponge) or of rods obtained by fusion; pulverized copper, blackish when dry, becomes orange when suspended in water or applied wet, in a thin layer, on glass, yet the same material, when polished on the bottom of a receptacle, assumes a bright red color, different from the light red that is its usual color; and sheets of very thin, transparent metal turn white and opaque at the points where they are bent. It should be noted, too, that the activity of infrared and ultraviolet rays, which constantly accompany visible radiations, can also influence the color of a substance. The thermic action of infrareds and the chemical action of ultraviolets can bring about slight alterations to the air and water present in intermolecular spaces, so modifying the inner structure and, as a result, the appearance of the color of the objects. In some substances, such as uranium glass, phosphorus, bisulphite of quinine, and calcium and barium sulphides, the chemical action of light and especially the action of ultraviolet rays can bring about phenom-

ena of luminescence so marked that they seem to possess their own light.

Those substances that under the direct action of light immediately restore the shortwaves absorbed, a phenomenon that ceases when the illumination is cut off, are called fluorescent; phosphorescent substances are those which continue to emit luminous violet and ultraviolet rays even up to thirty hours after the illumination has ceased. What is more, both types of substance can emit lights of other colors when illuminated in the dark by violet rays or by other forms of radiant energy, such as cathode rays. This is demonstrated by uranium glass, which, subjected in dark-

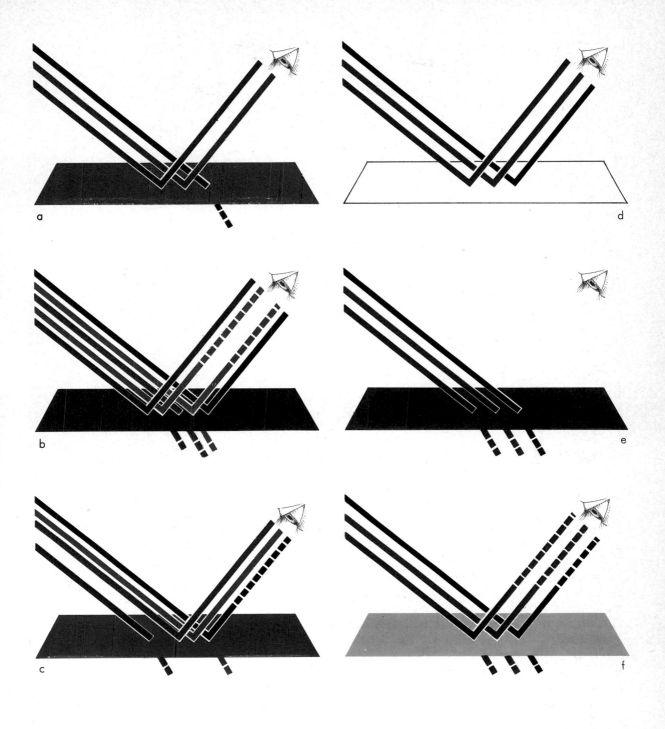

3-2. Surfaces appear to be different colors because of their differences in absorption and reflection. A surface that: a) absorbs all the short rays and reflects the medium and long rays appears yellow; b) absorbs all the medium rays, partially absorbs the medium-short and medium-long rays, and reflects the short and the long rays, appears magenta; c) completely absorbs the long rays and almost all the short rays, reflecting only some short rays together with all the medium-short and medium rays, appears cyan; d) absorbs only about 10% of the incident light rays appears white; e) absorbs nearly all the incident light rays, appears black; f) absorbs about 50% of the incident light rays appears to be a gray of an average tonality.

ness to the short- and ultrashortwaves of the spectrum, does not turn violet as one might expect, but takes on a splendid green light. In conclusion, we can say that a color seldom remains constant in a body due to the physical and chemical action of light, the composition of the material, the action of natural events (rain, fog, wind, lightning), and the interaction of atmospheric agents (gas in the air, vapors, acids, fumes) with other external agents caused by man (products of combustion, exhaust gases).

The same is also true of pigmentary substances used in paintings. The degree to which they are stable depends not only on the action of light, including infrared and ultraviolet rays, but also on atmospheric conditions, fluctuations of temperature, the degree of humidity in the environment, the action of atmospheric gases, or other internal or external agents (vapors, fumes, smog), or simply atmospheric particles. Each of these in chemical combination with one or another color may bring about various alterations to the color (reduction, clouding, dulling), depending on whether the pigments are natural organic or compounds derived from such elements as iron, chrome, copper, lead, or mercury. Changes such as these may in time modify the overall color of a painting.

The heat of infrared rays, which has a negative effect on paintings, since it can cause a softening of the binder and thus a modification in the behavior of the molecules, is one of the methods of increasing the stability of artificially obtained coloring substances. The most solid colors are those which have been subjected to the highest temperatures. In fact, the higher the temperature, the greater the overall loss of humidity within the binder, the uniform compactness of which results in greater resistance to atmospheric agents. Infrared rays are used in the car industry to speed up and regulate the drying process of body work, to preserve the fixity of the color, and to increase the shine and resistance of varnishes.

The highly energetic chemical action of ultraviolet rays, which can affect both the surface and the inner layers of paintings, is particularly evident on certain colored and coloring substances, which are composed or decomposed with modification of their tone. Natural organic pigments, including some lacquers and all aniline colors, are especially sensitive to such radiations. When exposed to excessive light, they may within a short time undergo considerable degradation of the original color or even total discoloration. Poor weather conditions and fluctuations in temperature can also contribute adversely to the keeping qualities of frescoes and paintings on exhibition.

Physical factors that affect the atmosphere (temperature and humidity level) may cause colors to come out in greenish or grayish spots or to suffer damage that may, in a short time, threaten the entire painting. Pictures keep best in a temperate and moderately dry climate; humidity, which encourages the development of mold, can be particularly harmful. Molds, in fact, by decomposing the glue, can remove the surface layer, cracking the painting, or even the underlying layer, lifting and thus detaching the preparation from the support. The harm done by foreign particles such as motes, always present to a greater or lesser extent in the air, depends on the nature of the particles themselves. Those arising from smoke and coal dust burned in industrial plants (soot) are especially dangerous for paintings, because they gradually eat into protective varnish and binders. Soot causes enormous damage to stone structures because of the sulphur dioxide it contains; through the action of humidity and rain, it is transformed into sulphurous and sulphuric acid, both of which corrode stone.

In addition to changes due to natural or accidental causes, colors can undergo alterations when substances are used in the course of production that are either not pure or have been subjected to the wrong temperatures, or were wrongly exposed or wrongly ground. Even colors that have been accurately prepared, especially those of animal or vegetable origin, may, through the action of light, suffer a whitening of tone or lose it entirely if exposed for too long.

The artist himself can also sometimes cause alterations of color through errors of mixing. Some colors when mixed with others come up against chemical reactions that, as time passes, bring about changes in the combined hues. This happens, for example, with Prussian blue, vermilion, and certain somewhat unstable Naples yellows, even if combined with quite solid colors. Colors with a lead base (white lead, light cadmium yellow, chrome yellow, Saturnine red) gradually undergo transformations, turning darker or black, whether used alone or mixed with others.

Finally, a color may undergo slight alterations as a result of possible chemical reactions between the layer of protective varnish and the underlying color. This possibility will be dealt with in depth in the next chapter.

Painting Techniques and Practice

Preparing the paint according to the ingredients, supports, primers, mixtures, impastos, glazes, and drafts. Techniques for applying color. New artistic procedures: collages, surfaces, industrial materials, etc.

Many physical and chemical alterations come about as a result of mistakes both in the way the materials are treated and in pictorial practice—mistakes made all the more easily either because of the many different ways of preparing the supports and of applying color to them or because of the different ways in which the ingredients of the paints are added together. For example, depending on how they will be used (for paintings in oils, watercolors, ink, pastels, tempera, acrylics, lacquers, etc.), the colored powders must be formed into a paste with liquid binders to make them stick together. These binders are made up of vegetable drying oils (linseed, walnut, poppyseed), gum arabic or tragacanth, glycerine, wax, animal or vegetable glues, casein, albumen, egg yolk, primer (i.e., mixed emulsion), synthetic resins, niter, or other materials. All these binders can alter the original tone of a color, giving it more or less intensity. It is generally the type of liquid used to hold the particles of pigment to each other that differentiates the artistic techniques. However, binders are not invariably used with pigments; in fresco work, for instance, the powdered colors (derived from earths or crushed stones and thus less likely to alter), having been finely ground and diluted in pure water, are applied directly to the surface of the fresh plaster.[1]

The paste, formed by mixing powdered colors with a binder, is very important since it will create different effects according to the light. Indeed, not only the quality of the binder (strong, weak, elastic, transparent, semitransparent, opaque) used for the paste but also the quantity can cause defects in the absorption and reflection of the light waves. The adhesive, which as it dries varies in elasticity, transparency, or opacity, may have an influence on the incident light, facilitating, hindering, or reducing its reflective action. The intensity of the colors thus undergoes a variation— either increasing or diminishing—so that it is necessary to calculate the extent to which this will alter in order to obtain the right tone.

Quantity control of the binder is very important because it may have a negative influence upon the adherence to the surface. A color that has been treated with a good binder, but with too much of it, may cause the painted surface to crack as it dries. If the paste contains too little of the binder, however, the paint may break up as it dries, becoming partially or entirely detached from the painting.

In order to ensure that the various coloring substances applied to many different supports (paper, board, masonite, wood panel, canvas, walls, leather, parchment, glass, celluloid, copper, or aluminum) are suitable in every respect, the artist has to carry out the process known as priming, which means treating the painting surface in a special manner that varies according to the kind of work he intends to do. It is not essential to treat the surfaces of impermeable materials (metals, glass, etc.) in order to enable the color to penetrate, but these may be prepared with a solution, commercially known as a medium, with a base of glue, honey, or oxgall; alternatively, they may be simply rubbed with pumice to give them a slight roughness.

In preparing grounds for oil painting on permeable materials, a different primer is used for each type of support. In general, however, it should be adapted to the particular needs of the colors and free of changeable substances that may, within a short period, modify the entire tonality of the painting.

Let us take as an example the traditional oil painting on canvas that has already been soaked and applied to the frame. Here the primer is made up of chalk, glue, and water and may vary (thick or very thick, rough or smooth, light or dark) according to the proportion of

[1] Plaster, which consists of sand, slaked lime, and water and is highly absorbent, allows the color to penetrate into its structure. The chemical process that gradually fixes and stabilizes the color in the plaster occurs through the action of atmospheric carbon dioxide on the lime, according to the following formula: $Ca(OH)_2 + CO_2 = CaCO_3 + H_2O$). The water ($H_2O$) evaporates and the calcium carbonate ($CaCO_3$), final product of the reaction, definitively confines the color within the plaster.

component materials and the manner in which they are used. If the primer is too thick as a result of too much chalk, it will have maximum absorptive capacity. This is inadvisable since the colors would then require too much oil, which, on turning into a resin, would cause an unpleasant yellowing effect and remove the sheen. A preparation that is too rough and uneven because of irregular chalk granules will reflect the incident rays in a nonuniform manner, taking away the color's strength and freshness, and making it impossible to paint a subject rich in detail.

After a first priming of glue, either a layer of a warm, semiliquid mixture obtained from finely ground chalk well mingled with the glue itself, or several layers of the same paste are applied to the canvas. Care must be taken to let each layer dry before applying the next; this produces a less absorbent, smoother surface, the grain of which is regular enough to take color, even for transparent effect. If, in subsequent applications, one adds a little vegetable glue and honey to the mixture, the primer becomes softer and more elastic. The elasticity of both elements, primer and canvas, is indispensable to prevent surface expansions or contractions with every change of temperature and to avoid having the colors subject to movement as they dry. Contractions of the ground cause the painted surface to crack or even the primer itself to break away from the canvas. It is highly important that the intermediate substances (chalk, glue, and water) be in the right proportions; if they are not, the painting may rot or develop mold, which comes about particularly as a result of weak, poor glues. The best glues are made from rabbit skin or from the waste of mixed skins, soaked in a *bain-marie* of water. The best chalk is that used for gliding (slaked), a very white chalk, finely and evenly powdered. The canvas itself must be strong and suitably porous, preferably of hemp (not too loosely woven) or of raw linen fiber; cotton and jute are too sensitive to water, and silk tends, in time, to split or to become powdery as a result of the action of the oils. The Venetians also use canvases with a herringbone weave, that is, with a different alternation of warp and weft, so accentuating the grain. Indeed, the choice of material for the canvas and whether it should be tightly or loosely woven will have a very definite effect on the final result desired by the artist.

Other types of ground paste also used for oil painting on canvas can be prepared with chalk, water, and vegetable glue (wheatmeal, rice, or potato flour) mixed with skin glue and a small amount of linseed

oil, sugar, or honey. This mixture, which is close to pure white, can be colored as required if mixed with powders of a red, brown, chestnut, blue, or other color. A dark, earthy primer reflects less light from the deeper layers, thus altering the various hues of the colors above and possibly causing, through too much absorption, irreparable damage, as has occurred in certain historical paintings, especially those from the seventeenth and eighteenth centuries.[1] White or gray-white grounds are best because they permit almost total reflection of the rays received and guarantee the colors better stability. Nevertheless, priming is essential for maintaining colors over a period of time; in fact, more than any other component it is indispensable to the finished result, adhering as it does to the color. A faulty preparation makes it impossible to achieve the desired color effects.[2]

[1] The same goes for varnishes worked into a colored paste as a diluent that change and darken the tones. To obtain greater fluidity in the application of an oil color, the pigment should be thinned with oleoresins (essence of turpentine and all the essential oils), which evaporate after application.

[2] The firm of Liquitex has recently introduced "Liquitex gesso" for priming various surfaces. It is a creamy, quick-drying substance, does not crack, remains stable and elastic, and can be applied in one layer (using the gesso by itself) or more (thinning it each time with water and putting a new layer on when the previous one is dry). The result is a surface that may be rough or smooth, and will take acrylic paint, watercolor, tempera, or oil. This brilliant white ground substance can be colored as required if mixed with other liquid colors.

Above: The pointillist method is unrivaled for revealing the quality of light. Here, in this example by Angelo Morbelli (*Un Natale al Pio Albergo Trivulzio*. Museo Civico di Torino), the pale, dusty ray heightens the sense of squalor of the surroundings in which the old man, forgotten, is forced to pass his bitter Christmas.
Opposite: In his choice of materials and procedures, Jean Dubuffet expresses his clear distaste for aestheticism in art (*Fleshy Face with Chestnut Hair (Head of a Woman)*. 1951. Peggy Guggenheim Collection, Venice).

The impasting of colors, or impasto, necessary for obtaining the tints desired is also extremely important. Impasto (application of paint in thick layers) entails a maximum of covering pigments, and thus, since each pigment subtracts light rays, diminishes the luminous intensity of the individual colors. This occurs, too, in the mixing of two basic colors. When two colors are mixed, the light reflected from one of them, already lacking some of the light rays, combines with the reflected light of the other, diminished in its turn by the absorption of other radiations; therefore the reflected light is reduced. The less complex the mixture, the less the tendency of the resultant hue to degenerate into black. The recommended technique, even in printing, is to use the least number of colors possible. In three-color and four-color work, when using tints that derive from mixtures of several colors, including basic ones, transparent colors are chosen so as to avoid loss of brightness.

In impasto, the colors are seen by the light reflected from them; in the case of glazing, which involves the processes both of absorption and reflection, the colors are also seen by transparency.

Glazing preserves the luminosity and liveliness of hues. This technique entails the application of a thin layer of colors, thinned in a suitable liquid, either on a white painting ground or on a sufficiently dry painted surface. It makes it possible to obtain new tonalities without mixing the colors beforehand, since by means of transparency reflected light is able to escape even from the underlying layers, resulting in marvelously fresh color effects. A thicker layer and a dark or black pictorial ground increase absorption and reduce the impression of freshness and brightness of tone. No matter how vivid they may appear, colored pigments never acquire the luminous intensity of the spectral colors. Dots or strokes of two or more colors alternating with minimal regular spaces on a surface, however, are seen by the observer (though obviously not from very close) as a single color of exceptional brilliance. This happens because the greater reverberation of reflected rays thus obtained—unlike those of impasto or glazing—excite in the eye a perceptive process of light additions, just as happens with mix-

tained when there is perfect accord between the ground and the painting; this conveys the greatest suggestion of homogeneity to the eye. Divisionism is

Left: Georges Seurat's work (such as his *Seated Model, Back*. 1887. Galerie du Jeu de Paume, Musée du Louvre, Paris) shows his very carefully thought-out use of color based on his understanding of the laws of visual perception.
Below: Giacoma Balla (*Nude at Window Against the Light*. 1908. Museo Civico di Torino) goes in for a freer form of divisionist experiment.
Opposite: For Jackson Pollock (*Alchemy*. 1947. Peggy Guggenheim Collection, Venice), the work is a "happening" in which the artist risks being involved haphazardly.

tures of spectral color.[1] Certain painters developed special techniques based on this scientific principle, juxtaposing dots (pointillism) or parallel or crossed lines (divisionism) of pure colors, arranging them according to the laws of contrasted complementaries. In this manner they aimed to obtain a vision of color as light. These effects of vibrant luminosity, similar to that which emanates from true light, are the essential feature of the colors of divisionist painting.

In divisionism the preparation of the ground is of paramount importance. The artist may use either a pure, very luminous color (yellow, yellow-orange, light azure, or even white) or an unsaturated color (grayish green, grayish azure, or gray) in such a way that it lends itself to subsequent application of lighter or darker zones of color. The maximum vibration is at-

[1] It was Johann Heinrich Lambert who, in the second half of the eighteenth century, pointed out the diverse nature and behavior of spectral lights and colored substances. And it was the physicist Mile, in 1839, who conceived the idea that by juxtaposing minute areas of complementary colors it was possible to achieve effects analagous to the mixing of spectral lights.

a painting technique, but its theoretical foundations, as we have already noted, are scientific, and will be included in that respect in the subject matter of chapter seven.

Instructions as to the use of color include technical advice on the different ways a pigment can be applied by varying the brushstrokes (which can be normal, long, sparse, or dense) in one thick layer or with several superimposed layers, giving an almost plastic effect. Even with the same color different results can be obtained depending on the characteristics of the stroke.

If one wishes to lighten full-bodied opaque colors (oil, tempera, or other glue colors), these must be laid on thinly. If applied with regular brushstrokes until the maximum color intensity is reached, this cannot be increased subsequently by adding more layers. In fact, the effect would be quite the reverse—a blackening. Indeed, if two or more layers of an opaque color are applied to the same area, the thickness may prevent some of the light rays from penetrating deep into the painting—rays that would normally then be reflected back—thus producing an undesirable absorption of other rays. This will reduce the reflection and luminous intensity of the hues, which will take on a less vibrant coloration and tend to become darker. The importance of the initial preparation of the underlying surface cannot be overemphasized, both for achieving the desired effects and for ensuring that the

work itself will last. A thorough understanding of colors and how they are used is also, of course, imperative. Choice of colors and artistic procedure are preliminary problems that the artist must resolve before setting to work on any painting project, whether the aim is to obtain a harmonious, colorful, and disciplined result employing traditional techniques, or to go for bolder effects through the use of dazzling new colors produced by modern chemistry and contemporary methods of work.

Art must always be supported by technique. Teaching how to use color also includes techniques and individual styles of painting, for there will be a considerable variation in the tone of a color depending on the instruments used (round or flat brushes, hard or soft bristles, spatulas, pads, sponges, sprays) as well as the procedure (pictorial practice). Even when the same instruments are used, a color can take on considerable—sometimes surprising—variations depending on the artist's strokes. Such strokes may be horizontal, vertical, oblique, radiating, undulating, or spiraling and may be applied with a sweeping, easy, confident movement or in a labored, mannered fashion. The colors may be light or dark, dull or bright; the touch, whether in continuous or broken lines or in masses, may be light or incisive. The particular manner employed and the diversity of colors used produce determined effects and reveal the personality of the artist. In this context, Italian art critic

and historian Giulio Carlo Argan writes of color: "It is a reality in which the artist works and, by working, identifies himself. Of all real materials, however, the pictorial is the most sensitive and impressionable, the quickest to absorb the inner impulses which the artist, by handling it, transmits." Later he adds, "but it is not the underlying layer of the unconscious, it is the artist's entire physical and mental existence that is involved in the rhythm of this action."[1]

The different qualities and appearances of a color depend on both the light in which the work is seen and the technique that has been employed. As far as methods are concerned, modern painting techniques are more varied and versatile than traditional ones.

In the early years of the twentieth century, with the advent of cubism and futurism, many artists veered away from late romantic forms and from all classical themes, aiming at an artistic renewal. They tried to

Above: This work (Enrico Prampolini. *Polimaterico*. Private collection, Michigan) is an example of how a happy compositional fantasy can result from the use of the most disparate materials and colors.
Opposite: Lucio Fontana (*Tela Tagliata*. ca. 1960. Private collection) synthesizes the interplay of light and shadow with that of the directions of force by means of his now-famous cuts on canvas.

avoid the limitations imposed by the art of the past, which they saw as only reflecting pictorial vision and the exterior form of reality without penetrating its essence. A new school of thought appeared: a union between works of art and existentialist practices summarized in the philosophy, "Art is life and life is art." The picture, in fact, was no longer a representation of a given object; it had become an autonomous creation in its free choice of expression and means. Many painters composed pictures by putting together pieces of paper, tram tickets, empty wrapping papers, differently sized printed letters, scraps of material, bits of photographs, cuttings from magazines,

[1] Giulio Carlo Argan. *L'Arte moderna 1770–1970*. Florence: Sansoni, 1971, pp. 709, 713.

newspapers, calendars, and other sundries, linking them with graphic symbols designed to give unity to the whole composition. Such "collages" were intended to involve the public in the phenomenon of art. The French painter Francis Picabia (1879–1953), for example, creating a landscape with broomsticks, corks, and goose quills, seemed to want to persuade the spectator that anyone could produce objects of art by using everyday materials.[1] On such principles as

"the material as an element with its own significance," color loses its traditional role, and the artist works directly on the most varied substances, among them gesso and sand, on which the drabbest and thinnest mixtures of colors may be applied. Enrico Prampolini (1894–1956), an Italian artist and art theoretician, was the precursor of this "polymaterial" technique. Using this method the artist divests the pigment of its original brilliance, obtaining a plain, restrained coloration devoid of splendor, which is his way of cutting himself off from all previous experiments with color and giving expression to his own

[1] See Corrado Maltese. *Le tecniche artistiche*. Turin: Mursia, 1973, p. 505.

Surprising results can be made with the most ordinary materials. Above: Alberto Burri (*Sacco e Rosso*. 1956. Galleria Blu, Milan) achieves delicate color effects by combining wood and coarse canvas; below: Daniel Spoerri (*Tableau-Piege*. 1966. Galerie Mathias Fels, Paris), by the shrewd arrangement of ordinary small objects, composes a picture that is reminiscent of the atmosphere of certain Flemish "interiors." Opposite: An example of obsessive repetition, possibly a protest against the "consumer society" (Andy Warhol. *200 Cans of Campbell's Soup* (detail). 1962. Private collection, Colorado).

artistic fantasy to create something new and personal. According to these new conceptions, the picture becomes, above all, a problem of surface, which, owing to the color and the rough and bulky nature of the materials used, arouses in the observer a mass of tactile sensations. In addition, this combination of the most varied materials also creates the suggestion of space. In fact, the interplay of light and shade brought about by the different thicknesses of the materials and the diverse types of finish (weave or texture) of their surfaces creates spatial effects that enable painters to escape from the traditional methods of representing space (gradations of color, rarefying of detail, distributing elements of the picture on different planes, and applying the rules of axonometric projection and perspective). Instead the artist can employ methods calculated to appear more relevant to the observer in relation to the complex culture of the modern world.

The problem now is whether we can still talk about technique in the traditional sense. The Italian painter Corrado Maltese suggests that the term "procedure" better describes the manner in which modern artists tackle their work. On an artistic level, the choice of term depends largely on the individual artist's ability to make the aesthetic and emotive aspects of each

different type of material stand out in its own right yet at the same time blend in with the others to form an artistic whole. Using materials and objects for their own sake in an artistic context is to invite the observer to see them in a completely new way, divorced from their normal purpose. Whether or not the artist manages to convey this experience in all its representational, allusive, and evocative detail depends in part on the sensitivity and imagination of the observer. It may be opportune here to allude to the famous episode of the *madeleine*, which, one fine morning, almost accidentally triggered off the complex psychic process that stimulated Marcel Proust to write his famous novel *Remembrance of Things Past*. The following passage from a book by Gyorgy Kepes attempts to define the nature of the complicated psychic rapport between the work of art and the observer, which may even be influenced by the quality of the texture of the various materials: ''On the model of avant-garde photographs, painters are beginning to assimilate the inherent textural quality of each material in the pictorial image. This new sensorial property enriches the picture because the texture has a special dimension. The particular rhythm of light and shade which renders it visible is beyond our capacity to distinguish in any form of visual organization or in terms of modeling by means of shading. The sensory impulse of its delicate grain can be comprehended only in terms of its structural correspondence to other psychic sensations. The texture of the surfaces of grass, of cement, of metal, of jute, of silk, of a newspaper, or of a fur, with their strong suggestion of tactile quality, provides us with a visual experience that is a kind of mixture of sensory impressions. We do not see light or dark, but the quality of softness, coldness, roughness, or calm; sight and touch are fused into a single whole.''[1]

In addition to traditional painting techniques and the imaginative combination of a variety of different materials, there are the techniques made possible by new chemically produced plastic substances. These come in different forms—shiny, opaque, spongy, rough, semitransparent, transparent, highly transparent—all capable of being reduced by lamination to any required shape or thickness, including the thinnest of sheets, either flat or undulating.

Plastic (like steel, aluminum, iron, zinc, wood, rubber, and glass) is used for both practical and artistic purposes; it has physical advantages and the ability to challenge an artist's imagination. Because it is so thin and easy to handle, plastic is ideal for three-dimensional creations and for transforming flat surfaces into curves. Painting and sculpture are no longer separate entities, so that we can now talk of them in terms of synthesis. Architecture is also involved, with the innovation of new types of wall coverings in laminated metals or plastics (opaque, smooth, rough, transparent, uncolored, or easy to color), which generate a large variety of light and color effects. Another material linking architecture with the closely related arts of painting and sculpture, is glass, which, when suitably treated, takes on a solidity greater than steel. Used in interiors, for dividing panels and doors, the varied reflective qualities of glass obviously have decorative as well as structural value, providing opportunities for imaginative lighting and ornamental effects; and because of its transparency it can link and enhance internal and external forms, creating suggestions of space.

Many artists, seeking originality and spurred on by new stimuli, disdain the traditional trappings of canvases, colors in tubes, and brushes. Instead of the usual palette mixtures, they choose unconventional mixtures of materials, finding new and surprising solutions for both technical and representational work. Artists who carry out such experiments are not only looking for unusual techniques or special aesthetic effects, they are often responding to the social and cultural demands of present-day reality. For example, the obsessive repetition of objects and human forms may be designed to emphasize the alienation of man in modern-day society; the repetitive use of the most ordinary objects, such as toothbrushes, toothpaste, lipstick, telephones, soup cans, and cigarettes, may also signify rebellion against materialism and consumer values. In a more positive sense, the exhibition of other objects, such as rocks, earth, water, and clouds, perhaps expresses aspiration for an uncorrupted reality, prohibited by social structures.

[1] Gyorgy Kepes. *The Language of Vision*. Chicago: Theobald, 1944, p. 166.

Visual Apparatus

Notes on anatomy and physiology. Theories of light and color vision: Hering and Young-Helmholtz. The most recent hypotheses. The primary spectral colors: Helmholtz's three-color theory. The CIE triangle. Luminosity of various radiations. Additive mixture of colored lights and subtractive mixture of colors. Metameric mixtures. Anomalies of vision. The paths of visual perception from the eye to the brain. Vision as formed in the brain. Interaction of immediate and acquired sensory perceptions

No one is surprised by the statement that colors cannot exist without light; it is equally undeniable that the eye is necessary for perceiving both light and colors. Students of physics, anatomy, and physiology have all investigated the complex phenomena relating to light, the eye, and the interactions between the two.

Notes on the Anatomy and Physiology of the Eye

The human eye, situated in the orbital cavity, is approximately the shape of a sphere (fig. 5-1), with a sideways diameter of about 22 mm and a diameter from back to front of about 26 mm. It consists of an outer membrane called the *sclera*, thick and strong, opaque white in color. The front part of the sclera is transformed into a transparent membrane called the *cornea,* more convex than the sclera and bulging slightly. The cornea completes the covering of the eye, and through it enters the light rays. On the inner surface of the sclera are the *choroid,* rich in blood vessels for feeding the structures of the eye, and the brown, almost black pigments that perform the function of a *camera obscura,* eliminating weak reflections of luminous rays inside the eye. The anterior part of the choroid, equipped with ciliary muscles, terminates in the *iris*. The iris has a central circular opening, the pupil, which appears black because of the eye's dark background. The sclera and the choroid in the posterior part are penetrated by the optic nerve, which originates in the eye cavity in the form of a highly delicate membrane, the *retina*, which contains the receptor cells and covers the rear two-thirds of the choroid like a cup, extending forward to the junction of choroid and iris. Located on the retina, opposite the pupil and very close to the optic nerve, is a small area, 2 mm in diameter, called the *macula lutea* (yellow spot). This surrounds an oval depression, the *central fovea,* the most sensitive part of the retina—the seat of clear vision. The part where the nerve fibers of the retinal cells come together to form the origin of the optic nerve is devoid of photoreceptors, and so is called the blind spot, or *optic papilla.*

After the light rays enter through the cornea, but before they reach the retina, they pass in turn through three refracting mechanisms which constitute the optic system of the eye: the *aqueous humor,* the *crystalline lens,* and the *vitreous humor*. Each of these mediums has a different density (always higher than that of air), which influences the velocity of the light and so increases the convergence of the rays on the retina. The aqueous humor occupies the anterior chamber of the eye, situated between the cornea and the crystalline lens. The liquid is clear and colorless, and is renewed every four hours.

The crystalline lens, which is transparent and has the shape of a biconvex lens, being more convex on the posterior surface, is positioned vertically and separates the eye's other two refracting mediums. The lens is contained in an elastic membrane attached to the ciliary muscles. The convexity of the lens varies according to the contractions of the ciliary muscles, modifying the focal distance so that the image formed on the retina is clear regardless of the distance of the objects observed. As the years pass, the cells that compose the lens begin to harden, and the lens loses elasticity; as a result, it becomes more and more difficult to get images into focus.[1]

[1] The accommodation of the lens, because it requires muscular activity, may be a cause of tiredness. The minimum distance at which the normal eye can look, without tiring, is about 25 cm. The closest point brought into focus by accommodation is called the *near point* of vision, and this gets farther from the eye with the passage of years. For example, at ten years the near point is about 8 or 9 cm, at twenty it is about 15 cm, and after the age of forty-five it has receded so far as to make it difficult to read without the aid of glasses with convex lenses (*presbyopia*). The most distant point brought into focus is called the *far point*. The distance between the two points is the so-called *accommodation distance*. A normal subject (*emmetrope*) has an accommodation distance that ranges from 17 cm to infinity, while a nearsighted, or *myopic* person can see from 17 cm to a limited distance.

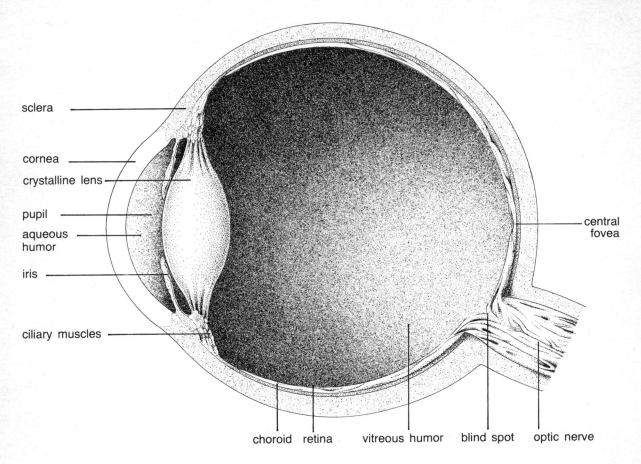

sclera

cornea

crystalline lens

pupil

aqueous humor

iris

ciliary muscles

central fovea

choroid retina vitreous humor blind spot optic nerve

The vitreous humor is a jelly-like substance contained in a very thin capsule called the yellow membrane, which is firmly held by the ciliary muscles; it occupies the posterior (and largest) chamber of the eye.

Among the accessory structures of the eyeball are the *extrinsic muscles* of the eye and the *lachrymal glands*, situated in the orbital cavity, and the eyelids, located in front of the eyeball. The extrinsic muscles, able to move voluntarily, serve to move the eye in various directions. The lachrymal glands, located above and to the outside of the orbital cavity in relation to the eyeball, secrete tears, a watery liquid mainly composed of sodium chloride and bicarbonates. The tears travel toward the inner corner of the eye into a small cavity called the *lacus lacrimalis*, and from there into the nasal sac; by way of the nasolachrymal duct, they reach the lower ducts of the nasal cavities, where they evaporate. The function of tears is to keep the surface of the eye moist and bar entry to foreign bodies (motes, bacteria). When we cry, tears are produced so abundantly that they flow outside onto the cheeks.

5-1. Above: Anatomy of the eye

5-2. Opposite, above: The two layers of nerve fibers composing the iris, seen at the instants of myosis or contraction of the pupil (a) and mydriasis or dilatation of the pupil (b). When the circular fibers of the first layer contract, the pupil also contracts; when the radial fibers of the second layer contract, the pupil dilates.

5-3. Opposite, below: Free compositions inspired by the contraction and dilatation of the circular and radial fibers of the iris

The eyelids, by closing and blinking, protect the eye from foreign bodies and from becoming too dry; in fact, their movements help to distribute the lachrymal secretion uniformly over the anterior surface. The eyelashes, situated at the outer edges of the eyelids, protect the eye from motes and sweat.

Having provided this general information about the eye, we will now examine the iris and the retina in greater detail.

The iris, which makes up the terminal part of the choroid, is a thin, circular diaphragm with a hole in the

center (the pupil) situated between the cornea and the anterior surface of the crystalline lens. It is formed of smooth muscle fibers arranged in two layers, the front one of circular fibers, the rear one of radiating fibers; as they contract, the former cause the pupil to shrink, while the latter dilate it (fig. 5-2). In this way, the iris regulates the entry of the light, much the same way as does the diaphragm of a camera. The size of the pupil varies considerably according to the light intensity, ranging from a diameter of 2 mm to about 7.5 mm. When intense light strikes the retina, the pupil shrinks (myosis); when the eye passes from illuminated surroundings to a darker environment, the pupil dilates (mydriasis). If, however, the light intensity varies gradually, so that the retina can adapt to it by degrees, the diameter of the pupil changes little if at all. Very strong bright light immediately provokes a marked myosis, but then the pupil gradually relaxes as the retina adapts to the intensity. Evidently the modifications of the pupillary opening depend more on the suddenness of the light variation than on its intensity.

71

The pupil also contracts and dilates for other reasons: it becomes myotic when the eye accommodates itself to close objects by increasing the depth of the visual field, with a consequent greater clarity of image, and during deep sleep, through the action of morphine and strong doses of cocaine, or under ether or chloroform anesthetic; it becomes mydriatic in states of emotional stress, in grief, anxiety, or fear, as a result of shock or sudden and intense acoustic stimulation, and through drugs and poisons (such as small doses of cocaine, alcohol, nicotine, or atropine).

The back of the iris is provided with cells containing numerous colored pigments that make it appear opaque. These pigments form only after birth. Thus, just as the sky seems blue on the black ground of cosmic space, the iris of a newborn baby appears deep blue. The color of the pigment in the iris, as in almost every other part of the human body, varies mainly in relation to genetic factors and to the intensity of light, and may undergo slight changes as a result of alterations in diet or state of mind. The diverse colors of the iris have always intrigued and fascinated artists, scholars, writers, and lovers, and its geometrical shapes have stimulated creative fantasies throughout history (figs. 5-3 and 5-4).

5-4. Free compositions inspired by the contraction and dilatation of the circular and radial fibers of the iris

The retina forms the internal coating of the eye cavity and is composed of ten layers; the most important layers are those of the cones and the rods, of the bipolar cells, and of the ganglion cells. The cones and rods, which contain the photosensitive pigment, are the receptor cells (sensitive cells) and are situated on the pigmented layer of the choroid nearest the retina. This layer absorbs the light rays and prevents them from reflecting onto the retina, which would cause the image to appear less distinct. The centripetal prolongations of the cones and rods terminate in synapses on the apexes of the bipolar cells, which connect in their turn, also through synapses, with the ganglion cells. The fibers that stem from the latter (terminal fibers) come together to form the optic nerve, which carries all the nervous impulses produced by the sensory cells to the centers of vision located in the occipital lobes of the brain (fig. 5-5). Since the optic nerve is formed of some 400,000 nerve fibers and there are approximately 6 million cones and 120 million rods

in the human eye, it follows that many receptors converge, through the bipolar cells, on single ganglion cells (about 340 on each). The exception is the fovea, which contains only cones; as we shall see, each cone connects with a single bipolar cell, which connects in turn with a single ganglion cell, and therefore each cone is connected to a single fiber of the optic nerve. Outside the fovea, rods and cells are variously mixed. The farther they get from it, the fewer the cones, while the rods become ever more numerous; finally, in the outermost zones of the retina, the cones are the only sensitive elements. The terminal part of the photoreceptors subdivides into a series of parallel disks containing photochemical substances known as photosensitive pigments.

The pigment of the rods is called *rhodopsin* and that of the cones *iodopsin*. Rhodopsin, also called visual purple, is composed of two substances, *scotopsin*, a protein, and *retinene*, of a prosthetic group. Under the action of light, rhodopsin undergoes a chemical transformation, as a result of which the receptor cells (rods) are excited; this stimulation is transmitted in the form of nervous impulses to the central nervous system. The process concludes with the dissociation of the scotopsin and retinene and the consequent modification of the red color of the rhodopsin, which changes to orange, then to yellow, and eventually turns colorless (the bleaching phenomenon). In the course of this progressive discoloration of the rhodopsin, the eye becomes less sensitive to light (adaptation to light). In darkness, part of the scotopsin is regenerated and part of the retinene is reduced to vitamin A, which recombines with scotopsin to form rhodopsin; the reconstruction of the rhodopsin restores the retina's sensitivity (adaptation to dark). The bleaching of the visual purple is in direct proportion to the extent of separation of the purple, itself a process conditioned by the quantity and quality of the light absorbed as well as by the wavelength. The light rays principally absorbed by the rhodopsin—and hence most active in the discoloration process—are in the middle part of the spectrum (green zone). Rhodopsin has a greater photochemical sensitivity than iodopsin, therefore the stimulation threshold of the rods is lower than that of the cones. Furthermore, the rods are interconnected in large groups: in this manner the actions of a large number of receptor cells are combined, and consequently there is a greater capacity to perceive minimal intensities of light (crepuscular, nocturnal, or scotopic vision). In fact, the adaptation of the retina to nocturnal vision and the

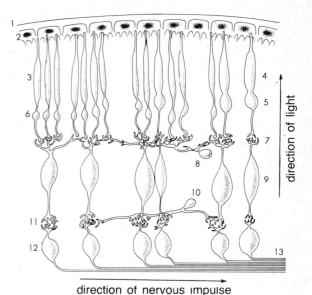

direction of nervous impulse

5-5. Diagram of the structure of the retina: 1) choroid; 2) pigmented epithelium; 3) and 4) sensitive epithelium (layer of rods and cones); 5) nucleus of cones; 6) nucleus of rods; 7) synaptic layer; 8) horizontal cells; 9) layer of bipolar cells; 10) inner associative cells; 11) synapses; 12) layer of ganglion cells; 13) fibers of optic nerve that carry the impulses to the brain

consequent increase in sensitivity to light is greater toward the periphery of the retina, where there are only rods. The spectral sensitivity of the rhodopsin is particularly high in the green zone: it corresponds with the wavelengths that act more intensely in the chemical sense, and is progressively reduced by longer or shorter wavelengths, toward yellow and toward violet; however, its sensitivity to red is completely extinguished. Since the rods, if observed in dim light, simply receive sensations of light and not of color, even their zone of greatest sensitivity, corresponding to green, will appear colorless and lighter than all the others. The cones are adapted to receive a high level of luminosity (diurnal or photopic vision) and therefore, being predisposed to color vision, perceive qualitative and quantitative differences of light within the visible waves. The cones also possess achromatic sensibility. The behavior of color vision varies according to the area of the retina that is struck (foveal, extrafoveal, or peripheral) and the extent of the areas stimulated. From the results of experiments, it has been verified that the field of vision is wider for a white than for a colored stimulus and that the limit of its extent varies from color to color. The field of vision for green is smaller than for other colors.

Iodopsin, the visual substance of the cones, which breaks up through the effect of light, is constituted, like rhodopsin, of retinene and a protein, this one known as *fotopsin*. In some ways the behavior of iodopsin is different from that of rhodopsin, both in respect of the intensity of light striking it and the greater speed with which the photodynamic substance is regenerated.[1] In fact, unlike rhodopsin, iodopsin is hardly sensitive to lights of low intensity. In full light, its greatest spectral sensitivity is in the region of yellow, whereas that of rhodopsin, in reduced light, is in the region of green. In contrast to the rods, the color sensitivity of the cones also extends to the red zone, the radiations of which are perceived as colored (red).

The curve shown as V′ in figure 5-6 demonstrates how the sensitivity of the rods varies according to wavelength. Its apex corresponds to 505 mμ, the most effective radiation for stimulating the rods (this wavelength always appears colorless but brighter than almost any other of comparable physical intensity). The sharp decline on each side of the apex indicates the rapid lowering of the capacity of the remaining radiations to stimulate light sensations. In order to be seen, these must possess a higher intensity; otherwise, being of the same physical intensity as the greens, they remain obscured. The curve marked V in the figure refers to the spectral sensitivity of the cones. Its maximum corresponds to 555 mμ; therefore, this radiation, when sufficiently intense to stimulate the cones, appears not only colored (yellow-green), but considerably more luminous than other wavelengths of equal physical intensity. The two curves depict the international visual standard adopted in 1931 by the CIE (Commission International de l'Eclairage): the photopic (curve V) and the scotopic (curve V′). These graphic standards obviously do not represent the visual faculty (of incalculable variability) of every individual, but the average deduced by an international poll of a large number of subjects.

The term *acuity of vision*, or *visus*, denotes the capacity of the normal eye to see separately the images of diverse stimuli that are close in space or time. Spatial acuity of vision varies in the different parts of the

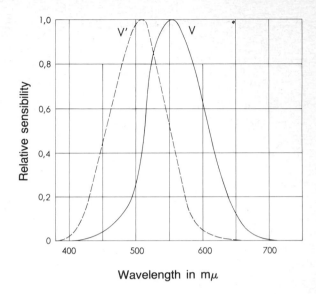

5-6. Curve of spectral sensibility in relation to rods (V′) and cones (V)

retina. It is at its maximum in the fovea (direct vision). Here there are only cones, and cones are given the task of perceiving the finest details, inasmuch as each one sends its message through its own fiber to the central nervous system. The farther from the fovea, the less the acuity of vision; the images that form on the peripheral zones (indirect vision) lack definition. Such zones are occupied mainly by rods, which are not connected directly by an individual fiber to the central nervous system but come together in groups in single ganglion cells, from which stem the nerve fibers that converge in the optic nerve. Thus the sum total of the differentiated impulses from many rods is concentrated in a single cortical cell, which translates the object seen into a complete image. In compensation, the fact that many stimuli are transmitted into a single cell by rods arranged in this manner is advantageous in poor light conditions, since at night a series of weak lights indicates an obstacle more effectively than one more vivid light.

To conclude, it is fair to say that although the visual acuity of the rods may be inferior, they play a part in broadening and integrating central (foveal) vision. Indeed, it is the rods that pick up the peripheral signals and movements, so triggering the reflex that attracts our attention to these and, if need be, brings the images into focus. Obviously, for those whose central vision is severely damaged, the complementary activity of the rods is exceptionally important in compensation.

[1] The different regenerative speed of the pigments of cones and rods appears in the process of adaptation, as one passes from light to darkness and vice versa. Whereas the cones require only about two minutes to adapt to the dark after a light stimulus, the rods need some thirty minutes or more, adapting more gradually and rather slowly.

Theories of Color Vision: Trichromatic, Polychromatic, Opposed Pairs, Stages

Our understanding of iodopsin, the colorless photodynamic substance of cones, more recently discovered than rhodopsin, is not yet complete. We refer here to opsins because it is assumed there are more than one; the ability of each of these to react most effectively to different wavelengths seems to be why we can distinguish different colored lights. Consequently, it would be logical to assume that there are as many photosensitive substances in the cones as there are fundamental colors. However, this matter has given rise to much controversy, and even now it appears that the last word has not been spoken.

Around 1860 Thomas Young advanced the theory, that there were three distinct types of cones (to which are connected three different types of nerve cells in the cerebral cortex), all capable of being excited by any kind of radiation, but each having a different level of energy in response to various wavelengths. According to its specific sensitivity to short, medium, or long waves, each type of cone would be responsible for the perception, respectively, of the colors of blue-violet, green, and red. The Young-Helmholtz theory regards all the other perceived colors as the result of the sum total of the most varied stimuli on the three groups of receptors (cf. fig. 1-3, page 14), preordained to see the three aforementioned colors (defined as fundamental or primary colors).[1] This theory, however, was met with skepticism by other researchers. Some claimed that there was only one type of cone, others that there must be a fourth type (as in Hering's theory) specifically sensitive to yellow. (In Helmholtz's theory, yellow is instead the result of the simultaneous stimulation of the red and green receptors.) More recently it has been demonstrated that there are many varied types of photosensitive substances associated with the different cones, but grouped into three distinct categories.

Today there is general agreement as to the existence of three principal types of cones, relating to red, green, and blue;[2] but six types of cells are recognized in the cortical centers upon which the incitement of the light stimulus produces opposite effects pertaining to the colors red/green, blue/yellow, and the light/dark binomial (Hering's phenomenon of opposed pairs).

Helmholtz's thesis (which, like most theories about the cortical organs of the perceptive process, stems from the observation of visual phenomena) offers plausible hypotheses concerning the nerve structures involved. Some experts agree with Helmholtz, others disagree. But more than any other discovery made or thesis proposed, the Young-Helmholtz trichromatic theory remains broadly valid as far as the outermost part of the visual system—receptor cells (cones and rods)—is concerned. If, however, the more internal features of anatomy and phsiology—central parts (thalamus and cortex)—are taken into consideration, then the theory put forward by Hering to explain the perception of the four primary colors still retains its plausibility even today. By and large, the most up-to-date theory is the "stages" theory, because it combines the theories of Helmholtz and of Hering, but at different levels (receptors/cortex).

The primary colors of the trichromatic theory, when mixed additively, produce new colors: red and green give us yellow, green and blue-violet produce cyan, and blue-violet and red-orange produce gradations of purple-red or magenta. The color tone thus obtained is identified by the respective dominating wavelength. Purples are the exception to this rule, since they do not exhibit corresponding wavelengths in the series of spectral colors, and are thus defined by their complementary wavelengths.

The three primary radiations projected on the same point of the screen in determined proportions gives white light, equal to that produced by the sum of the spectrum's visible radiations. The light remains white, even when some rays are eliminated, provided that the quantity of other component radiations is conveniently varied. Helmholtz demonstrated that it can also be obtained by combining only two rays in adequate proportions, which are therefore complementary to each other. In the visible spectrum we can have an unlimited number of complementary pairs because it is always possible to unite one color with another that contains the necessary wavelength and light intensity to form white (for example, blue-violet 470 mμ and yellow 570 mμ, or cyan-blue 480 mμ and yellow-orange 580 mμ). Only the greens between 500 and 565 mμ have no spectral complementaries, and these give white light by combining with purple-reds or magenta, which, as we have said, are not monochromatic or pure spectral colors.

[1] When we speak of primary, fundamental, or principal colors, this does not refer to the physical characteristics of the various electromagnetic waves but to the perceptive effects they produce on the visual system, particularly in relation to the peripheral or retinal receptors.

[2] "Blue" and "violet" are used without differentiation in the trichromatic theory.

The sum of two colors with a similar spectral wavelength gives a color midway between the two, strongly and often completely saturated (spectral): violet and blue give us an intermediate indigo which is wholly saturated; red and yellow give us a pure orange; and so on. However, there are cases in which the sum of two colors of a determined wavelength does not give a pure intermediate color, but produces a more or less unsaturated color that provides the sensation of a mixture of white light with a spectral color.

The CIE Triangle

In order to identify immediately the wavelength of a given color and its degree of saturation, reference is made to a flat, horseshoe-shaped diagram, proposed and worked out by the CIE in 1931.

This diagram is useful for anyone engaged in specialized scientific experiment and industrial measurement. The "horseshoe" represents the pure (spectral) colors, and inside it are situated all the nonspectral colors that are physically possible to realize. In the center, point C indicates the position of white light—the light supplied by the source.[1] This is the "chromaticity diagram" or the "CIE triangle," so named because of its almost triangular shape. The diagram, drawn on the system of Cartesian coordinates (chromaticity coordinates x and y), makes it possible to locate the position of every color arising from the mixture of two or more colors within the given space (fig. 5-7). The colors that appear most saturated are arranged along the outer edge of the triangle, according to their respective wavelengths, ranging from 400 to 700 mμ. If two radiations of a different wavelength are added together, an even more saturated color may be obtained if both components are situated along the straight line of the horseshoe (from 700 to 500 mμ). If one component is below 550 mμ the result will be a less saturated, nonspectral color, as found inside the diagram (see various examples in fig. 5-7). If two monochromatic radiations passing through point C are combined, for example 490 mμ and 610 mμ, the color obtained appears as white light (that is, achromatic), identical to

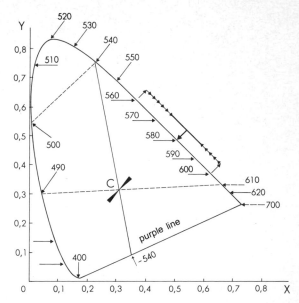

that from the source C. Almost any other mixture of colors found at this point will be "achromatic"; any two colors at the tips of any segment that passes through C will be "opposed" or "complementary." The purples are not present on the rim of the horseshoe because they do not correspond to any spectral radiation. Being products of the mixture of violet (about 400 mμ) and red (about 700 mμ), they are to be found on the segment connected by the tips of the horseshoe: this is called the *purple line* or *magenta line*. When a color of the purple line, nonspectral, is mixed with an opposed spectral color, the result is also an achromatic color, and to indicate the fact that they are complementary it is customary to mark the wavelength of the spectral color with the minus sign, such as has been done with the red line on figure 5-7 marked −540. From the chromaticity diagram it is possible to find out the dominant wavelength of the composite nonspectral colors present at different points inside the horseshoe, deducing from this also the degree of purity or saturation, which will increase or decrease according to their distance from the curve of spectral colors (fig. 5-9).

All this information can now be checked by examining the colored CIE diagram (fig. 5-10). From this it is clear that by mixing three very different colors with one another, for example a dark blue-violet of about 400 mμ of the spectrum, a green of about 520 mμ, and a red of about 700 mμ (conventionally taken to be primary colors), it is possible to obtain virtually all colors, even an achromatic color, except for those with the vertices of 400, 520, and 700 mμ, outside the triangle but still inside the diagram.

[1] The most commonly used artificial light source (the incandescent lamp) emits a white light tending to red, which is called source A. With suitable filters this can be made decreasingly red (source B), and culminate in natural light or white light (source C). According to the tendency of white toward blue, the light is defined with numbers indicating the temperature of color (degrees Kelvin), which are used mainly in photography. The space around point C includes, in different positions, all the other whites (see fig. 5-8).

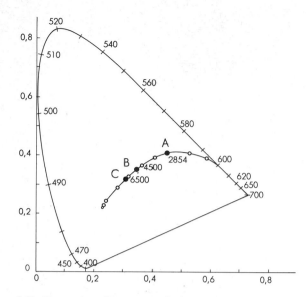

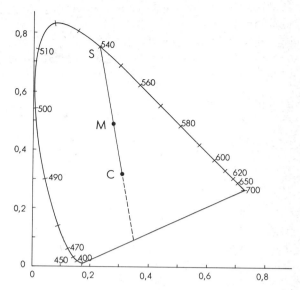

5-7. Opposite: Diagram of chromaticity. The curved line indicates the place of the colors of the spectrum within its visible limits. Point C represents white light emitted by a standard source called C. The mixing of two colors can sometimes give a completely saturated new color, that is, an intermediate spectral color (between 560 and 600), or it can produce a color that is still intermediate but unsaturated (540 and 500); at other times it may give the achromatic (between 490 and 610) and, finally, the purple colors that are not found in the spectrum (from 400 to 700).

5-8. Above: The CIE, in 1931, defined the trichromatic values of the three standardized illuminants A, B, and C, indicating their respective points on the diagram. These illuminants are also defined with measures of temperature (degrees Kelvin) as the color of their light corresponds to that of a body heated to the temperature indicated. Thus the illuminant A will also be described as having the "color temperature of 2854°K," B "4870°K," and C "6770°K."

5-9. Above, right: To examine a color that lies inside the curved triangle, for example, at point M, we have to determine the wavelength of the place on the edge where it meets the extension of the line M–C, in this case 540 mμ.
All the points along this line have the same dominant wavelength of 540 mμ, but the saturation of the color, called colorimetric purity, will decrease from S (100%), becoming 40% at point M and reaching saturation zero at point C.

The construction of this type of color triangle is not based on any of the theories of color vision but is purely experimental. All the best-known systems of color reproduction (printing, photography, cinema,

and television) use three fundamental colors. The fundamental colors employed in a particular system (a triad that can differ from the one mentioned above, provided it is formed by colors that vary greatly from one another) can be represented by three points in a CIE diagram, and the gamut of colors reproduced by the system lies inside the triangle connecting these points (fig. 5-11).

The CIE triangle, as we have seen, makes it possible to specify the chromaticity of the color, and consequently its purity and saturation (equivalent respectively to the "hue" and "chroma" of the Munsell system). In the overall definition of a color, however, the luminosity must also be taken into account.

Luminosity, as perceived by the human eye, relates to both the amount of energy contained in the radiations and the quality of the rays themselves. In fact, the retina is most sensitive to radiations of a certain wavelength, and this sensitivity decreases according to the extent of departure from this value. The luminosity of a mixture of rays is the result of the sum of the luminosities of each single ray. The comparative brightness of the various rays, as they appear to the average eye, is illustrated in figure 5-12. Here, in keeping with the physical intensity of the relative radiation, yellow (573 mμ) is found near the top of the curve (it appears very bright), green about halfway (appearing less bright), and blue very near the bottom (appearing very dark). Infrared and ultraviolet radiations are never seen, whatever their intensity, because the human eye is not sensitive enough to perceive them; consequently they do not appear on the curve.

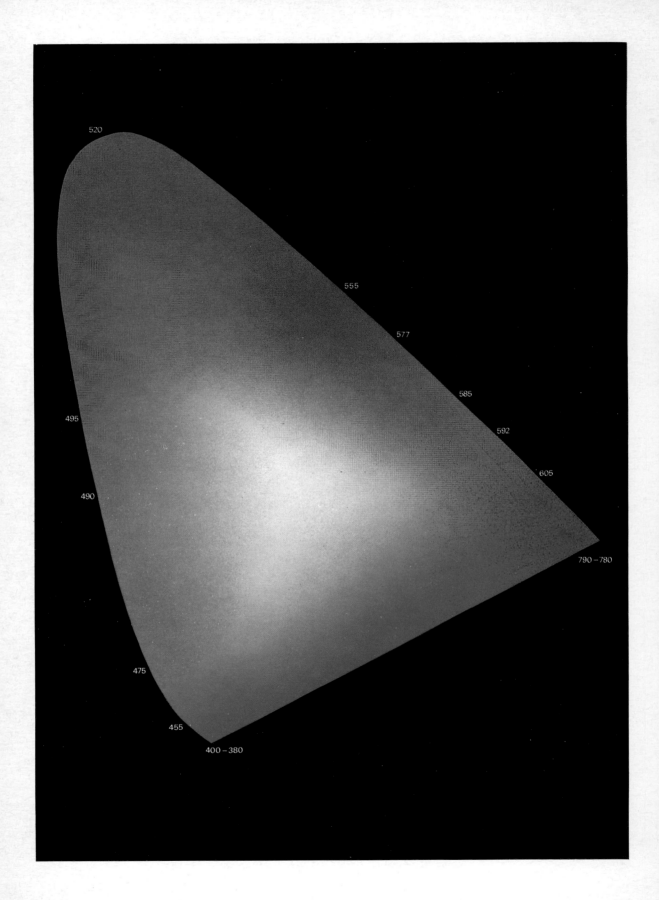

5-10. Opposite: Diagram of chromaticity. The colors represented inside and also the white can be obtained experimentally by mixing, in diverse proportions, the three primaries (violet, green, and red) that appear at the vertices of the curved triangle. For every tonality, the saturation of a color is expressed by its distance from the achromatic center of the diagram: the color becomes increasingly saturated toward the outer edge. The wavelengths expressed in mμ in the figure correspond to the spectral points that are better differentiated by color.

5-11. Right: Here we see how, by mixing three fundamental colors (not necessarily the three primaries red, green, and blue, provided they belong to their three different spectral zones), it is possible to obtain the achromatic from almost all colors, except those outside the triangle whose vertices are situated in the three chosen colors: 400-520-700, 445-530-650, and 470-545-620.

5-12. Below: The curve indicates the different grade of luminosity, as perceived by the human eye, of visible waves with the same physical intensity. Luminosity is greatest for the wavelengths included in the topmost zone and decreases from zone to zone as the curve gets lower until it becomes practically zero beyond 400 and 700 mμ.

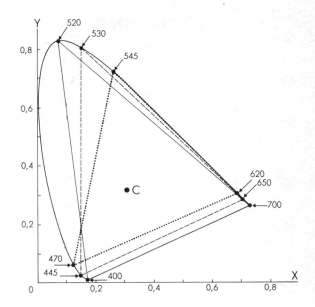

The union of colored lights produces a color in one of three ways: by *composition*, by *mixture*, or by *additive mixture*.

The term mixture is used, though improperly, also in the case of filtration, when a filter subtracts some radiations from a light passing through it, which is thus known as a *subtractive mixture*. The use of such a term is due to the fact that by mixing two pigments (for instance, blue and yellow) one obtains a third color (in this case green). Actually, what are being mixed are the substances, while the colors themselves are being subtracted, since, as we have already

seen, each of the two pigments absorbs a characteristic part of the spectrum from the white light, and what remains appears green. In fact, on mixing, the two pigments behave in much the same way as filters. A comparison of the two types of additive and subtractive mixing is illustrated in figure 5-13, a and b, in which the central overlapping area shows the results of the two processes.

Regarding pairs of complementary colors that when mixed produce an achromatic color, it is worth stressing that the same achromatic color can be effected in various ways. In other words, different spectral compositions provoke the same sensations. This phenomenon is called *metamerism*; it applies to any color, in the sense that two colors that appear indistinguishable are called metameric even if they

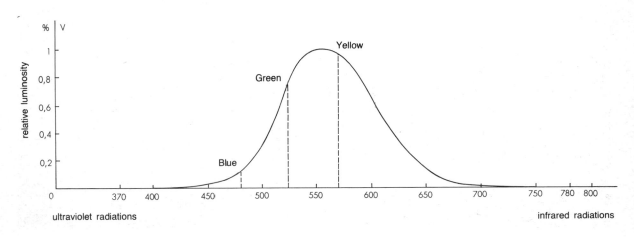

have different spectral compositions, provided they correspond to identical trichromatic values.

It is important to mention that trichromatic values depend on the illumination used. Thus two surfaces can be called metameric when they appear alike under one light yet different when viewed under another. This limitation, or incapacity to distinguish in some cases between two spectrally diverse colors, is a characteristic of the eye (differentiating it from the ear, with which it is possible to distinguish all sounds on the basis of their spectral composition, or "frequencies").

Anomalies of Vision

According to some authors, the hypothesis of three kinds of receptors is confirmed by certain anomalies of the eye, more often congenital than acquired, as a result of which color vision is in some way defective (*anomalous trichromatism*). The anomaly consists in difficulty in distinguishing two colors that normally appear very different. The most frequent is color blindness, or *daltonism*.

The daltonic eye is bichromatic because it is deprived[1] of one of the three receptors of color vision: if the red receptor is missing, the subject has *protanopia*, if the green, *deuteranopia*, and if the blue-violet, *tritanopia*.

In protanopia the long wavelengths have little effect in producing a color sensation, and the red, in relation

[1] Deprived in the sense that instead of cones sensitive to a color, there are cones sensitive only to its complementary.

5-13, a. Left: Mixture or additive synthesis of colored lights. Three projectors make the primary lights of red-orange, green, and violet converge, in darkness, on a white screen. In the central field all the colors are superimposed, and thus we see white.
b. Above: Mixture or subtractive synthesis of colors. The white square appears white because it is illuminated by a band of white light. Filters of magenta, yellow, and cyan, placed in the path of the light, modify its color, subtracting some wavelengths from the white light. The center appears black because all the wavelengths have been subtracted.

to its intensity, appears very dark, almost brown or grayish yellow; there is, however, a greater sensitivity than in subjects with normal vision (and even with deuteranopia) to shortwave rays, from the yellow on the extreme left of the spectrum to the extremity of violet, with a maximum absorption of wavelengths at 540 mμ. Probably the cones predisposed to the absorption of wavelengths about 540 mμ are replaced by others still sensitive to those of 540; in subjects with protanopia, therefore, the right extremity of the spectrum (toward red) is markedly shortened.

In deuteranopia green appears yellow or tends toward a gray if it is at a low level of saturation, and there is also reduced perception of red and orange, which also are seen as yellows of variable brightness tending toward gray. Deuteranopic subjects see only yellow and blue well; between these two colors there is a zone, the green zone, that gives no color sensation. This neutral point of the spectrum extends to the blue,

since blue-green is also generally seen as gray.

In tritanopia, a very rare anomaly, there is little or no capacity for discriminating between shortwave rays. Consequently the blue-violet zone of the spectrum appears neutral, and thus the left limit of the spectrum is shortened. In acquired tritanopia the difficulty in perceiving blue is often extended to yellow, in which case there are two neutral spectral bands. Since in both congenital and acquired cases of tritanopia subjects normally perceive the different degrees of luminosity of all the colors of the spectrum, it may be that the cause of this abnormality is simply a reduction in the number of receptors, with none of the sensitive substances of the cones being replaced.

Another type of anomaly, also reasonably rare, is the inability to distinguish any color (*achromatopsia*). This can be caused by a lack of the receptive substances in the cones, by the presence of a mixture of the three sensitive substances in each cone, or by the incapacity of the cones to react, while only the rods are active. A person affected by this anomaly will see only variations of gray, so that the spectrum appears as a scale of light and dark tones, lighter in the central part and darker on the edges. Everything will be seen in shades of black and white.

Due to individual variability in color perception, as revealed by recently conducted tests, each of the above-mentioned anomalies can be divided into two or more categories according to whether the ability to see colors is absent or merely diminished.

The capacity to distinguish or recognize colors is of great artistic and practical importance in such areas as weaving, interior decorating, dyeing, color printing, painting, stage lighting, traffic and railway signals, lighting for aircraft and ships, advertising and display signs, and all manner of other activities. In order to prevent people with visual defects from working in areas where perfect vision is required (persons with such anomalies are generally unaware of their problem), candidates are tested for suitability by means of an anomaloscope, in which the mixture of monochromatic radiations produces all colors. For example, to discover the most frequent forms of color blindness, that is, the inability to perceive red or green, the subjects are required to unite red and green radiations to obtain spectral yellow. A daltonic individual, depending on whether his or her eyes are anomalous to red or to green, will either introduce too much red or too much green. In order to detect daltonism, tests have also been introduced based on an assortment of colors, such as the plates of Stilling-Hertel and of

5-14. a. Ishihara's test for achromatopsia, chart number 3. The individual with normal vision sees "29," the daltonic subject "70," and the person with total achromatopsia recognizes nothing.
b. Stilling-Hertel chart number 19. Individuals with normal eyesight distinguish the color difference and read "CH," persons with daltonism only manage to read according to the degree of lightness and see it as "31."

Ishihara, known as pseudo-isochromatic plates (fig. 5-14, a and b). These plates are made up of those two colors that may be confused by the subject being tested. One of these colors is applied to the plate in shapes of every kind, regular and uneven, or in dots

5-15. The retinas of the two eyes, left (L) and right (R), are divided by the vertical meridian into two four quadrants. The corresponding quadrants have the same number; the two corresponding points are indicated by the same letter (A and B).

of varied lightness and saturation, to form the background; then numbers, letters, or shapes are drawn on top of the other color. The images thus formed can be discerned only by reason of the contrasted colors: to a color-blind person they will therefore remain invisible. Some of these tests are tiring, however, and identification of the images may be difficult even for the normal eye.

Another kind of test involves the subject looking, in complete darkness and at a given distance, at a flame, the luminous intensity of which is varied by differently colored glass slides. Faced with yellow-red or yellow-green, blue-red or blue-green slides the subject being tested may see only yellow or only blue respectively.

In some cases color blindness is not complete and the sense of color is merely weakened or diminished. According to some experts this is due to a weakening of the specific action of the receptors. To detect such anomalies, the Daae test is used. This involves placing a number of squares of colored paper (or even a sample card of colored wools) in several rows, the first ones made up of squares of a single color, but of decreasing intensity, the others of squares of a well-defined tone. The subject may be unable to distinguish the various shades of the same color (weakness of color sense), or he or she may have difficulty in recognizing the individual color squares (even when the light is increased), and in order to do so will need to view them more closely (diminution of color sense). But since it has been shown that not all such tests will reveal the various visual defects, the color-blind person must be subjected to more tests to make certain that the defect is not overlooked.

It is hoped that the most recent studies and findings, such as the use of colored filters or antidaltonic spectacles (which modify the wavelength and hence the color) or special exercises, will help to correct these anomalies.

The Paths of Visual Perception from the Eye to the Brain

As we have already said, the formative process of vision originates in substances contained in the cones and rods, which, when struck by incident light, undergo certain chemical reactions that transform them. Every reaction produces a series of modifications of the electrical potential of the nerve fibers, which is converted into sensations of light and color in the visual centers of the brain.[1]

The nervous impulses stemming from the retina are all of the same quality, whatever the luminous stimulation that has determined them. How then does it happen that the brain gives responses indicating the qualitative differences of the light — that is, registers the enormous variety of the colors and differences in intensity as well as achromatic sensations? Edgar D. Adrian, a British neurologist, offers the following explanation:

> It is clear that the arrival of the cortical extremity of messages emanating from the receptors for the red of a particular field of vision will modify the activity of the cortical neurons in a manner different from that which would be observed if the receptors for blue were sending the messages. There are several ways in which this difference may come about: for example, it could be that the coloured messages are separated in the cortex in such a manner as to produce something similar to the squares we use to indicate colours in black-and-white diagrams. But we have no proof of this, and all we can say is that the messages of the receptors sensitive to colour are all of the usual form, the only thing distinguishing them being the fact that they run along particular nerve fibers.[2]

[1] In addition to the visual centers of the brain, or areas of visual projection, where the various impulses that come from the eye are translated into images, there are other centers that go by different names according to their function: areas of projection of hearing, taste, smell, touch. The organs of sense, variously stimulated, transmit the impulses to the corresponding cerebral areas, giving rise to all the sensations.
[2] Edgar D. Adrian. *The Physical Background of Perception*. London: Oxford, 1967, p. 79.

The capacity to distinguish all variations of color, however, is not only due to physical signals or physiological processes that occur peripherally in different parts of the eye, but is also subordinated to a whole series of neural processes that take place in the cortex: we see only when the retinal impulses are received by the brain. The real image (object, person, etc.) that forms in miniature and upside-down on the retina is seen almost from birth—in the correct size and in an upright position as soon as the retina has transmitted signals to the brain. The image is double, because it is projected in a slightly different way on the retinas of either eye, but it is seen as single inasmuch as a single perception develops in the visual cortices, intercommunicating through the corpus callosum. The fusion of the two images occurs because they fall on nonsymmetrical but corresponding points of the two retinas, and owing to the particular type of chiasma of the optic nerves, they culminate in equivalent corresponding zones in the two superior hemispheres. If instead the image of the object falls on noncorresponding points of the retinas, the result is a double image (*diplopia*) because the impulses will in turn reach noncorresponding zones of the cerebral hemispheres, in which the two images consequently will not fuse. In figure 5-15 we see the retinas of the two eyes, left (L) and right (R), divided into two halves vertically—nasal (n) and temporal (t)—and horizontally—the upper and lower retinal; corresponding points are indicated by the same letters.

The identification of images in the retinal field (shape, outline, size, distance, direction, color) is likewise carried out by the cerebral cortex. Visual perceptions therefore depend on both the eye and the brain. In fact, if the optic nerve fibers through which visual impulses travel are completely severed, the faculty of sight will be instantly lost, even though the eyes are still perfectly functional. Similarly, there will be no vision when the cortical cells of both occipital lobes are wholly destroyed, despite the fact that the eyes and optic paths are normal (cortical blindness).

In figure 5-16, which illustrates the course of the optic paths, we see that the fibers of the optic nerve leading from the right hemiretinas of the two eyes are directed toward the right-hand geniculate body and thus toward the right occipital lobe; in this case the fibers leading from the right hemiretina of the left eye pass through the optic chiasma on their way from the opposite side (to the right). Similarly, the fibers coming from the two left hemiretinas lead to the left occipital lobe. The impulses from the temporal side of

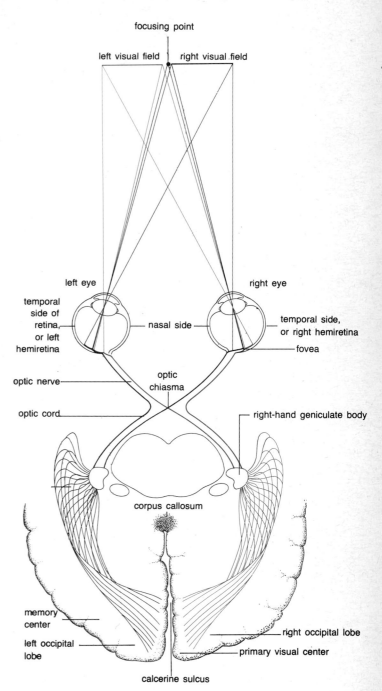

5-16. Diagram of the pathways of visual impulses from the two sides of the retinas to the cortex of the occiptal lobes. In each eye the light passing from the temporal half of the field of vision falls on the nasal half of the retina; the light coming from the nasal half of the field of vision falls on the temporal half of the retina. The resulting image is therefore inverted just as—for the same reasons of projection—the upper and lower halves of the field of vision are projected onto the retina in an upside-down position.

the right retina and the nasal side of the left retina travel to the right occipital lobe, whereas the impulses from the temporal side of the left retina and the nasal side of the right retina travel to the left occipital lobe. In the visual centers (situated at the sides of the calcerine sulcus), the retinal images, on the basis of the diverse activity of the cerebral nerve cells, are interpreted and translated into a special code, presently the object of investigation.

In the remaining parts of the occipital lobes, the nerve cells translate the stimuli taking into account direction, distance, size, and relief, thus providing all the characteristics of the objects to be found in the field of vision. A deeper layer of cells in the visual area reacts to general visual stimulations, working independently of the retinal zone.

In conclusion, vision occurs when light, passing through the various transparent dioptric mediums, reaches the photosensitive elements of the retina, thus initiating a series of biochemical processes that transform the radiant energy of the different wavelengths into nervous impulses. The latter reach the visual centers of the brain, where they are analyzed and retained as acquisitions.

In the same manner the brain receives the impulses stemming from the other sense organs. All stimuli in general (light, sound, taste, odor, or tactile object), having reached the related organs of sense (sight, hearing, taste, smell, or touch), produce specific sensations in different parts of the brain. Here they are interpreted and registered, to become memorized and sometimes so closely interconnected that the perception of a message by one of the sense organs may arouse the memory of a perception acquired from another sensory origin simultaneously. The centers of vision and hearing are especially closely linked: the sight of certain colors may arouse the memory of low or sharp sounds, voices, or murmurs, for example. Even Newton seems to have associated the clearest colors of the spectrum with the seven notes of the musical scale. Likewise sounds may evoke colors. As a result of such associations we attribute various sonorous qualities to colors, describing them as harsh, metallic, noisy, shrill, quiet, or muffled. Furthermore, as a result of the connection between the organs of vision and taste, some colors evoke particular tastes, so that we define them as sour, bitter, sharp, sweet, savory, and so on. Vision and smell also combine to produce colors perceived as smoky, burnt, or putrid.

The visual-tactile association is equally important for producing a wide range of comparisons: thus we may have colors that are hard, sharp, rough, dry, soft, smooth, velvety, or moist. And because the epidermal nervous system has the ability to receive stimuli that act on different receptors, colors can be viewed in combination with other perceptions to the point of arousing feelings of heat or pressure, so that we speak of warm, cold, light, airy, and heavy colors.

Vision and hearing, which have spatial connotations, are the most important of the organs of sense. More than the other senses, they involve contact with and adaptation to the outside world.

It is clear that visual perception, determined by the combination of visual sensations, is still not enough to provide us with knowledge of an object. In order to do this the intervention of memory, which, by analogy, evokes models of images stored through previous observations, is required. Plato, interpreting the role of memory in a metaphysical context, said that to know is to remember, to recognize in the objects of the material world the ideal archetypes known by the human soul, when, prior to taking on an earthly guise, it dwelt in the world of ideas. The perception of an unknown object tends to be associated with features of known objects that have some resemblance to them. Thus, for example, we distinguish the differences among red, yellow, and blue by referring to our recollection of colors already known. Estimation of colors differs from one individual to another, and it is as difficult to arrive at an objective definition of a color as a description of an event, precisely because the constituent data of the memory vary in every one of us. Other variations of perception depend on the emotional state, temperament, state of mind, suggestibility, capacity for attention, and store of knowledge acquired through education, environment, and culture.

Finally, it can be said that the definition and valuation of any perception of the visible world, including that of color, can never be identical in any two individuals, even if they have equal vision.

Psychophysical Parameters of Color

The three essential aspects of color: tonality, lightness, and saturation. The external factors governing color vision: how perceptions to colors vary in sunlight and in artificial light. Perceptions modified by reason of physical and psychological causes

Every chromatic experience is characterized by at least three different perceptive aspects: tonality, lightness, and saturation.

Tonality, or hue, is "color" true and proper, or what makes a yellow, for example, appear different from an orange or a green. As a rule, color, as we have already seen, is a characteristic of the surface and linked with its spectral reflectance, and therefore it may vary according to the background or adjacent colors or the effect of different forms of illumination, depending on the time of day and the atmospheric conditions.

Lightness—the sensation of a color appearing lighter or darker than another—governs a color's "value." It is conditioned in part by the intensity of the stimulus, and partly by the nerve structure of the retina. The different sensitivity of the retina to diverse wavelengths determines to a considerable extent which color appears more luminous than another. Yellow, for instance, seems brighter than blue or green. Brightness, however, depends also on the eye's capacity for adaptation, on the contrasts between colors, and on other situations.

Gyorgy Kepes defines saturation as the measure of the true and proper content of a color in a given instance. When we see one red that is redder than another (which thus appears more gray) we experience a particular sensory quality that is manifested in greater or lesser purity, rendering colors more or less rich and full. Red and pink, deep and pale yellow, are perceived as diverse qualities of sensation.[1]

The three qualities may vary independently; consequently the same color may appear more or less bright or more or less grayish. However, the three characteristics are not completely independent of one another, and the measure of saturation, in fact, varies

within certain limits together with the lightness, when the intensity of the illumination or the duration of the stimulation increases or decreases, and also in relation to the distribution of the stimulus over the central or peripheral section of the retinal zone.

It is clear that the light and the eye are the two factors determining the differences in tonality, saturation, and luminosity. However, they are relatively independent of one another: one may vary and not the other. The term eye is used for the sake of simplicity; actually, as we have seen, it is a system composed of physical, chemical, and physiological elements. The same applies to the light factor, which may vary according to the structure of the radiations, the intensity of the illumination, and whether it is natural or artificial.

How Colors Vary According to Different Conditions of Sunlight

Color is best seen by sunlight, but we must remember that the solar rays that reach us are very different from the original rays, because they have undergone changes of speed, diffusion, and direction as a result of the varied composition and distribution of the mediums through which they have traveled. These variations are due to the presence of suspensoids—gaseous, solid, or liquid particles suspended in the air, including gas molecules, meteoric, terrestrial, volcanic, or saline dust, seeds, pollen, bacteria, and water droplets. These last may be very tiny, as in mist or clouds, or larger, as in rain, and refract light differently according to their diameter and density. In fact, long-wave radiations, having greater force of penetration, undergo less refraction and so less deviation than shortwave rays, which, since they undergo greater refraction, tend to deviate more. Irregularity of the particles in suspension therefore causes irregularity of diffusion, reflection, diffraction, and dis-

[1] Kepes. *The Language of Vision.* 1944.

person of light—phenomena which, together with other atmospheric conditions, influence the coloration of the sky. A particularly rich diffusion of blue and violet rays through the action of the molecules in air in which there are very few particles present produces the typical azure color; a dispersion or rather an extensive reflection of short, medium, and long rays through the action of relatively big particles, which gives white light, makes the blue of the sky paler, to the point of becoming almost white.

As far as the absorption of light is concerned, a distinction has to be made between gaseous, solid, and liquid particles, and black or dark (smoke, smog), gray (dust, sand, mist mixed with smoke), or white particles (frost, snow, hail, mist consisting only of water vapor). The absorption is in proportion to their number—the degree of atmospheric cloudiness—and also to the wavelength of the incident radiations. Shortwave rays (azure and violet) are strongly absorbed by smoke and dust, for example, and not by snow, which reflects it almost totally.

Light varies considerably in relation to meteorological conditions such as season, climate, cloud cover, and air conditions, and also according to the position of the sun at various times of day and the consequent inclination of the rays. Around midday the sun's rays strike the earth's surface almost or exactly perpendicularly. If at the same time the sky is clear, without clouds, vapor, or humidity to modify the brightness of the light by filtering, deviating, or masking the solar rays, there will be a noticeable increase in the brightness. Even the very short rays of the violet zone will not undergo dispersion; therefore all the rays spread through the atmosphere in equal fashion. The rate at which they spread, however, is never constant, but changes continually as a result of the incessant, though imperceptible, variations in atmospheric transparency and incidence of solar rays.

The variations in brightness that occur during a day when the sky is clear also bring about changes in the color of the daylight. This is why it is not advisable to look at colored compositions under the type of light that modifies the color yield according to the time of day (thus causing variations toward one color or another). Consequently, proper daylight is by definition given off by a slightly overcast sky, coming from a northerly and vertical direction; and an object's "own" color is the color observed under these optimal conditions of illumination. Direct and too intense sunlight is never an advantage to a painter. A painted surface, exposed in full sunlight around midday, does not show colors well: the discriminatory power of the color tones of the receptors, if stimulated simultaneously to the maximum degree, is diminished, and the colors appear to fade under a whitish veil. The negative effect of intense light has to be taken into account not only in works of art but also in industrial processes, since if the light is too bright it may cause modifications of natural color substances and of artificial colorants, used, for example, in manufacturing.

Excessive sunlight—and consequently excessive heat—in an environment may be reduced by frosted glass, which neutralizes infrared rays; by special transparent materials that selectively filter the rays of varying wavelengths; or by such barriers as curtains. Recently a new type of anti-light, anti-heat glass known as neutral gray glass has been produced. This is particularly useful in factories, offices, schools, and hospitals in hot and tropical climates. The efficiency of this glass and the extent to which it is able to reflect sunlight and absorb caloric energy is much greater than ordinary glass. In addition to not allowing anyone to see in from the outside, neutral gray glass does not undergo any change of color from the sun.

At dusk, as the sun gradually sets and its rays become more oblique, the blue and violet radiations are already weakening in the purer layers of air and are very quickly extinguished, since they have to pass through a thicker belt of atmosphere. Long-wave rays such as those between red and yellow, on the other hand, have more penetrative strength, and, striking irregular particles such as condensed vapor or motes, they are reflected in all directions and are widely diffused: thus the sun and clouds at sunset appear red or yellow. Under these lighting conditions objects normally seen as red, yellow, or yellow-green tend toward orange, whereas blue and violet objects appear darker in color, since they do not reflect the red and yellow rays.

The phenomena described above relate to the cloudiness of the atmosphere; consequently, when there is little dust, green rather than red tones may predominate in the sky at sunset.[1]

When the sun sinks below the horizon and the light becomes very dim, the same painted surface that had appeared white or yellow when illuminated by very

[1] A similar phenomenon occurs at dawn, except that the colors appear in the sky in the reverse order. Since there is less dust in the air when the sun rises than when it sets, green and blue appear first at dawn, followed by a more or less deep red.

Variations in conditions of light and color in the same landscape over a period of twelve months. The light varies strongly with meteorological conditions season, climate, cloudiness, atmospheric conditions and also with the sun's position at various times of day and the consequent inclination of its rays.

bright light tends toward blue (the Purkinje effect);[1] if the light becomes dimmer still, the surface appears increasingly dark until it turns totally black.

The color of an object illuminated by daylight of average intensity also varies according to the wavelengths of the incident spectral rays and the structure of those reflected. These latter depend on the selective absorption the object exercises on the

[1] Johannes Purkinje (1787–1869), a Czechoslovakian physiologist, was the first to describe and study this phenomenon. He stated that in moderately bright light the red zones of an object appear lighter than the blue, but in very dim light the blue zones appear markedly lighter, although colorless, than the red, which instead becomes almost black.

various wavelengths. The quality of the surface (rough, smooth, opaque, clear, light, dark, polished, dusty, etc.) also has an influence on a given color, because it determines variations in the distribution of light flow and hence in the reflection of the light. Other factors can also modify perception of a color: size and shape of the surface; position of the observer; position of the object and direction of illuminating source; the presence of differently colored surfaces in the vicinity; and so forth.

The dimensions of a surface influence the saturation and lightness of a color. This becomes evident if we

place a color sample of a few square centimeters on a broad surface (fig. 6-1), and we make a copy different in size from the original. The change of color that is noted is due mainly to the fact that the broader surface involves a bigger retinal area beyond that of the fovea, in which the ratio between cones and rods varies, and consequently causes an increase in sensitivity to color as well. Through the mechanism of lateral inhibition, moreover, there is also a variation in the phenomena of simultaneous contrast, linked, as we shall see, with the dimensions of the colored surfaces. The distance of the colored rays from the

6-1. An example of how a color apparently changes in relation to its extent. Comparing two squares of the same red color on the same black ground, the one above appears more intense and slightly darker than the much bigger square on the opposite page.

eye likewise varies according to the size of the illuminated surface. Also to be taken into account are the variety of angles at which the rays emanate from the various zones under observation: as a rule different surfaces do not reflect light rays in the same manner and in a certain direction. Finally, not all the points of a large flat surface are at the same distance from the eye, and the closer they are, the lighter they appear.[1] Thus the color changes of a copy with dimensions different from the original depend not only on the faithfulness of the copy to the model but also on the change in spatial relations of the rays of light reflected from each painted portion.

[1] In order for two colors to be compared and analyzed for sameness, they should be isolated and observed through a hole, with all other conditions (distance, illumination, inclination, etc.) being equal.

The shape of the object, if not flat, influences the distribution of light intensity, creating variations of tone, luminosity, and saturation in the color as well as contrasts of light and shade, heightening the plastic effects. The shape of any object can also change with the position of the observer; indeed, according to the angle of vision from which it is examined, the object presents various aspects of shape that in turn correspond to other positions of the object itself in space. In addition, the change in position of the light source (frontal, sideways, or from below; direct or indirect; closer or farther away; etc.) varies the angle and intensity of the light rays and consequently also alters the color saturation. Sometimes a change in position of the surface in relation to the light source upsets the rule of constancy; the variation that has been introduced is not perceived as a variation of illumination (lighter or darker, with the same color maintained) but as a variation of the colored surface itself, which appears to be of a lighter or darker color rather than more or less illuminated.

The distance between object and light source (window or lamp) and that between object and observer influence color perception as well. A color undergoes a progressive loss of tonality—appearing more gray—as such distances increase, because of the incident light rays that gradually but steadily diminish in intensity as they get farther from the source. In daylight, everyday objects appear different in color according to distance: the green of trees, for example, tends to be warm when seen close up, while seen from afar it tends toward a colder blue. The difficulty in retaining a constant perception of color when objects are situated at a certain distance is due to the air in between, the effect of which is directly related to the cloudiness. The inconsistent concentration, size, nature, and color of suspensoids, or the presence of mist and haze, for example, can cause us to see different colors at different moments, even though the light source is unaltered. Distance vision also depends on humidity; visibility is better when the air is dry.

The colors of the surroundings influence the color of the object being viewed because the latter reflects the numerous light and color variations of other surrounding objects. Color does not exist in isolation, but always by interaction with other hues: "Every color," as Giulio Carlo Argan says, "itself colors all space, adding its contribution to others."[1]

[1] Argan. *L'Arte moderna 1770–1970*. p. 285.

In addition to surface colors, other types of colors exist; these, however, have no consistency or defined position in space, and furthermore they are not subject to the distinction between the intrinsic color of an object and the illumination striking it. These are known as *filmary* colors. The colors of the sky, continually changing (blue, gray, red, yellow) constitute one of the best examples of such colors. The character of the sky's filmary color appears most evident in the morning or the evening, when the oblique rays reach us reflected at a maximum by the atmosphere, so that the sky seems even more highly colored.

How Colors Vary According to the Conditions of Artificial Light

Artificial light, too, modifies colors in relation to the type and color of the light source. Artificial sources of light can be divided into three groups: incandes-

cent or warm (candle, torch, common electric filament lamp, luminous gas lamp); electric arc (in vacuum or various types of gas); and fluorescent (prepared with various mixtures of phosphorus in different concentrations).

Incandescent sources emit wavelengths of white light, infrared rays, and, to a lesser extent, those from the violet side of the spectrum. Under the influence of this type of illumination warm surface colors tend to appear brighter, cold ones duller; this is particularly evident with pale green, azure-green, blue, and violet. These lights are therefore little suited for illuminating industrial premises, where the color green is often used as a safety signal and blue as a warning signal. Incandescent lamps, therefore, should not be employed where a clear distinction of colors is required.

Electric arc sources involve electrical discharges within certain substances (sodium, mercury, neon, and xenon gas, for example) that give rise to lights of different colors. Xenon produces an especially white light and is the best suited for faithfully reproducing colors. It is useful for integrating natural light and for replacing it where lacking, without the viewer being aware of it.

By daylight the intensity of pure colors seems to increase or decrease according to the distance of the observer from the object. In these two photographs we see how the tonalities of the one taken at 1,000 m (below) appear duller and more gray than the other, taken at 50 m (opposite).

Finally there are fluorescent lamps, which, since they are made with varying mixtures of phosphorus, can produce lights that are not perfectly white but partially colored, and thus modify the color of surfaces observed under it. The radiations given out by this type of lighting are due to the reactions of particular fluorescent substances (deposited on the inner walls of the lamp) when an electric discharge occurs. As a rule such rays contain little red and yellow, and their light appears predominantly blue; but there are certain types of fluorescent lights that are particularly white and can produce a faithful reflection even of soft colors because their composition imitates that of ordinary daylight. The tube is white, and its light is

In this beauty salon the bright white illumination is tempered by warmer light sources. Not only does this lighting create a pleasant atmosphere, it does not alter the colors of skin and cosmetics. A deep red band runs all along the edges of the walls and makes patterns on the floor, drawing attention to the machines and furnishings. The imaginative band of strong, bright colors seen in the adjoining room makes a good contrast with the light monochrome tones.

called "warm white" if it emits short waves, including green, blue, and violet. This light, because of its yield and economy, is chosen to illuminate large rooms, work premises, and streets. For street light-

ing, sodium vapor arc lamps are preferred, as these give out a monochromatic yellow light of great intensity, visible at a considerable distance, even in poor atmospheric conditions of mist or fog. Lamps giving warm white light, best for illuminating inorganic or plastic materials, have a negative effect on organic material because they weaken warm tones, making them appear azure, and reinforce the blue. When, however, they are used in conjunction with incandescent lamps, the result is quite pleasant. A rational use of light and color in places of work reduces eye strain, and so makes the work less tiring while at the same time improves output.

David Katz (1884–1953), a German psychologist expert in the study of optics, writes: "With our present methods, that enable us to produce high luminosities in very small areas, and to control them almost completely as regards intensity and spatial position, man has now triumphed almost totally over night. At the same time a wholly new field of research has developed from traditional optics, i.e., illumination engineering, a study that is very closely linked with physiological and psychological optics. Eminent practitioners of the technique of illumination are now prepared to recognize that their science can no longer be considered simply as a branch of applied physics, as in the days when it was believed that the determination of photometric values would exhaust the problems in that area. It is now established that a study of the effects of light on the human organism is extremely important—important enough to constitute a separate branch of illumination engineering."[1]

When deciding what type of illumination to have, one must select the form of light best adapted to avoid modifications of color. This is particularly important in museums, in studios, for retouching and miniature work, in textile dyeworks, in hairdressing salons, in restaurants, and in clothing shops.

In surroundings where colors are manufactured for various purposes, the illumination must be complete in terms of spectral composition and of constant intensity to guarantee a reflection of color that is always even for strong tones, soft tones, and shades of similar colors.

Since the color of a surface depends significantly on the spectral structure of the light emitted by the source, as well as the intensity of the lighting, in defining or qualifying a color sample, it is important to mention the precise type of illuminating light. Pro-

fessor Manfred Richter, in an article in the magazine *Der Peliken* entitled "The German Color Chart DIN 6164," describes how color does not depend only on its sample or on pigment, but also on the quality of light that illuminates it. He explains that a group of color samples can exhibit the characteristics of the system only with that type of light for which the sample has been devised. In fact the DIN color table fulfills this condition since it is defined as valid for the "standardized C type of light" (a form of artificial daylight that has been internationally determined and standardized). If the color chart is examined in a different light, the characteristics originally foreseen are lost in increasing measure as the quality of illuminant light deviates more and more from the "standardized C" light quality. The conclusion must be that use of a suitable light gives a correct valuation of the color, even if the factors that impede continuity and constancy of perception are not wholly eliminated.

The link between light and color obliges us always to bear in mind the effect of the surroundings, the position of the light source and the powers of absorption or diffusion that the surfaces impose on the light itself. The distribution of the light, whether concentrated or diffused, creates tonal differences in color that are also very important in color photography. In order to floodlight buildings, monuments, and statues to emphasize their particular qualities, concealed reflectors with concentrated white or colored light are used to accentuate shadows and facilitate perception in depth, as well as to bring out color contrasts. Inside museums and art galleries, opaque diffusors with white light are preferred, as they have the advantage of illuminating objects homogeneously, keeping to a minimum the damage that ultraviolet rays might do to a painting.

Perceptions Modified for Physical or Physiological Reasons

Color as perceived by the retinal receptors differs from individual to individual by reason of variations in physical makeup and prevailing circumstances, such as tiredness, age, and state of health, and also because of differences in light intensity.

When the light intensity is weak, as at twilight, the chemical modifications of the retina are less rapid, and consequently the brain receives a delayed visual stimulation, with important practical results. English psychologist Richard L. Gregory writes: "The retinal delay produces a lengthening of reaction-time in driv-

[1] David Katz. *The World of Colour*. London: Kegan Paul, 1935, p. 230.

ers in dim light, and the increased integrating time makes precise localization of moving objects more difficult. Games cannot be played so well: the umpire calls 'Cease play for poor light' long before the spectators think it right to bow before the setting sun.''[1] When the light intensity drops below a given minimum level, the rods come into play, and these, sensitive only to medium-short and medium wavelengths of the spectrum, continue to give us the perception of blue and green when we no longer see red. If we compare at twilight a red and a blue that appear equally bright in full light (when color valuation is associated with the cones), visibility of the red will diminish as the light intensity dwindles until the color is confused with black, while visibility of the blue will increase and be seen more clearly. At night, in fact, the spectral sensitivity of the rods toward long-wave radiations is virtually nil, while it becomes more acute for those of the central zone.

Red is unsuitable as a signal color during the hours of half-light, when sensitivity of the rods predominates. Blue, which in the evening becomes brighter in comparison to the red and thus lends itself to easier recognition even during the processes of adapting to darkness (the Purkinje effect), is used for signals, legends, or symbols in any warning context. In poor light, surfaces of other colors show the following modifications: bright orange, like red, quickly changes to black; yellow, which in intense light is at its brightest, takes on a green or blue tint; and violet colors lose their tone more gradually. These are instances of so-called crepuscular vision, associated with the mechanism, previously described, of the rhodopsin of the rods.

Sudden variations in luminous intensity influence the capacity for vision: a strong, unexpected increase of light causes dazzling, with a consequent painful sensation and temporary loss of visual capacity. Sudden darkness produces similar effects, though without impressions of pain. The driver of a car, subjected to alternations of light and shadow (as when traveling through a tree-lined street by day or when passing other cars at night), is continually forced to vary the eye's adaptation. This results in fatigue, decrease of visual capacity, and possible negative repercussions on body and mind. Several devices reduce these harmful effects of fluctuating light: slightly colored glass for the windscreen selects certain radiations and makes the differences in brightness less evident (the same purpose is achieved by wearing specially tinted spectacles); headlights giving out a yellow-green beam also diminish the effects of dazzle and enable the driver to see farther. The photometric test, which serves to measure an individual's capacity to adapt to light, involves displaying increasingly bright letters on a more or less illuminated background. The lighter the background, the better the sensitivity to the light. The color tone seen by an observer in relation to a given object derives from the intensity and duration of the light stimulus: short, sharp stimuli work in the same way as long, weak stimuli. Little importance is generally attached to the time factors associated with visual response, and thus to the way in which an impression of light develops and ceases after a beam strikes the eye. Normally, in fact, we are subjected to continuous visual stimulation, so that it seems of secondary importance to determine the manner in which the visual system responds to intermittent stimuli on the receptors themselves. The problems are more complex than they might seem: in the case of projection the intermittent light is seen as continuous, while with regard to ocular movements the continuous light is made intermittent in order to be correctly perceived. A uniform stimulation, in fact, after an initial visual response, provokes an undifferentiated reaction to light in which nothing is distinguished. A change in timing is necessary to maintain a constant adjustment of perception.

But how does the system respond to the temporal variations of the light stimulus? The first thing to consider is that the level of excitation rises and falls more rapidly as the stimulus becomes more intense; consequently a strong light activates the eye more quickly, but its disappearance deactivates it just as quickly, whereas a weak light needs more time to activate it and also more time to deactivate it.

The second consideration derives from the first: if several light stimuli follow one another, separated by intervals of darkness, they can be distinguished as successive flashes if the levels of visual excitation oscillate in a sufficiently abundant manner—above a value, known as the threshold, that makes it possible for them to be distinguished without confusion. (This capacity is called *temporal acuity of vision*, in paral-

Examples of proper selections of the colors most appropriate for various types of signs in a workplace in order to guarantee the safety of the employees.

[1] Richard L. Gregory. *Eye and Brain: The Psychology of Seeing*. London: Weidenfeld & Nicolson, 1971, p. 79.

lel to spatial acuity, where the stimuli to be distinguished are spatially diverse, as explained on page 74.)

It is now evident why flashes sufficiently close to one another appear as one continuous light and also why, to achieve the same sensation, there must be shorter intervals for flashes of greater intensity. This means that above a certain frequency, called the *critical frequency of fusion* (high for bright flashes, low for weak flashes), the succession of different stimuli will be perceived as a continuous stimulation, while below this frequency the stimuli will be individually differentiated. Obviously, when differentiation is required (as in lighthouses and intermittent signal lights), the apposite devices must be regulated in such a way that the critical frequency of fusion is not reached.

The retina reacts differently to a given color stimulus depending on the momentary situation in which it happens to be as a result of simultaneous, adjacent stimulations. The transition from one color to another also influences perception; if the eye, accustomed to an object of a given color, switches to other objects, it will perceive them as different colors than if it had been preadapted by another color stimulus.

It has been shown by single stimuli of color (made up of red, yellow, green, orange, blue, and white) displayed in optimal conditions of lighting to subjects with normal eyesight, that rapidity of perception differs in each individual by reason of the variety of speed of the retinal reactions, the nervous conduction and reception of the brain cells, and the reaction and excitement levels of each observer. In terms of reaction time in every test carried out, yellow is the color most immediately perceived, followed by white, red, green, and blue, in that order. Thanks to these experiments, researchers can work out on a scientific basis the most suitable applications of colors for purposes of communication and signaling in places of work, with special regard for the safety of the employee, particularly where the work performed demands prompt identification of colors. Following is a general guideline, based on specialist research, as to which colors are best suited to different types of signals:

Yellow is the color most immediately perceived, even in half-light, and is therefore to be used for signaling imminent danger.

Orange is similar to yellow and catches the eye in cases of danger inherent in the use of industrial machinery.

White, on a black ground, should be used for signals relating to street irregularities or obstacles (uneven surfaces, mud, rubbish heaps, etc.). If at the same time there is danger of impact or falling material, yellow warning stripes should be painted inside.

Red is in general unsuitable for indicating imminent danger, since it cannot be distinguished by color-blind subjects, but it may be used in factories for anti-incendiary devices.

Green can be used in work premises as a signal of right of way (emergency exits, shelters, first aid posts, etc.).

Blue, which is perceived clearly even in poor light, can be used for signals warning of electrical danger and, generally, as a warning of nonimminent danger.

Perception and Color Equilibrium

*Successive or consecutive contrast. Positive and negative afterimages. Some practical
suggestions relating to the psychophysical effects of colors. Simultaneous contrast and
external factors. Kinetics, or movement of colors. The reciprocal influence
and interference of shape in comparing colors. Importance of such phenomena
in artistic and industrial practice. Some considerations on harmony*

Successive Contrast

The human visual system is especially adapted to perceive temporal and spatial variations of stimuli rather than uniform, prolonged stimuli. This means that color sensations are more vivid when a light strikes the eye and then disappears than when there is constant stimulation. From a physiological viewpoint, much of the visual system, when at rest, displays an average level of nervous activity, or frequency of discharge. When initially struck by a light, the eye responds by increasing this frequency, and we perceive a given color; if the stimulus persists, the frequency reverts back to normal and the color appears less saturated; when the stimulus ceases, the eye gives a contrary response, decreasing the frequency of discharge so that we see another color, the complementary. Thus the color perceived depends not only on the spectral characteristics of the stimulant light but also on whether such a light is beginning or terminating its stimulating action on the eye.

The opposition of colors in the chromatic circle clarifies the way in which the human eye perceives color, in that after the eye fixes on one of a pair of complementary colors it is the complement that tends to appear successively. In fact if one stares for about one minute at the color red and then at a uniformly white or, better still, light gray background, a green spot will appear, since green is the complementary of red. Likewise, if the eye is fixed on green, it then sees red; if on yellow, violet; and if on blue, orange (fig. 7-1); white is followed by black and black by white. On the other hand, if one looks at a certain color and then immediately afterward at a colored background, the color perceived is the result of a mixture between the complementary of the first color and the background color. If, for instance, one stares at a red square, the successive image on a yellow ground appears yellow-green; the same yellow background appears even more yellow if the eye is first fixed on its complementary, violet. The images that appear to the eye after the direct stimulus has ceased constitute "successive" or "consecutive contrast."

The phenomenon of successive contrast is not a consideration when we look at a painting, because our eye does not linger on precise points but moves rapidly from one area to another. We do get a successive image or afterimage, however, when we look for a long time at very bright colored lights. The image is either positive or negative according to the way in which the retina reacts.

A positive afterimage forms as soon as the stimulus ceases and appears with the same chromatic characteristics as the latter; it is connected with the progressive toning down of the visual impulses in the nerve cells. A negative afterimage represents the final phase of visual activity and appears in the complementary of the color of the positive image. This afterimage, although appearing equal in size and shape to the first, has a less intense, distinct color, because the excitation is becoming weaker; also it tends to shift as we move our eyes, as if the image were engraved on the retina. This suggests that consecutive and complementary images do not depend solely on the working of the brain centers but are also due to a fatigue phenomenon in the retinal cells or, more likely, in the neuronic synapses. It is thought that cones, rods, bipolar cells, and gangliar cells possess an organizing function in addition to their receiving and transmitting functions.

The duration of the afterimage depends both on the intensity and duration of the stimulation and on the eye's ability to adapt. If the eye is fixed for several seconds on the setting sun when it appears dazzling orange, the positive afterimage may last two or three minutes, after which it will exhibit changes in brightness and color until it appears blue or blue-green, the complementary tones of the initial stimulus, or a negative afterimage.

An intense stimulation of white light can produce colored afterimages called "color flights"; the colors of the iris are perceived in succession, one after the

other, gradually becoming dimmer until they lose all trace of hue. Factors such as the duration, intensity, extent, and location of the stimulus can bring about marked variations in the series of colors perceived. When a dark room is suddenly flooded with bright red light and then quickly returned to darkness, the eye sees spots of red and of blue-green alternately. This permanence of the phenomenon after the cessation of the stimulus is called perseverance.

If instead of lights we look at colored surfaces, we will almost always get only negative afterimages, because no matter how brilliant and vivid the surface

7-1. If one stares for about a minute at the dot in the center of the colored squares above, then switches one's gaze to the center of the gray square on the opposite page, the corresponding complementaries of the colors originally observed will appear in the individual gray squares: violet in place of yellow, green in place of red, orange in place of blue, and red in place of green.

colors may be, they can never be as bright as those of light, and thus they produce weaker stimulations on the retina. The strength of the stimulations can, however, vary according to the colors.

Numerous tests have demonstrated that the visual system will tire more or less according to the color perceived, and that red causes the greatest fatigue, blue the least, in direct proportion to the excitability of the retina. Because of the possibility of tiredness, a painter should not work too long with a single color. For example, bright red on a white background will appear less bright after a time—even grayish or greenish—to such an extent that an artist may suspect there is a defect in the pigment. If this does happen, he should turn his eyes to a green ground; his perception of bright red will then return. Working for too long with yellow on a white background will cause a modification of the color's intensity until it fades to white. On a black background, bright red becomes confused with black, while yellow first appears paler and then loses its purity of tone until it appears a sort of dirty white. In fact, there may be an altered perception of almost any color.

Fatigue also varies according to the size of the surface; the smaller the painting, the less chance of excessive stimulation, even by the brighter colors. In choosing colors for large surfaces, however, it is important to understand what effects they may have

alone and in contrast with other colors regarding tiredness and retinal fatigue. It is extremely difficult to set down rules about this, because color vision is always conditioned by subjective mental reactions.

Color and the Observer

Just as a person's mental reactions influence his or her perceptions of colors, colors themselves as well as light and darkness influence an individual's state of mind. As Itten writes, "Colors are forces, radiant energies that affect us positively or negatively, whether we are aware of it or not."[1] Scientists engaged in the field of study called chromodynamics have proved the effects that certain colored lights and pigments reflected from broad surfaces have on the processes of vision and hearing, on respiratory rhythm, on circulation, on the endocrine system, and on other bodily functions. As a result of such research the use of colors has been accepted as a genuine method of therapy (chromotherapy). Red, green, and blue are colors that most easily lend themselves to

Above: The image of the outside stimulus and the consequent afterimage are always made up of two colors that are opposite each other, or complementary, in the chromatic circle. When the craftsman, having looked fixedly for some time at the red statuette on which he is working, raises his eyes to the light-colored wall, he will see a fleeting green image.

Opposite: A room made for listening and composing in a musician's house in California. The indirect lighting and quiet colors contribute to its special atmosphere.

such experimentation; red is the most exciting color, green the most restful, and blue the most cheerful. The study of the psychological influence of colors has by now become an applied science because of its importance in everyday surroundings—in advertising and road signs, for example. Suitable colors and illuminations are an aid to visual perception and can reduce fatigue, thereby increasing the pleasure of living and working and arousing feelings of well-being. Some colors are most appropriate for places of work: yellow, orange-yellow, or orange on the side walls, in sober tones, with sky blue or pale pastel green on

[1] Johannes Itten. *The Elements of Color*. New York: Van Nostrand Reinhold, 1970, p. 12.

the front wall, thus inducing a restful visual balance. In laboratories or professional institutes it makes sense to have walls painted in cool tones like light blues, and ceilings in warm tones such as ocher-yellows and similar colors. In places where concentrated mental activity is performed (universities, libraries, museums, research laboratories, and the like) soft and moderately contrasted colors are advisable.

The same findings should also be considered when decorating the interiors of private homes. Discreet colors should be selected for rooms intended for rest and sleep, more stimulating tones for rooms used for working or entertaining. However, when it comes to choosing a color scheme for homes, few people are in a position to call on expert advice. General guidance could be made available, however, to explain to people how to use colors shrewdly to make their environment more pleasant. There is considerable debate in some quarters as to the validity of this proposition since it has been proved that even if the occupants find their surroundings particularly pleasing, in the long term they will become bored or simply indifferent, due to familiarity. Evidence in the United States

grays are advisable for violent patients, relaxing blues and restful greens for those who are merely agitated, and reds and oranges for apathetic or weak-willed individuals. In each of these cases it is sensible to interrupt the uniformity of the colors, varying the shades and arrangements, in order to prevent any possible obsessive side effects.

In pediatric hospitals bright colors—reds, yellows, blues, and greens, in that order—are preferred. Because it is now believed that newborn babies are capable of perceiving color, their rooms and furniture would best be painted with soft, warm colors (such as pinks alternating with greens), opaque so as to avoid tiring reflections. As the awareness of color develops more fully, between the ages of two and four, a child

On these pages are three aesthetic responses to the practical necessities of industrial and public buildings, using color. The printing factory at left incorporates a conspicuous advertisement of the company's product; bright colors adorn the parking area at the Philadelphia Museum of Art (below); and a company (opposite) tries to make the workplace a more inviting environment through the use of bright colors.

shows that whatever color is used in a particular room, the people living or working there would be just as happy with a different color.

The choice of colors used in the interiors of hospitals is especially important. In operating theaters the most widely used color is green—both for the walls and the gowns—because the surgeon's eye, strained by the red of the patient's blood, finds this color restful. A careful choice of colors, however, is advisable in any place of work, because not only the visual apparatus but also the whole body of the worker can become tired due to a poor choice of colors. For example, in a dyeworks or factory where colored precision instruments are manufactured, the color white often provokes nausea, because workers see consecutive images of the objects they are handling in the white of the walls. In other circumstances—such as in psychiatric hospitals, waiting rooms, or places where boring sedentary work is done—the same consecutive images may have an advantageous effect, producing psychologically favorable stimuli. In buildings designed for the elderly, it is a good idea to alternate sober, restful colors with more lively hues in order to avoid monotony. The combination of warm, exciting colors and cool, restful tones is pleasing. In rooms of mentally ill patients, black, violets, and

will generally be attracted by bright colors. At this age walls can be multicolored, perhaps with designs of objects with which the child is already familiar, or those with which familiarity will be useful. In rooms where children of over six years old are likely to stay for long periods, it is a good idea to draw or paint designs of various shapes and colors casually arranged against a neutral background on the ceilings to divert and stimulate the imagination.

Choice of colors is also of major importance on the roads. It is essential, for example, that the colors of traffic lights do not become confused, since this would cause accidents. For the same reason, the colors on advertising billboards should not cause the phenomenon of perseverance, which might overlap dangerously with other colors used for road signs. In fact, the choice of colors is so important that in hospitals and on the roads it is usually left to color experts, who, familiar with the laws of successive contrast and other psychological effects of color, are able to produce combinations best suited to different circumstances.

Simultaneous Contrast

About 1840 Michel-Eugène Chevreul, a French chemist, discovered the phenomenon he calls "simultaneous" or "reciprocal contrast," based on the principle of complementary colors. In addition to the afterimage one gets after prolonged observation of a color, its complementary may appear simultaneously in the immediately adjacent zones. This phenomenon is also called "chromatic induction" and is explained by the physiological process of lateral inhibition, whereby a retinal area, when stimulated in a certain way, inhibits the immediately adjacent (lateral) zones, provoking a contrary impression. In this way, if a particular area of the retina is struck by a given color tonality, the complementary tonality will be seen in the surrounding zones. Similarly, if it is stimulated by a bright light, the adjacent zones will appear darker. This process accentuates the differences between the stimulations, in the sense that the margins of the different stimulations are emphasized. A light area next to a dark area will appear lighter than it is in fact, and the dark one will appear darker. In other words, the light area provokes a further "darkening" of the adjoining dark area, and the dark area causes a "lightening" of the light area next to it. In colors the maximum contrast occurs when two complementary colors are adjacent, each accentuating the characteristics of the other.

When a red cross is placed on a white background, its outline appears green in color, a phenomenon that highlights the cross itself; similarly, a yellow cross on a white background appears to be outlined in violet. If, however, it is placed on a background of another color, each of the two color areas modifies its color along the dividing edges, in the direction of its companion's complementary. For example, looking at the red cross on a yellow background, we see an appearance of violet spread over the edges of the red, or green over the yellow.

Simultaneous contrast occurs as the result of a sec-ondary excitation in an area of the retina immediately adjacent to that part originally stimulated: the adjacent area, in addition to experiencing the same effects of the original stimulation, though to a lesser degree, also tends to react to a simulated stimulus of a complementary nature. This secondary excitation is at a maximum at certain distances and decreases when the ratios of interacting areas change, according to which colors are involved. In fact, when there are alternating bands of different colors in certain proportional widths, an opposite phenomenon, *equalization*, occurs, in which the two colors appear more like

Above: The interaction of contiguous colors through the effects of simultaneous contrast can be seen in *Discs and Half-Discs*, a painting by Ernst Wilhelm Nay.

Opposite: This painting (Victor Vasarely. *Aran*. Private collection, Colorado) also shows, in addition to the effects of simultaneous contrast, the effects of variously correlated shapes: it gives the sensation of three-dimensional kinetics.

each other than contrasted (as will be seen in due course on pages 125–29 and in fig. 7-14). It is important for the painter to realize that the phenomena of successive contrast and simultaneous contrast are both inevitable. The artist should also bear in mind the external factors that can influence these effects. Of the many factors to consider, the following are perhaps the most important: the distance between the interacting zones of color; the way in which colors behave when placed next to each other, whether complementary, varying in luminosity or hue, or very similar in luminosity or hue; the opposition of light and dark or cool and warm; the amount and type of illumination; the presence or absence of outlines;

amount of saturation; the background on which the colors lie, and the relation between figure and background; their figurative function; the dimensions and shape of the colored elements; and their spatial position and texture.

Color contrast depends on the distance between the colors themselves: two azure bands of equal size seem to be of the same color even if a little violet is added to one and a little green to the other, as long as the bands are reasonably far apart; however, when they are moved next to each other the one appears slightly violet and the other slightly green, since they strike the same foveal area. Similarly, two yellow bands a distance apart still seem to be the same yellow even if a bit of green is added to the first and a little red to the second, while they appear different (slightly green and slightly red respectively) when brought close. In this context the German art theoretician Rudolf Arnheim writes, ". . . if a third yellow of intermediate gradation is inserted between the two, the contrast is lessened and the whole effect is of a more unified yellow."[1]

[1] Rudolf Arnheim. *Art and Visual Perception*. Los Angeles: University of California Press, 1974.

Simultaneous contrast is also exhibited in paintings, because the various adjoining colors, seen together as a whole, immediately show the reciprocal action of one color on another [1] When two complementary colors are contrasted, each color of the pair takes on—at the same time and to the same degree—an increase in luminous and chromatic intensity, because the eye superimposes on each of the colors the complementary of the other. This highlighting of colors may result in notable chromatic effects: red stands out next to green, and green next to red. A tomato, as the German psychologist Heinrich Frieling observes, appears bright red to us against a background of green leaves, but against a red background it becomes a faded reddish brown color. Frieling goes on to remark that many failures in business are caused by ignorance of the effects of color contrasts. A butcher, for example, would best display his meat on a blue-green background and not on a reddish brown slab,which may give it an unappetizing look.[2] In general, colored goods should be displayed on neutral backgrounds and according to the contrasts required: dark items on soft or light grounds, light ones on deep or dark colors. White appears whiter next to its complementary. This is useful to know when working with print, because black characters stand out best against a white page. Similarly, yellow appears much more yellow next to violet, violet stands out most against yellow, blue against orange, and so on.

This does not mean that a highly accentuated contrast will necessarily best show off the chromatic effects of every object. In fact, the colors to be used depend also on the particular object to be displayed and the characteristics of its surface. For example, decorative ware such as plates, cups, or vases of hard or soft porcelain, with, say, a deep red or blue lacquer, would be set off better against a dark-colored background than against a strongly contrasted (complementary) but lighter background. On the other hand, a small piece of sculpture in white or light marble or ivory shows to its best advantage against a well-illuminated white wall on which its shadow is projected. Jewelry and precious stones require bases and backgrounds of dull, drab tones or neutral gray to stand out; by contrast, in food shops dull or neutral gray tones are counterproductive, diminishing the attractiveness of the display.

When pairs of complementary colors (or even noncomplementary, but very different in luminosity) are juxtaposed, simultaneous contrast does not modify the tone of the colors but accentuates the opposite one, making the light color appear lighter and the darker one darker. In this manner a wide variety of deceptive optical effects can be created, such as irradiation and color kinetics. "Irradiation" makes colored surfaces appear to be of a different size than they really are: a white square on a black ground seems bigger than a black square of the same size on a white ground; equal squares, or other geometrical figures, on a chessboard undergo the same effect of irradiation, the white ones appearing larger (see figs. 7-2 and 7-3); dark clothes make the wearer look slimmer, while light or white clothes have the opposite effect; colored surfaces varying in degree of brightness but equal in dimension appear to differ in size because of the phenomenon of irradiation. For example, if we look at three squares, one yellow, one green, and one blue, the yellow, which is irradiant and expands beyond its edges, appears bigger, and the blue, which develops a concentric movement and contracts within its edges, appears smaller (fig. 7-4).

The illusion of greater size of bright surfaces is not derived from imprecise evaluation but from the fact that more light is reflected from brighter surfaces, causing a more intense stimulation of the retinal cells and the sensory centers. The excess of sensory stimulation causes outlines to be perceived less sharply, so that the objects appear bigger than they actually are. Apart from modifications in size, surfaces of different colors, even if they lie on the same plane, appear to be displaced on different planes, producing a kinetic effect in which the colors appear to move: painted yellow disks on a black wall, if seen from a distance of a few meters, appear to be raised some 20 cm from the background. The same phenomenon is observed with orange on black, red on black, green on black, and blue on black, listed in order of decreasing movement. On the other hand, violet on a black ground does not appear to be raised at all. The kinetic phenomenon may perhaps be due to the differ-

Here we see good positioning of soberly colored ceramics on light backgrounds. On the pieces of pottery themselves, colors such as pale pink, pastel green, and yellow blend well with the neutral azure if divided by a very light neutral color.

[1] This reciprocal action is diminished, or even wholly annulled, if the different-colored zones are observed selectively (the attention may isolate them from comparison); in this case the retinal area stimulated is also different.
[2] Heinrich Frieling and Waver Auer. *Il colore, l'uomo, l'ambiente*. Milan: Del Castello, 1962, p.11.

7-2. The white square on the black ground seems larger than the black square on the white ground, though they are in fact of equal size; the white and black squares of the chessboard, also the same, seem to be of different sizes.

7-3, a. Equal geometrical figures with equal surfaces, set on individual squares or on a chessboard, appear larger or smaller according to whether they are white or black (see also fig. 7-3, b).

7-3, b. Again, the white figures on black grounds appear larger than their black counterparts.

7-4. The three squares, though of equal size, appear to be of different dimensions due to the phenomenon of irradiation: the yellow seems the biggest, the blue the smallest.

ence in refraction of the various light waves that demand two or more successive pupillary adaptations for focusing. More probably, however, it may be the result of the degree of luminosity of each color; this seems likely, because if the seemingly protrusive color is made less luminous, the above-mentioned progressive scale is reversed. Similarly, if the background is white instead of black, the dark colors, not the light ones, will appear to be pushed forward; violet stands out much more than yellow, which is close to white.

The luminosity and intensity of colors are also altered according to the color of the background and of the illumination. On a white ground light colors also decrease in luminosity but increase chromatically, so reinforcing their tone. On a black background light colors appear even lighter and more brilliant, while dark ones are diminished in chromatic intensity but gain in luminosity; gray of the same lightness may appear darker against a white background and lighter against a black background (fig. 7-5). In general, the same hue placed on differently colored grounds will vary in luminosity or in intensity, appearing different from its real value (fig. 7-6). Luminosity and color intensity vary according to the intensity, the quality (natural or artificial), and the position of the light source.

Every hue has its own individual luminosity, and the difference in luminous intensity of differently colored surfaces on the same plane brings out, by contrast, the diverse lightness of the colors themselves and creates illusory movements and varieties of structural effects. Because of the greater or lesser luminosity of colors, which influences movement according to the rule of chiaroscuro, the illusion of reliefs and depths is created, both in interior decoration and scene painting, because the details are exhibited on different planes. Kinetic effects are used in theaters, factories, and other buildings, and painters too can use them to create illusory effects of realism in their works. The kinetic phenomena of protrusion and recession can be used to represent the three-dimensional effect of an object, without resorting to color shading or drawing of the object itself. If, however, we wish to eliminate any volumetric effect so as to obtain a flattened, two-dimensional representation, the color of the object has to be of the same luminosity as the background color. When, with a view to achieving compositional balance in a work of art, one wishes to restrict the dynamism of pairs of complementary colors, such as yellow and violet, orange-yellow and

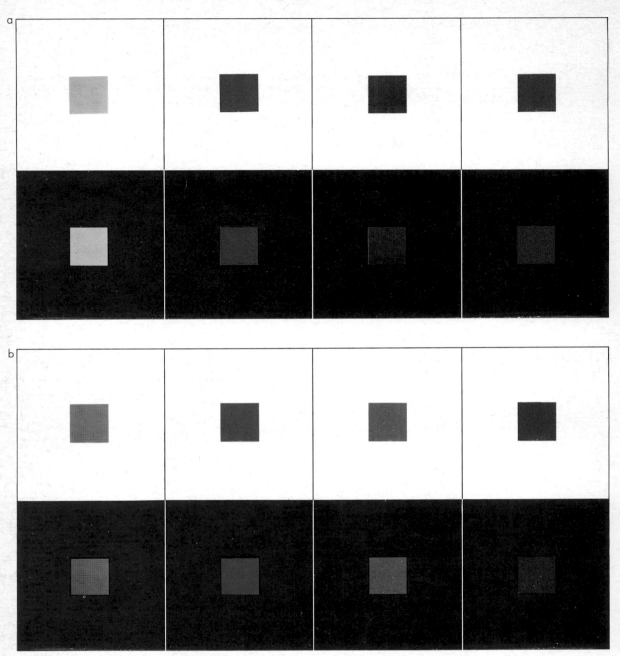

indigo, orange-red and cyan, black and white, the diversely colored areas have to be arranged proportionally in accordance with the known effects of color luminosity (e.g., 1:3 for yellow and violet). If we want to lessen or eliminate any form of spatial movement while keeping the areas of the two colors equal, such as by alternating them repeatedly as on a chessboard, we must increase, decrease, or extinguish the luminous intensity of one or the other by the addition of white, black, or gray, or by adding to one color a little of the other.

7-5. Above: A gray, a yellow, a red, and a green, all light in tone, seen on a light or white background appear darker and less luminous than the same colors on a black background (a); similarly, a dark gray, violet, blue, and green seen on a light background appear darker and less luminous than if observed against a black ground (b).

7-6. Right: In the chart, the same yellow and the same red appear modified in color as a result of different relationships of contrast in each section. The effect may be a variation in luminosity, purity, or intensity, or a combination of such variations.

Robert Delaunay (*Corridors*. Peggy Guggenheim Collection, Venice), left, by means of a calculated association of colors with different luminosities, gives life to shapes and a feeling of movement and three-dimensionality without resorting to shading or drawing, which, by contrast, are used to great effect in *Composition* (below) by Theo van Doesburg (1918. Peggy Guggenheim Collection, Venice). Of interest, too, is the painting by Paul Klee (opposite, *A Young Lady's Adventure*. 1922. Tate Gallery, London), which, far from pursuing illusory optical effects, reduces to a minimum the contrasts of color and luminosity, aligning almost on the same plane subject and background, inseparable parts in a uniquely magical atmosphere.

If in place of the two colors we use three or more, of different luminous intensity but still with the same surface area, the most luminous will predominate over the others, altering their tone: if purple-red, light cadmium yellow, and turquoise blue are set side by side, the yellow, being the most luminous, will exert an influence on the red and the blue, which are less brilliant and more submissive colors, making the first tend toward violet and the second toward ultramarine. An artist can express his sensitivity by using the prevalent luminosity of a color to arouse an effect of dynamism in the others, as if the pigment were living matter, seeking in this manner and without further retouching, to enrich the expressive effects of the images and elements inherent in the work. The observer, too, is involved in the effects of this dynamism, collating and interpreting in his own way the artist's chromatic message. When the excessive luminosity of one hue in comparison with others arouses an impression of strident contrast and disharmony, the defect can be corrected by separating the colored zones with white or black margins, even if reduced to the thinnest strokes; black, especially, separates colors while retaining their original chromatic values. If, however, the intention is to obtain simultaneous contrasting effects of different contiguous colors, white or black outlines have to be excluded. The heightened luminosity of contiguous colors may derive, as we have seen, from the contrast in color, but it may also spring from the contrast of color and lightness. For example, if we juxtapose either a yellow with an ultramarine blue, an emerald green, or a maroon, or a carmine red with a yellow-green, the yellow and the red will be highlighted on the basis of "color contrast"; but if we juxtapose a very light blue with a pure, saturated yellow, or a pale pink with a deep green, or, vice versa, a bright red with a

Above: In this painting by Vincent van Gogh (*Pavement Café at Night*. 1880. Rijksmuseum Kröller-Muller, Otterlo, Netherlands) the very bold zone of yellow retreats into proper perspective because of the even more luminous touch in the foreground and the black demarcation at the side, while it lights up the underlying red.

Opposite: A black line, even if very thin, bounding the areas of various colors, helps each of them to retain their own chromatic value (Luigina De Grandis. 1969. Collection of the artist).

116

very pale green (for other examples see fig. 7-6), the heightening effect is due to "contrast of color and lightness." These color combinations, intended to reinforce oppositions, are not advisable on walls or floor tiles because they create vision fatigue. If used, however, in commercial art (appeals, public announcements, and so forth), as danger signals, or as calls for help, such juxtapositions may be an advantage because they are so conspicuous. Differing in this respect from other pairs of principal complementaries are closely placed colors of equal luminous intensity, like red and green, which produce an excessive fatiguing effect

from tonal contrast. Colors of equal luminosity should never be placed side by side in advertising material, since the letters will stand out from the background with the same intensity and cause confusion. The same phenomenon occurs with wall or floor tiles: equally luminous tones tend to dazzle, and so tire the eyes (fig. 7-7, a and b). These disadvantages can be eliminated by altering the saturation or luminosity of one or the other color with white, black, or gray, or by tempering one with a small amount of the other.

If we now go on to examine the "simultaneous lightness contrast" as distinct from the "simultaneous

a

b

c

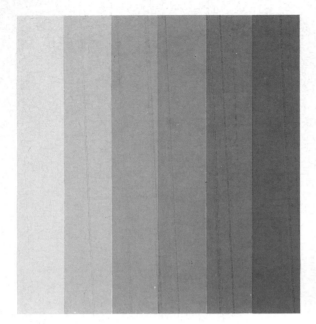

7-7. Opposite: Red and green, placed alongside each other or superimposed, if of the same luminous intensity, are not suitable for advertisements in which the written message is important because legibility results first and foremost from a contrast in luminosity. In fact, we can see how the letters fail to stand out from the background (a, above left). The same combination also has a tiring effect when used on walls or floors because of the brilliance of both colors (b, above right). The trouble can be overcome by reducing the lightness or saturation of one or the other color with white, black, or gray, or by tempering one of the two colors with a small amount of the other (c, below).

7-8. Above: A uniformly gray surface may appear lighter on one side if bounded by a slightly darker zone, and likewise darker on the other side if bounded by a slightly lighter zone.

7-9. Below: Even minimal differences in lightness between equal contiguous bands of the same uniform color tend to emphasize very markedly the actual diversities of light and dark tones. Because the accentuation of contrast occurs only along the line where the two shades meet, there is an optical illusion of an undulating surface (below left). This illusion vanishes if the bands are separated; then the eye is made immediately aware of the color, gradation, and flatness of each (below right).

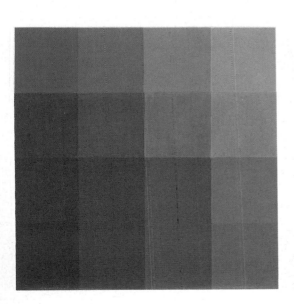

chromatic contrast'' (phenomena that are in fact linked, because in each color there is always a certain darkness or luminosity quite independent of the addition of black or white), we can see that the use of the first produces effects totally different from those so far described.

When surfaces of different lightness (achromatic or chromatic) are placed alongside each other, it is the contiguity that clearly reveals even minimal differences in their tonal values—and the results are surprising, deceiving perception. The colors, in fact, reverse their respective opposed aspects of lightness and darkness, accentuating their difference: an evenly gray surface may appear lighter on one side if bordered by a slightly darker zone, and darker on the other side if bordered by a slightly lighter zone. This difference of lightness within the same surface produces an impression of deformity in depth, so that it appears as a concave, convex, or otherwise folded surface (fig. 7-8).

The same effect may be observed when bands of slightly different lightness are placed side by side, even if each band is in turn composed of several colors that do not set up mutual contrasts of lightness or

tonality. The alteration of colors in this case is evident only along the line where the two shades meet, and it is to this point that the gaze is irresistibly drawn. Because the apparent increase of lightness or darkness occurs only along these edges and rapidly diminishes as we get farther away from them, an optical illusion is created whereby we see waves flowing from one edge to the other, giving the effect of

hollows and reliefs in a continuous flux of movement (fig. 7-9, a). If we wish to avert this optical illusion, all we have to do is to separate the surfaces marginally (fig. 7-9, b). The powerful plastic sensations of reliefs and hollows are caused by the alternations of light and dark and not by the color proper. Proof of this is the pictorial representation of architectural elements such as windows, moldings, fluted columns, or other forms of ornamentation obtained by light-dark alternations. In other words, even the light and dark effect provoked by contrast is capable of representing three-dimensionality on a flat surface.

7-10. Color combinations according to Déribéré's classification (see text).

Arnheim points out that the plasticity of objects is obtained better with a complementary color than with the different shades or tonal values of a single color. If in one of Cézanne's still lifes we are confronted by one apple with shadings in various tones of green and another colored light orange or dark blue, we will probably note the volume of the latter more clearly. We see, too, that the autonomy of the oranges and the blues is limited by their tendency to unite as complementaries. In this manner the representation of the object remains unified.[1]

Several experts have ventured opinions on the subject of juxtaposing black and white so as to provide the maximum contrast of light and dark, and these are sometimes advised for making reading easier. Some experts maintain that blackboards in schoolrooms with white walls do not aid vision, and the same criticism applies to the use of black ink on white paper. Déribéré, discussing visual efficiency in reading, has devised an interesting classification of color combinations (fig. 7-10).

This classification is based on physiological considerations, and more precisely on the diverse capacity of the eye to respond to the more or less intense demands of the various colors; however, experimentation and further research inevitably produce some variations. This should of course be taken into account in preparing informative signs and signals where visibility is the essential quality. However, visibility also depends on other factors such as illumination, spacing of letters and words, size of words in relation to background, and size of letters, particularly if the letters are variously colored. A soft color used for a small letter may be toned down so much one would not be able to perceive it at all should it occur beside a larger letter in a much brighter color. Similar results will occur with letters of equal dimensions but of differing luminosity or saturation.

Distance visibility is also influenced by the form of introduced details (dashes, lines, dots, squares, etc.). Dashes and lines are preferable to dots because they stand out better from a distance. In fact, if a series of dashes and a series of dots are observed from equal distances, the dashes will still be visible when the dots are not. It has been established that lines and dashes are still visible at a distance of 2,200 times their width, while squares, for example those of a chessboard (black and white or alternating different colors), are visible up to 1,700 times the length of their side. This too is connected with contrast, the difference in luminous intensity between the contiguous colors. If we look at squares at different distances, their visibility varies according to their color and surface: a small yellow or green square, placed on a background of a different color, even white or gray, will be lost if observed from about three meters away; at the same distance a cyan square of one square millimeter, placed on a white background, appears black; a red square maintains its color at one meter, but it too appears black if seen from a distance of six meters.[2]

The juxtaposition of red-orange and blue-green, like any other pair of complementaries, produces an increase of luminous and chromatic intensity in the two colors; furthermore, orange and blue, although in a less evident manner than the yellow-violet and black-white pairings, exhibit a light-dark contrast and constitute a perfect example of warm-cold contrast. The degree of luminosity and temperature of warm and cold colors do not have fixed values dependent upon the degree of chromaticity; in fact, the greater the extent to which the luminosity diminishes or increases, the more the contiguous colors recede from or approach their complementaries, and their temperature changes according to whether the adjacent colors are warmer or colder. For example, a violet, the first color of a gamut that terminates in blue or orange, may appear warm or cold depending on whether it is compared with the gamut veering to blue or toward orange.

In the scale of warm and cold values, the red-orange and blue-green complementaries have the maximum and minimum temperature, respectively. The combination of equal parts of these two colors will therefore have a neutral warm-cold effect. However, there will also be an emphasis of the luminous contrast, by virtue of their being complementaries. But when the warm color occupies a smaller surface, a cold note will be introduced into the luminous effect, and vice versa (fig. 7-11, a, b).

Varied luminous effects can also be obtained by linking warm or cold colors with light or dark colors,

Imaginative composition by G. Pintori to advertise an electric calculator. We can see here how the clarity of the symbols depends on contrast with the background, on color, and on dimension.

[1] Arnheim. *Art and Visual Perception*. p. 290.

[2] Gaetano Previati. *I principi scientifici del divisionismo*. Turin: Fratelli Bocca Editori, 1906, p. 236.

simply exploiting the light-dark and warm-cold contrasts as they are, without lightening or darkening the colors with white or black. For example, a gamut of hues between a violet and a green-blue, through ultramarine, arouses a cold and dark luminous effect; that between a green-blue and a yellow, passing through green, has a cold and light effect; that from violet-red to red-orange, through red, has a warm and dark effect; and that from a yellow to a red-orange, through orange, has a warm and light effect.

Such contrasts, in which the dominant color plays a discreet role, are advisable in painting places where more violent combinations would risk causing visual or mental fatigue, or when it is necessary to correct insufficient or excessive lighting.

Warm and light colors, which come closest to daylight, can be used in surroundings lacking direct exposure, to bring about impressions of sunlight. Cold and dark or cold and light colors can be used to arouse a relaxing sensation of freshness. These last also produce an illusion of greater space in small places. As already mentioned, there are many psychic effects of colors, including the definition of certain colors as quiet or noisy. Indeed, it has been established that in noisy places predominantly green colors make it easier to stand the din, and light yellow colors give relief against hollow noises. In addition, colors can also have an influence upon the senses of smell and taste.

As already mentioned, we can create cold and dark, cold and light, warm and dark, and warm and light luminous effects. However, if an artist wishes to produce a work on the basis of a particular contrast, say, warm and cold, he has to do this by virtually eliminating all the others, so that the warm-cold contrast appears spontaneously.

Because orange, a warm, luminous color, tends to

7-11. Opposite: Juxtaposed warm and cold colors attain the maximum level of luminous intensity when they are complementary. The luminous effect takes on a cold or warm note in relation to the surfaces of the colored zones: the luminous effect above is cold, because the warm color occupies a smaller surface area than that of the cold color beside it; below, it is warm, because the orange extends over a greater surface area.

7-12. Right: The contrast between a pure cold color and an impure warm color inverts the particular movement of the cold color. The two examples show how cyan, next to impure yellow, orange, and red, leaps forward, although as a rule it recedes.

advance and expand, while blue, a cold, dark color, retreats or contracts, if the intention is to preserve the balance of the two colors so that neither prevails, the space devoted to orange must be reduced and that devoted to blue increased in the ratio of 1:2; this proportion balances the dynamism of the two colors. Because of their warm-cold opposition and their contrast in luminosity, orange and blue, used next to each other in a painting without any attention to proportionate quantities, create the appearance of expanding in space, moving closer together and farther away, and thus cause the illusion of relief or third dimension, just as happens with light and dark, pale and deep colors. In order to bring out the kinetic quality of single chromatic elements in a painting, the background colors must be neutral and static, lacking tension. This capacity of dim, uniform backgrounds to provide a harmonious setting for objects of different colors and to enable their chromatic and kinetic values to stand out is also exploited in interior decorating, window dressing, and scenery painting (although modern scene painters aim more for psychological than dynamic effects of color).

As we have seen, the combination of warm and cold colors creates an illusion of perspective simply by

Below: To verify the natural kinetic effects caused by the combination of warm and cold colors, the photograph has made use of special expedients such as a clear delimitation of the colored areas and a reinforcement of the background planes.

7-13. Effects of depth obtained by placing a light and dark ocher-yellow next to a cold azure, which changes color until it becomes white (opposite); by juxtaposing a yellow earth with two shades of azure (above); and by applying warm, pure, earthy colors to the foreground and a cold, deep, blue, becoming progressively lighter, to the background (above right).

virtue of a contrast in luminosity between pure or saturated colors in the same measure. In such a case, the cold colors look as if they are behind the warm ones. However, the ratio of luminosity is altered, the warm tones toned down or darkened (or made less saturated by adding their complementaries or gray), the kinetic effect becomes reversed, and the cold colors instead leap out into the foreground (fig. 7-12).

When one of the two colors is lightened, the typical spatial activity of each color is increased: for example, cyan, or almost any other blue, achieves greater depth and coldness if lightened to sky blue through the addition of white; red-orange, too, if much lightened, appears more insistent, because the greater lightness accentuates movement. If we bring the cyan to the same level of luminosity as the red-orange next to it by adding white, the cyan takes on virtually the same kinetic value of the red-orange. The commercial artist must avoid coupling cyan and red-orange of the same luminosity because this produces a dazzling

effect that reduces clearness of vision, just as happens with red and green.

In painting a picture, we can obtain effects of depth and light if we place pure, warm colors (simple or compound) or earthy colors (yellow ocher, orange-brown, red-brown, brown) in the foreground, and very light, cold colors in the background (fig. 7-13). In the same way we can modify the appearance of the surroundings, since the impression of volume and space is deeply influenced by color: a small room seems larger if painted in cold, light colors that tend to retreat from the observer; a big room appears smaller if painted in warm colors that move forward toward the observer; and a long, low, narrow room, appears more square in shape if the short walls are painted in bold colors or earthy tones of orange or red, and the ceiling in very light, cold colors.

However, the sensation of rooms painted in light colors being bigger also depends on the amount of illumination: a very light ceiling that is well illuminated shows all its details and appears closer than a less well-lit ceiling in a strong color.

Apart from lightness and warmth, a certain weight is also attributed to each color: we speak of light, airy, or heavy colors, for example. Thus a cadmium yellow seems to weigh more than a lemon yellow, a purple-red more than a vermilion red, and an ultramarine blue more than a cyan-blue. However, even the lighter colors rendered unsaturated or earthy by being

mixed with other hues appear heavier than the pure color. An unsaturated lemon yellow seems to weigh more than a pure cadmium yellow, an earthy vermilion more than a purple-red, a green earth more than a viridian, whether they are seen as colors on their own or on objects; objects that are equal in size, weight, and shape appear less heavy if painted in pure, cold, light colors and heavier if painted with warm, dark, or earthy colors. Of all the colors of the chromatic circle, yellow seems the lightest in weight and violet the heaviest. Among the warm colors, red, in particular, influences the weight of other colors, making almost any other color, including white, appear

heavier, even if it appears in only small quantities. Thus a yellow with a red component appears to weigh more than the same yellow with a green component, and a pale pink more than a yellow of the same lightness.

The weight of colors is very important in painting and decorating. In fact, a brown-orange, brown-violet, or dark green ceiling seems to be lower than a light-colored ceiling. This is probably the result of an unconscious association with color relationships in nature: the dark, heavy earth low down, and the clear, blue sky high up.

The kinetics and temperature of colors also depend on

7-14. The same red-orange ground and the same cyanic blue ground appear different if combined with white and with black: this is evident in examples a and b if we switch our gaze from the part with light elements to the part with dark elements and back again. If we want the tone of the background to appear unvaried, we have to darken it where the decoration is white and lighten it where it is black.

their wavelength, however; because of the links between the various sensory organs, an unheated room seems warmer if painted in warm colors.

As happens in the case of light and dark colors, the background and illumination have an influence, not only on the luminosity and temperature, but also the kinetics, of warm and cold colors. White and black, furthermore, if placed as figures or as decorative motifs on a warm (say red-orange) or cold (say cyan-blue) background, modify the tonal intensity through the effect of the phenomenon of diffusion, also known as "assimilation" or "equalization." The greater light reflected from the white, mixed respectively with the reflected orange or cyan rays, provokes a diffused effect of lightness over the entire background; combined with black, on the other hand, which throws a shadow on the underlying color, the

a b c

effect is to make the background look slightly darker. To keep the tone of the background unaltered, it must be darkened if the decoration is white and lightened if it is black.

In figure 7-14, the sequence of bands of different sizes and widths brings out various different effects in the spatial interaction of the two colors (phenomena already described at the beginning of the section on simultaneous contrast). Here, in fact, we see that the horizontal bands of color alternating with black and white produce a strong contrast when there is a wide distance between them, whereas they tend to look more alike when the distance is reduced to a minimum; the bands seem to undergo yet different effects when the proportionate widths are varied. In our figure, for example, the same red-orange and the same cyan-blue are modified in four different ways in relation to the color and width of the overlying bands: where the white and black bands are wider there is a stronger effect of contrast, and where they are narrower there is a greater equalizing effect. These effects probably depend as well on the extent to which the degrees of lightness of the orange (and the blue) are similar to the white or the black.

A colored background can in many ways change the

7-15. Above: Two adjacent colors appear more alike if the transition from one to another is gradual, that is, shaded (a); their difference is accentuated when the transition is sudden (b). The use of a black dividing line heightens the contrast of the two colors, even if they do not differ greatly and if the transition from one to the other is gradual (c).

7-16. Opposite: The same color, of average saturation, appears opaque and little saturated over a background of the same, but purer, tonality (a); but it appears more saturated and brilliant over a background still of the same tonality but much saturated with black (b).

appearance of a superimposed color, according to the similarity or difference in luminosity of the two: for instance, the same yellow appears more brilliant on a less bright blue background than on a far brighter orange background. Furthermore, the appearance of a color is modified by how gradual is the change to the adjacent color. In fact, two adjacent colors appear to become more similar if the transition from the one to the other comes about by shading, while their diversity becomes greater if the transition is sudden. In

130

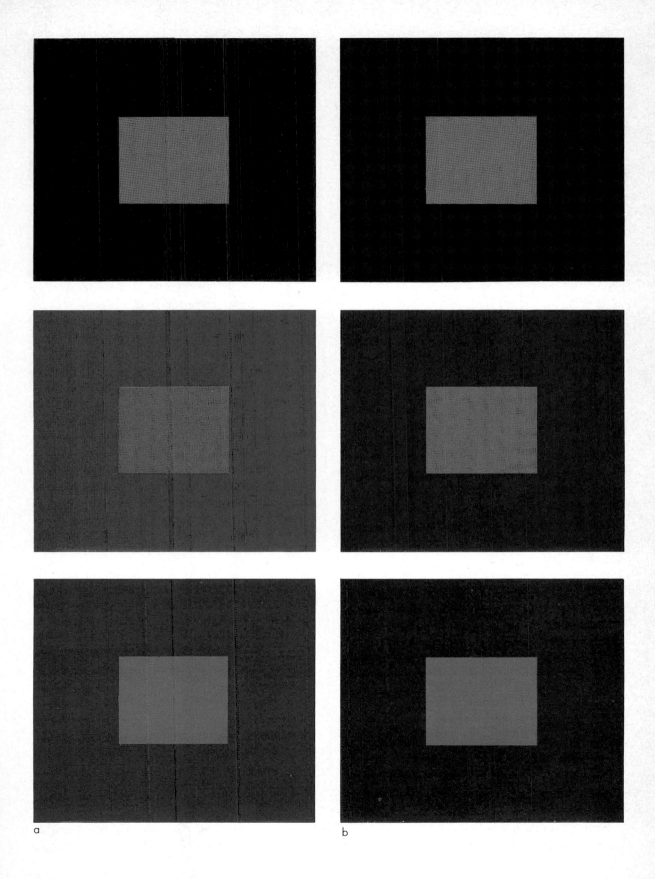

a

b

the latter case, there is greater contrast bringing out the differences between the two colors. The use of a black line to separate the colors accentuates the contrast (fig. 7-15, a, b, and c), even when the difference is not great, for the reason that the black line itself (or even one of another color) creates a powerful contrast.

The apparent change that the same chromatic color undergoes, due principally to the stimulus of the background, is known as the phenomenon of "chromatic induction." The saturation, too, is strongly influenced by the background and gives further emphasis to the phenomenon of chromatic induction: a red, a green, a blue, or a brown (induced colors), for example, desaturated by the addition of white, appears paler and grayish if its background is of a pure (inducent) color; the same colors, however, appear brighter and more saturated if their background, too, is unsaturated by the addition of black (fig. 7-16). In the same way, an orange, lightened with white, changes its hue, which appears paler and unsaturated over a pure orange, and more brilliant and saturated than it really is over a dark, that is, highly unsaturated, orange. In other words, the saturation of an induced color diminishes or increases with the addition or subtraction of the saturation of the inducent color.

The lightness of a color, in an even more obvious way, may likewise be altered by the characteristics of the background: indeed, even if physically uniform, a color may at the same time appear lighter at some points and darker at others if the background lightness varies (fig. 7-17).

The relation of figure to background is another factor that can determine variability in perceiving the same color, whether chromatic or achromatic. The German philosopher Max Wertheimer demonstrated by ex-

a b

7-17. Right: In the composition b it is very obvious how the progressive lightening of the background induces an equally progressive and inverse darkening of the color band, actually homogeneous if looked at alone, a. The effect undergoes an interesting variation if composition b is seen from different angles.
If we manage to avoid the comparison with the background, it is easy to see that the two ends of the band, which seem so different in b, are objectively of the same uniform color as the isolated band a.

7-18. Opposite: Benary's cross. The same gray of the triangle on the cross has one value on its own and another when it appears against the background.

periment how formal unification may nullify antagonistic chromatic induction in favor of tonal equalization. A gray ring is placed over a half-green, half-red ground so that half of it lies on the green field, half on the red; the first half of the ring appears greenish and the other reddish through chromatic induction of the respective backgrounds. However, if we try to take in the ring as a whole, the effect of the induction disappears and we see the ring as uniformly gray (equalization). The conception of the shape may therefore tend either in the direction of the contrast or toward the constancy of the color. In the former case, the perception of the shape follows a direction tending toward a particular perception, in the latter toward a general perception. We may thus conclude that structured shape favors constancy of colors. The Swedish physiologist Ragnar Arthur Granit demonstrated, too, that in color relationships between figure and background, the inhibiting strength of the figure usually prevails (in the sense that its color remains almost constant) even if the color of the background is changed, while modification in the color of the figure produces more obvious effects of contrast in the background.

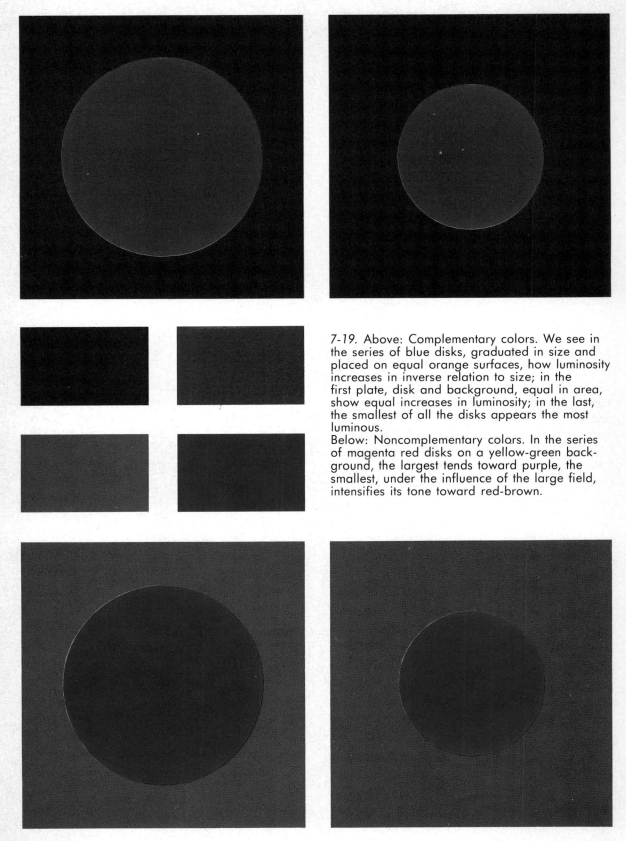

7-19. Above: Complementary colors. We see in the series of blue disks, graduated in size and placed on equal orange surfaces, how luminosity increases in inverse relation to size; in the first plate, disk and background, equal in area, show equal increases in luminosity; in the last, the smallest of all the disks appears the most luminous.

Below: Noncomplementary colors. In the series of magenta red disks on a yellow-green background, the largest tends toward purple, the smallest, under the influence of the large field, intensifies its tone toward red-brown.

As we have seen, the strength of contrast between two colors depends on both the spatial relations between the two diversely colored surfaces and their structural relationship. However, if physical conditions (colors, spatial relationships, and illumination) and physiological conditions are identical, the contrast produced by a colored or gray figure is determined by the surface on which it is placed, regardless of whether it is figure or background. W. Benary's experiment (fig. 7-18) is relevant in this context: each of two identical gray triangles, one inside the arm of a

black cross on a white ground, the other outside the two arms, is placed with its hypotenuse bordering the white ground. The two triangles should both undergo the same antagonistic induction of lightness from the white surface (being darkened by it) and from the black (being lightened by it). What actually happens, however, is that the inner triangle appears lighter because of the antagonistic induction of the black of the cross, which seems to form its background, and the outer one appears darker through induction of the white background. The question, then, is why and

when formal unification sometimes brings about chromatic contrast and sometimes equalization (as in Wertheimer's experiment). Benary has proved, by continuing to lighten the gray of the two triangles, that the effects of contrast and equalization become inverted, so that at a certain point the triangle outside the cross seems lighter than the one inside. With further lightening, the outer triangle suddenly becomes dark, but loses its character of surface tonality and assumes one of transparency: the uniformly white surface appears like a shadow in front of it. Cesare Ludovico Musatti (b. 1897), Italian psychologist and psychoanalyst, considers the phenomenon of equalization to disprove the theory that contrast is due to physiological processes of the retina and so has paved the way for formulating a new hypothesis on the subject.

So far we have briefly outlined notions that explain the fundamental phenomena of color perception on the basis of theories formulated over more than a century of investigations by students of physics, physiology, and ophthalmology. However, the problem of color vision becomes complicated when phenomena—such as the constancy of colors—are considered that do not appear to be sufficiently explained in terms of simple physiological processes of the retina. This introduces the theory of the active complicity of the mind in the formation of perception itself. Obviously, this problem, like all those concerning the functions of the mind, has been much debated by psychologists. Helmholtz, in making a distinction between sensation and perception (defining the latter as a cortical function), has opened the door to psychological inquiry; for him color perception involved a secondary and higher mental activity, over and above elementary psychological processes.

Hering, on the other hand, refuted Helmholtz's hypothesis of duality, relegating the basic phenomena of perception to the senses. Subsequent important contributions to the debate have tended to support one or the other doctrine: among the more distinguished proponents of theories on the subject have been such psychologists and philosophers as J. von Kries, Katz, Vittorio Benussi, Enrich Jaensch, George Elias Muller, Oswald Kroh, Karl Bühler; and, of the Gestalt school, Kurt Koffka, Ernst Fuchs (an Austrian ophthalmologist), George Katons, Eino Kaila, and Anton Terstenjak.

Developing the ideas of Bühler and his pupils, Musatti has recently propounded an interesting theory of distinguishing between the colors of objects (colored surfaces) and surrounding colors. For Musatti the most important phenomenon in the reciprocal influences of differently colored surfaces is not the contrast or the constancy of the colors but their tendency toward equalization. He looks upon this tendency as an aspect of the biologically determined disposition of the mind to assemble, in a perceptive field, a limited number of homogeneous elements conforming to the general principle of maximal homogeneity. Musatti observes that the rays reflected from the surfaces within the field of vision are divided into a double order of impressions: those sensed as the surface color of objects and those related to the surrounding luminosity. Because light becomes visible only as it is reflected, the perception of surrounding colors must be produced on the basis of the lights reflected from the various surfaces that are present; thus every colored or achromatic surface contributes to the color of the light surrounding it a part of its own rays, which will be minimal for dark surfaces, giving off little reflection, and maximal for light surfaces. If the luminous components are separated from many heterogeneous surfaces so as to constitute the homogeneous luminosity of the surroundings, the differences between the lights reflected from the different surfaces will be accentuated. Therefore the phenomena of tonal contrast and lightness, as well as constancy, are all, for Musatti, secondary effects due to ambient equalization.

As we have seen, the contrast is associated with the dimensions of the interacting colored surfaces. As a rule it is safe to say that the smaller the area inducted, the greater the contrast. However, the contrast also depends on the complementary relationships of the two colors. As already noted, small color surfaces placed on extensive colored grounds stand out more strongly when the two colors are complementary, or when the two colors are not complementary but have a different degree of luminosity.

The luminosity of a series of blue circles of decreasing size, placed on orange surfaces, equal in extent, shape, and color, is inversely proportional to the size

7-20. On each field of contrasting dimensions and color shades (a), the smaller, lighter figure in the center appears to stand out from the dark ground. Reversing the relationships of color surfaces (b) does not reverse the structure of figure and background; in fact, the small dark zone, through its low level of luminosity, does not project the figure forward, but makes it appear as a hole in the large light field.

a b

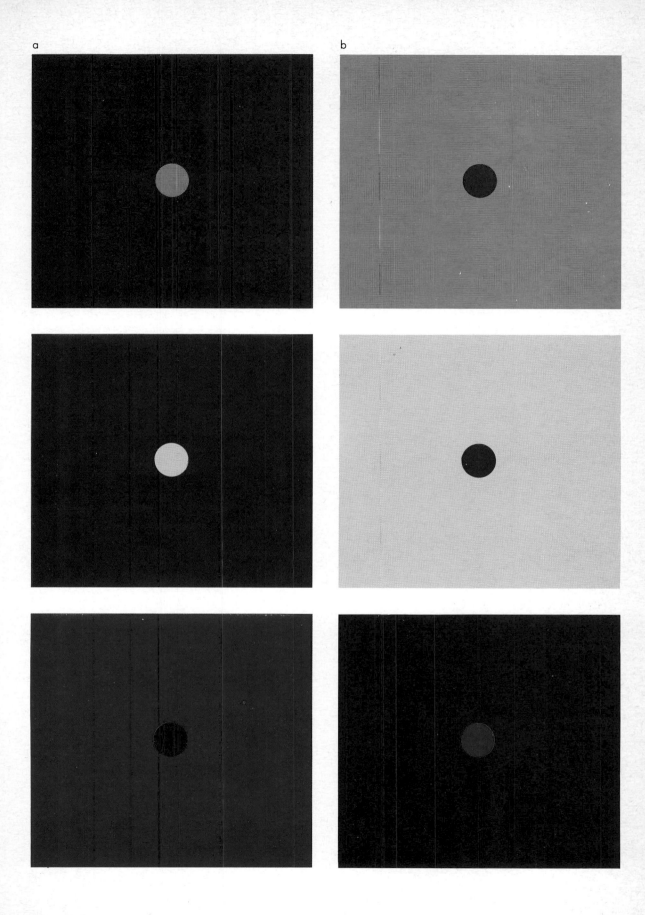

of the circle; thus the smallest circle appears the brightest (fig. 7-19, top). Where the surfaces of both disk and background are of equal size, the luminosity of both the blue and the orange increases in equal measure. On the other hand, with a series of painted red disks of decreasing size, on backgrounds of yellow-green (not their complementary color), the biggest disk tends toward purple and the smallest toward brown-red due to simultaneous contrast associated with the quantitative contrast (fig. 7-19, bottom). It seems that there is an increase of energy almost to survive, as Paul Gauguin noted: ''A meter of green is greener than a centimeter of green, but it seems that the centimeter fights for survival with added strength.''

Size of surface and color contrast can also influence the appearance of figure and background when the colors, without being complementary to each other, have a light-dark relationship, or one of differing luminosity. For example, a small yellow, pink, or red circle, in the middle of a large dark green, violet, or blue surface, is perceived as a figure and the green, violet, or blue as background: the luminosity of the small central area, subsequently augmented by rea-

7-21. Linking these plates with fig. 7-20, we show one of the possible ways of making the light parts perceptible as background and the dark parts as figure. As can be seen, what has to be done is to extend the light spot until it approaches the edges of the pictorial field. All the dark zone between the inner and outer edges of the field will be perceived as a frame (and thus with the quality of a figure) that stands out from the light background, now undifferentiated.

son of contrast, expands and projects the figure forward (fig. 7-20, a). If the colors of figure and background are reversed, the green, violet, or blue does not stand out as a figure over the large light zone: these colors, in fact, because of their low degree of luminosity, suggest a movement in depth and tend to be contrasted, arousing, instead of a central projection, the impression of a cavity (fig. 7-20, b). Only if we extend the light circle until it almost touches the edges of the painted zone does the green, violet, or blue, contrary to expectation, appear as a figure. In this case the dark colors are projected forward, constituting a kind of frame to the large, uniformly light background (fig. 7-21). If we tone down the

contrast in luminosity of the two planes (by placing the yellow, orange, or red circle on a background of equal color but slightly lighter or darker), we will see that in order to make the circle perceptible as a figure, we must make it bigger than was necessary on surfaces of a dark color or of more contrasted luminosity. The artist, aware of the importance and interdependence of these two components—which influence the

It is difficult to organize these proportions according to a fixed principle, because the equilibrium between size and color is also determined by other reciprocal factors, such as the different situations in which the colors are seen, their central or peripheral arrangement, and the physio-psychological conditioning of the artist, all of which preclude any categorical formulation.

effective energy of a color and accentuate form—must first of all arrange the dimensions of the various zones, in perfect harmony with the contrasts of color, if he wishes every part of the composition to acquire the movement and significance desired. Haphazard treatment of color zones, both in terms of quality and quantity, may lead to incorrect spatial relationships or to ambiguities of meaning, and thus, in consequence, to arbitrary interpretations.

Above: Klee (*Ad Parnassum.* 1932. Kunstmuseum, Berne) calculates the essential effects intrinsic to color relationships (quality, weight, and quantity) and distributes them almost with the minute care of the worker in mosaic. Opposite: The essential aim of Piet Mondrian is to express the balanced relationship of two complementary colors (*Composition with Colored Planes on a White Background.* 1917. Rijksmuseum Kröller-Müller, Otterlo). Here, however, the black strokes provoke a sense of movement in the form of an imaginary ellipse.

The paintings of Paul Gauguin, Henri Matisse, Paul Klee, and Piet Mondrian give the observer an impression of great compositional confidence, born not only of a vast and profound understanding of the reciprocal effects of colors, but also of an ability to organize their proportions very shrewdly. Such ability (and it is the masters themselves who underline this) is attained only after much trial and error, much research, and many patient experiments. Consequently, there is no point in fixing rules before setting out to paint a picture, because the manner in which one combines the various zones of color only becomes apparent when one is actually working, that is, when the colors are compared with one another. Nevertheless, it is useful for the artist to understand certain inevitable effects that will result from combining colors in dif-

ferent proportions. Mondrian speaks of the balanced relationship between value, position and degree of color, and Klee of exact proportions between quality, weight, and quantity. As a general rule, therefore, one can say that the success of a work in color (either a painting or a place) derives not only from the harmony or pleasing happy contrast of colors, but also from a division of the surfaces according to propor-

7-22. A square or rhomboidal shape in orange, yellow, or red, by reason of its position and the tensions it arouses in relation to the bounds of the field in which it is situated, may give the impression of constant motion (above). The same shape, and even a curved shape, may appear immobile in different comparisons with other shapes and colors if they are opposed in such a way as to balance any tension (below).

tions that balance their diverse chromatic forces (see page 151). Certainly a loud, very intense color should occupy less space than a more soberly colored surface adjoining it. In a room, for instance, a touch of very bright yellow (in a picture, curtain, carpet) can pleasingly enliven a background of neutral tone, whereas the opposite would be quite counterproductive.

The shape of a pictorial feature can also define its position in a painting. As Wassily Kandinsky says, a color without limits—that is, without form—can only be perceived by the mind, not realized on canvas. In fact, there is no brushstroke of color on a surface that does not suggest a sense of form, direction, or space; and because the color in a composition is inevitably bounded by other colored areas, the spatial dynamics of the painted surface is always condi-

Opposite: The analytical "skeleton" of the painting above (Wassily Kandinsky. *Small Dream in Red*. 1925. Private collection, France). The prevalence of curves and oblique lines, the distribution of "weights" according to the diagonal running from left to right, the almost quadrangular shape: all come together to build up what Kandinsky himself called a "lyrical" tension.

7-23. Diagram by Kopferman. The square placed in the center of rectangle a appears very stable because the sides of both figures are parallel to each other. The square placed in rectangle b, rotated by 45°, alters its shape until it seems rhomboidal; furthermore, it appears to be moving because of its relation to the sides of the rectangle. In c, the square appears static and unchanged if seen in relation to the sides of the page; but if we look at it inside the parallelogram, it resists the movements aroused by the oblique sides. In d, because of its position in relation to the sides of the parallelogram, the square shows a more accentuated movement than in b.

tioned by the forms that the eye perceives. The suggestive position of the chromatic elements in the picture may be imposed by either the shape, the expressive force of the color, or both together, acting in unison. Arnheim, referring to a painting by Matisse entitled *Opulence*, which represents three female figures in a landscape, points out that the small bunch of flowers placed centrally but not in the foreground, polarizes the attention and actually becomes the pivot of the composition, solely by virtue of its circular shape and dark blue outline—the only part of the picture where this color is found:[1] the blue, indeed, helps to give strength to the movement and is the color most appropriate to act in unity with the circle, just as yellow is with a triangle, and red and green with a square.

[1] Arnheim. *Art and Visual Perception*. p. 291.

145

Curved forms give a more vivid sense of movement, whereas straight lines appear static; yet even lines, according to their context, may have a kinetic quality. A square or rhomboidal shape in orange, yellow, or red, seen as the only motif on a geometrically regular but colored plane, may appear less concrete and give the impression of continuous movement, depending on its position and the colors used (fig. 7-22, top). The same shape, as will perhaps a curved shape, may, on the other hand, appear immobile in relation to the overall structure in which it appears when its force is hemmed in by the surrounding chromatic elements (fig. 7-22, bottom). Several quadrangular shapes on the same pictorial plane, regular or irregular, of equal or only slightly different dimensions, and at a different (though not great) distance, according to the contrasts of tones and the psychological reactions of the viewer, may give the impression of moving in different directions, to the point of even seeming to change place: the entire opposition is animated by it.

What has just been said for color applies also to defined shape; a circle and a square of the same color with equal measure, diameter and sides, may give the appearance of not being exactly aligned, even though they really are.

Straight-edged shapes may seem to be moving if the relationship of the lines themselves is altered. Thus a star may appear to have far more movement than a curved shape. Even black or white squares placed on geometrically regular white or black grounds, respectively, may appear to move or seem different in shape depending on their position in relation to the edges of their surfaces (fig. 7-23).

The positioning of colors in a painting is likewise important in determining spatial effects, given the capacity of every color to expand and project, or to contract and retreat, as well as other active and passive characteristics. The colors of the various elements set in the lower half of the composition move less and stand out more because they are closer to the observer; placed higher up they give the impression, if the tonality permits, of lightness. Johannes Itten writes in this context: "Low blue is heavy, high blue is light. Dark red at the top acts as a heavy, impending weight; at the bottom, as a stable matter of fact. Yellow gives an effect of weightlessness at the top, and of captive buoyancy at the bottom."[1]

In interior decoration, window dressing, and other displays of goods, the position of colors is also important, but the principles to be adopted vary according to the end in view. For instance, in a supermarket, where it is essential to arouse attention by means of the color of the display, red objects placed high up, yellow ones low down—even though the one may appear heavy and the other inconspicuous—will attract the eye and tempt the customer.

Apart from position, the direction of the colored elements must also be considered. Itten believed that every direction had its own particular features: the horizontal implied weight, volume, and breadth; the vertical expressed absence of weight, height, and depth; and the diagonals gave the sense of movement toward the depth of pictorial space. Together they suggested, for him, a sense of equilibrium, solidity, concreteness.

Even a contrast in the texture of the pigment may have a dynamic effect. The smallest unevenness in the application of the painting material or the slightest variation introduced in the binder tends to modify a color's spatial position: if a thick, uniform brushstroke is combined on the same surface with one that is thin and transparent, the denser stroke will appear to be raised above the fluid part (fig. 7-24, top). This, however, occurs only in the case of the same color, whether cold or warm; if, on the other hand, we combine colors of opposed temperature, however concentrated the cold ones and however diluted the warm ones, the former will appear to be in retreat and the latter to be advancing (fig. 7-24, bottom). A mixture of colors made more drab with gesso or sand may create a sensation of space if placed alongside a mixture made from pigments alone. Similar sensations may be aroused when we look at colors laid on with a brush next to colors spread with a spatula or poured onto the surface.

Even the deliberate use of different levels in priming or the combination of a variety of materials to prepare a painting surface may, by forming an uneven surface, dynamically enrich a homogeneous color applied to it, because of the different ways in which the incident light is absorbed or reflected. The same effects can be obtained by alternating the roughness and smoothness of plaster on walls. Other spatial move-

7-24. A dense application of color stands out alongside a thinner application of the same color. If the two colors are of opposite "temperatures," however, the cold color, whatever its concentration, will always seem to be placed behind the warm color, even if much diluted (below).

[1] Itten. *The Elements of Color*. p. 91.

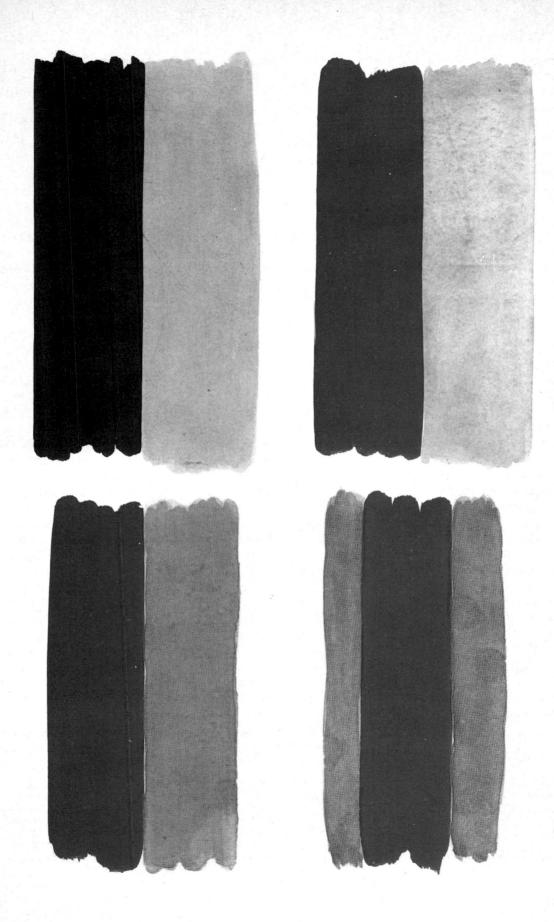

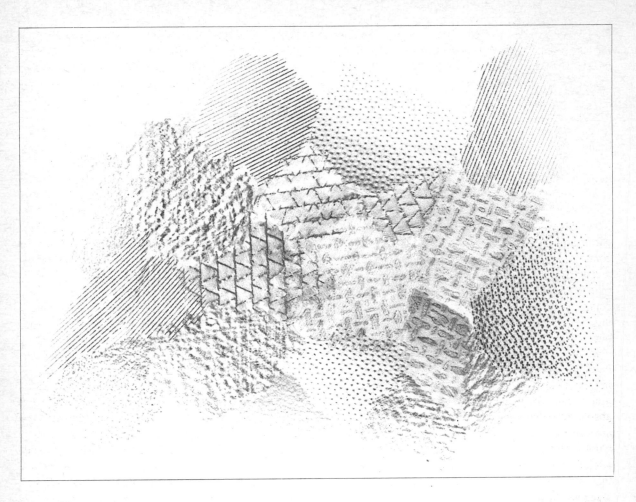

ments can also be produced by combining free forms traced with pencil or brush, when either their depth of impression or direction varies (fig. 7-25).

Like the fundamental pairs, other pairs (provided they are positioned opposite each other in the color circle) exhibit an increase of luminous intensity in both colors. When two colors not diametrically opposed in the chromatic gamut are juxtaposed, the natural tendency of the eye to seek opposition in order to attain physiological equilibrium may produce in them the effect of changing tone, purity, or temperature, and even of an apparent increase in diminution of luminous intensity, although not simultaneously and in equal measure as with complementary colors. Simultaneous contrast modifies or alters contiguous colors in various ways, depending on the position they occupy in the chromatic circle.

In combining colors, the closer they are in the chromatic gamut, the more their natural tone tends to deviate toward the colors that precede or succeed them. Thus, if we combine a bright red with an orange, the

7-25. The closeness of these free shapes drawn with a pen provokes impressions of spatial movements, when the intensity and direction of the strokes are varied.

bright red fades and appears more purple, while the orange becomes more yellow; a yellow alongside a green loses its brilliance and appears darkened and warm, because it tends toward orange, and the green appears blue-green and therefore colder; a violet and a carmine red, if paired, tend to take on ultramarine and a bright red tone, respectively.

When the adjacent hues are separated in the color circle by an interval, similar results are seen: for example, alongside yellow, bright red appears less bright and opaque, because it tends toward purple, and the yellow appears less luminous and slightly cold because of tending toward green.

Two noncomplementary colors separated in the chromatic circle by two or more intervals both undergo a slight darkening when placed next to each other. The tonal deterioration can be explained by the arousal in

the eye of the appearances of the respective complementaries, which determines a reduced perception of the purity of the colors observed: next to yellow, the complementary of violet, magenta appears less gaudy and more violet, and yellow appears greenish; an orange alongside a green turns grayish; magenta next to ultramarine blue becomes warmer, as if soaked by orange, complementary to blue, whereas blue appears colder and slightly lighter, because it assumes a coloration tending toward green; the same blue may appear less cold, darker, or grayer, according to the color with which it is combined; and a carmine red appears cold in relation to orange and warm in relation to blue. These chromatic flights due to the effects of simultaneous contrast may suppress the vibration of colors or falsify their characteristics, so as to make their perception more difficult or erroneous. However, the closer the contrasted colors are to diametrical opposition, the less they undergo modifications of tonality, while they exhibit in a more or less obvious way an increase in luminous intensity.

E. H. Gombrich, discussing the difficulty in perceiving the absolute character of a color, quotes a paragraph from John Ruskin's manual: "While form is absolute, so that you can say at the moment you draw any line that it is either right or wrong, color is wholly *relative*. Every hue throughout your work is altered by every touch that you add in other places; so that what was warm a minute ago, becomes cold when you have put a hotter color in another place, and what was in harmony when you left it, becomes discordant as you set other colors beside it; so that every touch must be laid, not with the view to its effect at the time, but with a view to its effect in futurity, the result upon it of all that is afterwards to be done being previously considered. You may easily understand that, this being so, nothing but the devotion of life, the great genius besides, can make a colorist."[1]

The tendency of every color, especially if it is bright and applied evenly with the brush, to invade the adjacent color with its complementary is still more evident if that color is gray; if this gray has a lightness equal to that of the inducing color, it more easily takes on the complementary tone. Therefore a gray on a magenta ground or on a bright red ground appears slightly greenish; on a yellow ground it appears violet; on a blue ground, orange; on a green ground, reddish; on violet, yellowish. Every color next to gray loses its typical chromatic quality with variations of luminosity; gray, in its turn, appears more or less warm in an opposite way to the inducing color.

These variations of gray and of the other color give energy to the chromatic nature of the painting.

If we want a gray beside another color not to receive its complementary, we have to add a small quantity of that color to the gray, as long as the color itself has a lightness similar to that of the gray. If we have white instead of gray, the appearance of the complementary is less evident. If the induced zones are a very dark gray, the complementary may not appear.

Even black on a colored background may take on the complementary of the inducing color by reason of simultaneous contrast, while it will retain its original blackness if on a white background. In this connection, there is an incident reported by Chevreul in which a dyeworks received a commission to print patterns in black on materials of single colors—purple, azure, and indigo. The clients complained that the patterns on the purple ground appeared greenish, those on the azure ground a leathery color, and those on the indigo ground dark greenish yellow. Chevreul, called in to decide the controversy, covered each background with white sheets, revealing the black of the patterns; he then explained that the effect of simultaneous contrast had to be taken into account.[2]

Anyone who works in the field of color has to have some understanding of what happens to colors when juxtaposed. When we wish to tone down the intensity of a color without retouching the work, we can obtain the required tint by adding a little of its complementary or by combining it with another tonality. To deaden a bright, intense red we juxtapose colors close in the chromatic circle, such as an orange, an orange-red, a magenta, a carmine, or even a yellow-ocher or red-ocher. An ultramarine blue is diminished in chromatic intensity next to blue that is more luminous or darker, or a different color containing a certain amount of the same blue, such as a green, a violet, or a bluish red (fig. 7-26).

To retain the freshness of a color or increase its brightness, it is sufficient to place it next to its complementary: orange or yellow next to azure, green next to red, and so on. Using such contrasts is important wherever people live and work: in factories it can be used to clearly distinguish the object being worked from the machine making it, to reduce the clarity of

[1] E. H. Gombrich. *Art and Illusion*. London: Phaidon Press, 1960, p. 261.
[2] Chevreul, in 1839, published a monograph of some seven hundred pages on the phenomenon of color contrasts. Because of his reputation, he was often asked to resolve disputes about the colors of textiles. The Gobelin dyers avoided possible ruin only when Chevreul demonstrated that some of their woolens did not show their proper colors because of the effects of induction on the retina.

less important objects, and above all to warn the employees against the risk of danger.

The phenomenon of the simultaneous and successive perception of images is the result of physiological processes that form the basis of vision, and must be taken into account by the painter, the graphic artist, the designer, the interior decorator, anyone who obtains particular effects by taking advantage of one or the other perception. Above all, the understanding of the reciprocal action of colors and the interdependence of color and lighting, dimension, shape, position, and direction encourages the artist to not dwell individually on such factors but to consider them all and attempt to use them all together so that the composition becomes a harmonic unity.

Harmony

I had originally decided to end this book here, determined to avoid the somewhat tricky problem of "harmony," which, where painting is concerned, is in my view still an open question. But there are many valid results that have emerged from the continuous theoretical research into this question pertaining to modern applications of color. Therefore I propose mentioning them, though briefly, in conclusion, keeping them within the bounds of what I conceive to be their true sphere, namely functionality or utility.

All theories of harmony—including those of Goethe, Ostwald, Field, Albers, and Itten—have in common an assumption that the sensation of harmony, or concord of parts of a whole, as aroused by a pictorial composition, results exclusively from the relationships and proportions of its chromatic components. So harmony must be derived from the juxtaposition of equidistant colors, from closely placed colors, from tones of the same gamut presented in regular gradations or at different levels, from contrasts between a bright and a dull color, or from their spatial positions and the dimensions assigned to the various chromatic zones. Analysis of such characteristics makes it possible to deduce both the natural (physiological or psychic) predispositions that induce the sensation of harmony and the norms or rules which they inevitably produce.

The idea that art should have as its object the fulfillment of aesthetic requirements, "beauty" according

7-26. The intensity of a color may be toned down by placing it next to more luminous or darker colors of the same tonality, or even of different tonalities, but containing a percentage of the color itself.

to rational and predictable rules, is an ancient and tenacious tradition, which every now and then is strongly reaffirmed wherever Greco-Roman culture has been assimilated or wherever its influence is felt. But beyond this, from remotest times to the present day, there have appeared, all over the world, indigenous art forms wholly immune to the rational exigencies of classical culture, and firmly rooted in the realm of magic and superstition that inspired man's first graphic symbols and figure representations. In modern art, through Impressionism, Expressionism, Fauvism, and other innovative schools and trends, we see that the vast majority of contemporary painters are deliberately and sometimes provocatively breaking traditional rules, asserting a right to absolute freedom of expression. Can we truly describe these unconventional art forms as disharmonious? I believe that by now we should be abandoning the aesthetic concept of harmony as restrictive. If strident combinations, unexpected chromatic proportions, and violence against traditional taste can come together effectively to express dramatic effect, mental disturbance, or the ideological complexities that are part and parcel of the modern human condition, then it is clear that we must still speak in terms of harmony, of all parts converging into an expressive whole. When, therefore, in the present chapter, we speak of a composition's chromatic equilibrium or balance, we are referring to a conscious use of the psychic potentialities of color, so balanced as to proceed in a concordant manner (with harmonious effects) toward a determined expressive end—of sweetness, excitement, provocation, horror, or any other sentiment. And this is what we mean by reference to a composition's harmonic unity. It is worth repeating, nevertheless, that in order to achieve harmonic unity in this sense, many of the proven findings and suggestions derived from theoretical research can undoubtedly be useful, especially in the various fields of practical and functional application of color.

Rules and recommendations, however, cannot be allowed to hamper the indisputable freedom of the artist, who has absolute discretion as to how much or how little they should be used in conjunction with all the other incalculable expressive resources at his or her disposal. Kandinsky says, "the creation of a work is the creation of the world" and "the expression of the eternal objective resounds in the subjective-temporal mind of the artist" with that force defined as "inner necessity." In other words,

an artist's work is the ultimate, unique expression, not in any other way translatable, of an absolute significance, which is part of the deeper reality of creation. These things, as Hölzel once said, will always be "beyond a simple formula."

This Congolese mask of the Bateke tribe (in the Musée de l'Homme, Paris) seems to validate, if not all the theories of Kandinsky, at least his intuition that pictorial art is always guided by a secret rhythm of linear structures, to which the consonant "weight" of colors should correspond.

152

Selected Bibliography

Adrian, Edgar D. *The Physical Background of Perception*. London: Oxford Univ. Press, 1967.

Albers, Joseph. *Interaction of Color*. New Haven: Yale Univ. Press, 1963.

Argan, Guilio Carlo. *L'Arte moderna 1770–1970*. Florence: Sansoni, 1971.

Arnheim, Rudolf. *Art and Visual Perception*. Los Angeles: Univ. of California Press, 1974.

Begbie, G. Hugh. *Seeing and the Eye*. Garden City, N.Y.: Anchor Books, 1973.

Chevreul, Michel Eugène. *The Principles of Harmony and Contrast of Colors and Their Application to the Arts*. New York: Reinhold Publishing Corp., 1967.

Fabri, Ralph. *Color: A Complete Guide for Artists*. New York: Watson Guptill, 1967.

Frieling, Heinrich, and Waver Auer. *Il Colore, l'uomo, l'ambiente*. Milan: Del Castello, 1962.

Goethe, Johann W. von. *Theory of Colours*. Cambridge, Mass.: MIT Press, 1963.

Gombrich, E. H. *Art and Illusion*. London: Phaidon Press, 1960.

Granit, Ragnar. *Receptors and Sensory Perception*. New Haven: Yale Univ. Press, 1955.

Gregory, Richard L. *Eye and the Brain: The Psychology of Seeing*. London: Weidenfeld & Nicolson, 1971.

Hickethier, Alfred. *Color Mixing by Numbers*. New York: Van Nostrand Reinhold, 1969.

Itten, Johannes. *The Art of Color*. New York: Van Nostrand Reinhold, 1973.

— — — . *The Elements of Color*. New York: Van Nostrand Reinhold, 1970.

Ishihara, Shinobu. *Tests for Color Blindness*. London: H. K. Lewis, 1951.

Jacobson, J. *Basic Color*. Chicago: Theobald, 1948.

Kandinsky, Wassily. *Tutti gli scritti, 2*. Milan: Feltrinelli, 1974.

Katz, David. *The World of Colour*. London: Kegan Paul, 1935.

Kepes, Gyorgy. *The Language of Vision*. Chicago: Theobald, 1944.

Klee, Paul. *Teoria della forma e della figurazione*. Milan: Feltrinelli, 1955.

Maltese, Corrado. *La Technique artistiche*. Turin: Mursia, 1973.

Munsell, Albert Henry. *Atlas of the Munsell Color System*. Malden, Mass.: Wadsworth, Howland, 1915.

— — — . *A Color Notation*. Boston: G. H. Ellis Co., 1905.

Newton, Sir Isaac. *New Theory About Light and Colors*. Munich: W. Fritach, 1967.

Ostwald, Wilhelm. *The Ostwald Color Album*. London: Winsor & Newton, 1933.

Previati, Gaetano. *I Principi scientific del divisionismo*. Turin: Fratelli Bocca Editori, 1906.

Wright, W. *Research on Normal and Defective Colour Vision*. London: Kimpton, 1946.

Index

Acknowledgments

I would like to take this opportunity to thank Professors Giacomo Gava and Lauro Galzigna of the University of Padua for their interest and encouragement in the preparation of this book, and especially Professor Osvaldo Da Pos for writing the Preface. I would also like to mention Dr. Luigina Santi and Dr. Maddalena Martinelli, who supplied me with several pieces of useful material as well as sharing with Giovanni Zorzi the task of reading through my manuscript. I am especially grateful to professor Antonietta Minasi, with whose kind help I revised the whole work. All the graphic and color representations were carried out by my students, either in the art colleges in which I teach, or in my studio, as a practical application of all that they have learned. Consequently, I would like to mention them by name: Giorgio Brunelli, Ivan Ceschin, Massimo Daissé, Pietro Disegna, Franca Fazio, Laura Fornezza, Sandro Francescon, Renzo Guagno, Michela Presotto, Stefano Rizzo, Omero Rovoletto, and Nicoletta Scarabellin. Special thanks go to those students who gave me particularly willing and constant cooperation: Guglielmo Costanzo, Renato De Santi, and Mariella Pizzo.

Picture Credits

Photographs

Stelvio Andreis, Verona: 90, 91, 117. Enzo Arnone, Milan: 87. Fabio Cianchetti: 101. Franco Fontana: 126b. Foto Mercurio, Milan: 66a. Fratelli Fabbri Editori, Milan: 61, 62r. Carmelo Guadagno, The Solomon R. Guggenheim Foundation, New York: 29b, 60, 63, 114b. Kagome Food Co.: 103. J. Klima, Detroit: 64. Kodansha Ltd., Tokyo: 66b. Norman McGrath: 92. Giancarlo Molinari, Verona: 29a. Mondadori Archives, Milan: 2, 37, 65, 67, 80, 102r, 104, 105, 114a, 116, 123, 140, 141, 144a, 145, 152. Rizzoli Editore, Milano: 621. Tate Gallery, London: 115. Leo Torri: 106. Masakatsu Yamamoto: 1021.
Copyright © by ADAGP, Paris, 1984 for the works by Dubuffet, Kandinsky, and Delaunay; copyright © by BEELDRECHT, Amsterdam, 1984 for the works of Van Doesburg and Mondrian; copyright © by S.P.A.D.E.M., Paris, 1984 for the works of Vasarely and Monet; copyright © by VAGA, New York, 1984 for the work by Warhol.

Illustrations

Giorgio Brunelli: 13, 44, 70. Ivan Ceschin: 15, 18 r, 19 l, 19 r, 23, 25, 30, 73, 77 l, 77 r, 127 r, 131, 142–43, 148. Guglielmo Costanzo: 76, 79 a, 108, 109, 110, 111, 112, 118, 120–21, 128–29, 134–35, 154. Massimo Daissé: 14, 20, 27 b, 38, 41, 42, 43, 45, 56, 74, 78, 79 b, 83, 126 a, 132. Renato De Santi: 12, 24 b, 49, 50, 82, 145 b. Pietro Disegna:130. Franca Fazio: 72. Laura Fornezza: 71 b. Sandro Francescon: 39, 119 b, 127 l, 137, 138–39. Renzo Guagno: 88–89. Mariella Pizzo: 18 l, 21, 22, 24 a, 27 a, 28, 31, 32, 34, 35, 36, 71 a, 98–99, 113, 119 a, 124, 125 a, 133, 147. Michela Presotto: 40, 57, 100, 125 b, 142–43. Stefano Rizzo: 24 a, 25, 26, 46, 51, 52. Omero Rovoletto: 150. Nicoletta Scarabellin: 33. Giorgio Seppi: 95. Lino Simeoni: 12, 13, 14, 15, 18 l, 18 r, 19, 20, 21, 22, 23, 24 a, 24 b, 25, 26, 27 a, 30, 31, 32, 33, 39, 42, 43, 44, 45, 46, 47, 49, 50, 51, 52, 57, 70, 72, 73, 74, 76, 77 l, 77 r, 79 a, 79 b, 82, 83, 88–89, 98–99, 100, 111, 112, 113, 124, 128–29, 131, 133,134–35, 137, 138–39, 142–43, 145 b.
Note: The illustrations by Lino Simeoni are based on original drawings by Giorgio Brunelli, Ivan Ceschin, Guglielmo Costanzo, Massimo Daissé, Renato De Santi, Franca Fazio, Sandro Francescon, Renzo Guagno, Mariella Pizzo, Michela Presotto, Stefano Rizzo, and Nicoletta Scarabellin.